To Remember a Vanishing World

D.L. Hightower's Photographs of Barbour County, Alabama, c. 1930-1965

To Remember a

D. L. Hightower's
Photographs of
Barbour County,
Alabama,
c. 1930 - 1965

Michael V. R.
Thomason

Vanishing World

Historic
Chattahoochee
Commission
Eufaula, Alabama

and

The Clayton
Historical
Preservation
Authority
Clayton, Alabama

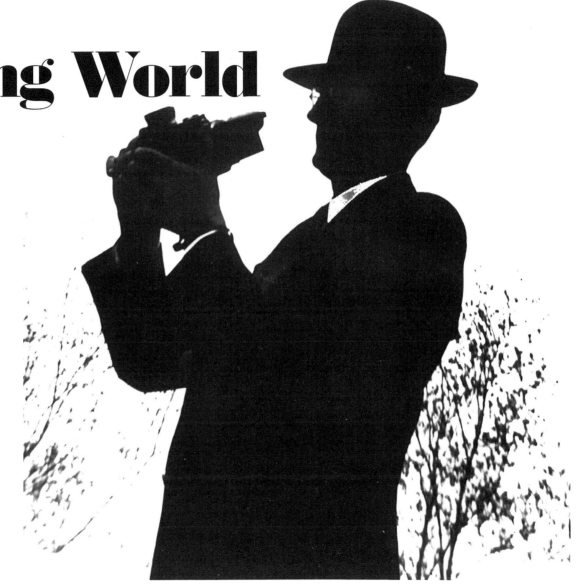

Library of Congress Cataloging-in-Publication Data

Hightower, D. L. (Draffus Lamar), 1899–1993
 To remember a vanishing world : D.L. Hightower's photographs
of Barbour County, Alabama. 1930–1965 / Michael V.R. Thomason
 p. cm.
 Includes bibliographical references and index.
 ISBN 0-945477-11-2 (alk. paper)
 1. Barbour County (Ala.)—Social life and customs—Pictorial
works. 2. Barbour County (Ala.)—History—Pictorial works.
I. Thomason, Michael. II. Title.
F332.B3H54 1997 97-24144
976.1'32—dc21 CIP

Manufactured in the United States of America

*For more information about this book, or other
publications sponsored by the
Historic Chattahoochee Commission,
contact:*
Historic Chattahoochee Commission
Post Office Box 33
Eufaula, AL 36072-0033
(334) 687-9755
or
Post Office Box 942
LaGrange, GA 30241
(706) 845-8440

Book design and production by
Anna Jacobs Singer / afj graphics
Jacket design by Paula C. Dennis and
Anna Jacobs Singer

Dedicated to

Draffus
Lamar
Hightower

*He had a
photographer's eye*

Contents

About the Book

In 1983, D.L. Hightower gave several hundred prints and a large body of negatives to the town of Clayton. Several people had encouraged him to do this. Margaret Kline, Leila Vinson, and Bertie Parish all talked to him for some time before he made the gift. Their efforts were an important part of this story. With the receipt of the gift, the Clayton Historical Preservation Authority set up a Hightower Collection Committee to take steps to organize, preserve, and use the collection. It was initially housed in city hall where Margaret Kline began the cataloging process. At the request of James Kessler, chair of the Clayton Historical Preservation Authority, it was later moved to the office of Andrew Clingan in the Barbour County Courthouse for security reasons. While the collection—by then housed in a large crate—was in the courthouse, there were a limited number of short exhibits of the original prints. In the spring of 1983 Louella Hobbs prepared an exhibit in the Octagon House in conjunction with the Alabama History and Heritage Festival. This was the first chance the people of Clayton had had to see more than one or two of Hightower's pictures at a time. During the period he was actively involved in recording his vanishing world, he sometimes gave friends pictures, but never had a public display. In the 1980s there were other displays mounted in Memorial Hall by June Hurst and Nancy Compton and photos were published in *The Clayton Record*. Louella Hobbs did a great deal to develop information about many Hightower pictures for the *Record*, and later for displays shown at Eufaula Pilgrimages and the Clayton Town and County Library. Hightower lived to see two of his pictures included in the exhibit and catalog, *In View of Home: Alabama Landscape Photographs* (1989). It was the first time any were exhibited outside Barbour County.

Mayor Ed Ventress had established the Clayton Historical Preservation Authority when the Hightower donation was first made. In turn it created a Hightower Collection Committee to look after the photos. The committee's members were Andrew Clingan, Rebecca Parish Beasley, Sharon Martin, Dick Martin, Bobby Kessler, Nancy Compton, Mary N. Whittingon, and Lois Warr. Their first concern was preservation of the collection. After speaking to Doug Purcell, Executive Director of the Historic Chattahoochee Commission, Kessler called me for preservation recommendations. I visited the collection and made some suggestions, but the task was a daunting one.

In the spring of 1990, committee member Lois Warr found time to play a more active role in our story. After teaching high school literature and drama for many years,

she retired and took the part-time job as head of the Town and County Library. That summer she arranged to have the increasingly fragile original prints moved from the courthouse to the library. (The negatives were not transferred at that time and it would be nearly four years before they were found. During that time it is impossible to say how they were cared for or by whom.) After the library acquired the prints, Lois Warr arranged over five hundred of them into subject categories and put them in albums so people could look at them without damaging them. She was assisted by Ann Mason, Joyce Rogers, and Annie Florence Daugherty in making Xerox® copies of the prints, so people could also use them to survey the collection before looking at the originals.

Also in 1990, Lois Warr and Mary Neal Whittington traveled to Troy to interview Hightower who was living with his wife in a nursing home there. His health was declining by then but he helped as best he could. In these interviews they recorded the majority of his surviving comments about his pictures. Since he was recalling an era already long past, some of his identifications must be accepted cautiously, but overall these interviews were very helpful.

After organizing the prints and interviewing the photographer, Lois Warr prepared an exhibit called "The Fabric of the Forties." In the course of doing so she became convinced that there should be more exhibits and a book of Hightower photographs should be published. In 1993 she went to see Doug Purcell to see how such a publication could be arranged. The Historic Chattahoochee Commission has a long record of publishing books of historic interest about the region. Purcell had long felt that Hightower's work deserved to be published, but Mrs. Warr was the first person from Clayton to urge this course and to offer to facilitate the process. Purcell contacted Kessler, the Hightower Collection Committee met, and after lengthy negotiations an agreement was reached making the book possible. In addition to Kessler and Warr, Claytonians Danny Hartzog and Nan Ventress Parker also played an important part in the process.

As this was being worked out, Dick Martin selected and ordered archival supplies so that Diane and John Lichtensteiger could begin the meticulous organization and archival stabilization of the print collection. They have also recorded much information for the Clayton archives, housed at the Town and County Library, that I could not include in this book because of space limitations, specialized interest, etc. Unfortunately, the conservation of the negatives, presently in some thirty-six containers, mostly cigar boxes, has yet to be undertaken. However, they are presently stored in an archival environment.

Despite the work done over the years to identify people, places, and events in the photographs, there remain a lot of questions. In February 1996, over fifty people came to the library over a three-day period to look at the pictures in this book and help to identify them. Their names are at the end of this essay and their sincere interest in the project and love for Mr. Hightower simply cannot be overemphasized.

The Hightower family has also been generous with their time and uniformly supportive and helpful. Jerry Vinson, Marie Hightower's nephew, came from Troy to talk at length about the couple and Mr. Hightower's photography. Bill and Beverly Bush, who live in the house Hightower built for his wife, Marie, showed me every scrap of correspondence, books, magazines, and surviving photographic paraphernalia stored there. They also described the man himself in ways which helped tell his story accurately and with feeling.

Although I never met Hightower, after working with his negatives and prints, I felt that I knew him. Handling a photographer's negatives is an intimate act, because looking at thousands of exposures you simply get to know what he was trying to do. It is like reading a diary which was not meant to be read by a stranger. Eventually, I came to feel much less a stranger and more a friend and admirer. Also I own and have used the Rollei and Leica models he used as well as press and folding cameras similar to his. That experience helped me to understand and appreciate his work even more.

Surrounded by so many people who had put so much effort into preserving Hightower's legacy, it is very hard to thank anyone adequately, especially Lois and Walter Warr for their hospitality as they fed and

housed me on my visits to Clayton. It was wonderful to meet people in the flesh whom I had seen in Hightower's pictures, especially two of his foster daughter Martha Bush's sisters, Eleanor and Mary Jane. It has been like one long family reunion, except that the family which made this possible is larger and more diverse than any I can imagine, representing as it does the community D.L. Hightower loved so much.

In addition to people in Clayton, I wish to thank Frances Osborn Robb for sharing her notes on her interview with Hightower, her informed impression of his work, and her helpful comments on the manuscript; and Doug Purcell for his patience with me in getting this project done. My colleagues at the University of South Alabama Archives, Elisa Baldwin, Barbara Asmus, and Peyton Russell certainly deserve my thanks for their tolerance and help. Walter Beckham and Benny Booker, two very knowledgeable photographers also critiqued the project as it went along. Mark Weems, graduate student in the History department, helped me with a lot of research for this book. My wife Marilyn and the History department's secretary, Helga McCurry, deciphered my handwriting and prepared the manuscript. Everyone worked with grace and good humor. Perhaps they all came to share my appreciation of Draffus Hightower.

The following is a list of people who helped identify pictures at the Town and County Library in Clayton or elsewhere in Clayton:

T.J. and Susie Bell Adams	Elton Heath
Pearl Adams	Gloria, David, and Cody Helms
Lillie Baker	Mary Henderson
Billy and Rebecca Beasley	Winfred Horne
Thomas Dean and Martha Beatty	June Hurst
James Beaty	Jack Jenkins
Dempsy and Frances Boyd	James and Bobby Kessler
Ben Bradley	Sarah Clayton Lawson
Walter Lamer Bush	Diane and John Lichtensteiger
William and Beverly Bush	Winn Martin
Joe and Betty Caraway	John and Phil McLaney, Jr.
Harvey Cole	Mary Alice Monk
Ronny Cooper	Thomas Snead
Mary Jane Byrd Culpepper	Betty Spires
Annie Florence Daughtery	Leila Vinson
William and Dean Fenn	Jerry Vinson
James and Jean Fenn	Jack Wallace
Aubrey and Eleanor Byrd Green	Walter and Lois Warr
Grace Hagler	Bobby Warr
Ida Mae Hall	Charlie Weston
Marilyn Harrod	M.J. Williams

I apologize to anyone whose name I have omitted from this list. It was unintentional because I do appreciate all the help and support every person gave. Any errors of fact or interpretation are, however, my own responsibility, not the fault of anyone named in the introductory essay or on this list.

About the Photographs

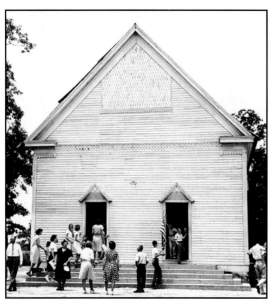

see page 176

The pictures in this book were printed on Ilford Multi-Contrast fiberbase paper processed archivally. About 80 percent are from Hightower's original negatives; the rest are from copies of his prints in cases when no negative survives, or the negative was so badly damaged that it could not be printed. I made the copy negatives using 4" x 5" Kodak Professional Copy film.

The lengthy negative selection process was done at the University of South Alabama Archives, as was some of the initial printing. However, I made most of the prints in the darkroom at my home using an old 4" x 5" Omega enlarger with a cold light head. Most of the original negatives required contrast-reducing filters.

In printing Hightower's negatives I tried to follow the compositional norms of his day. Thus, I cropped the 2 1/4" square negatives to make either vertical or horizontal 8" x 10" prints. Other film formats were also cropped as needed to make the sort of prints I felt Hightower would have made himself. Of course, doing this is very subjective, but I think he would have liked the prints that resulted. I did not print full-frame, i.e. the whole, uncropped negative, because that was rarely done in his day. It is much more common today, but I am sure that he would have been surprised to see his square Rollei negatives printed square. He had a vertical or horizontal composition in mind almost always. None of his surviving prints are full frame and several are indeed cropped as I had done before seeing them. However, I had seen several hundred of his prints before I printed any of his negatives and so developed a feeling for his style of composition.

Unfortunately the negatives desperately need to be organized, resleeved, and contact-printed. But there are so many, perhaps four thousand or more, that this will be a very major task. Pictures from the same roll may be found in several different boxes in little or no order. This situation probably has developed since 1983, when the photographer donated his negatives, but there is no way of knowing. Whatever the case may be, their organization and conservation must take a top priority now. However, I am sure the leaders of the Clayton community will find a way to do this, having carried the project this far already.

About the Photographer

Draffus Lamar Hightower was born June 16, 1899, near Perote, Alabama. Perote is close to Union Springs and a few miles north of the Barbour County line. His parents, Robert Sidney and Lizzie Brabham Hightower, were living with Sidney's parents on their farm at the time, but in December 1901 they purchased a 240-acre farm six miles west of Clayton on the Smuteye Road. The Hightowers had five more children and lived on that farm until Sidney died unexpectedly of a heart attack in 1930. Lizzie continued to live in what her daughter Mary dubbed the "Hightower Hospitality House" until shortly before her death in 1953 at age eighty-three.

Life on a farm in the early twentieth century meant long hours of hard work and no guarantee that your enterprise would be rewarded monetarily. The crops the Hightowers grew are not recorded, but cotton was certainly the largest as it was for virtually every farmer in Barbour County until the Great Depression. Corn was probably also important, and the family did keep at least one milk cow for the children. There were pigs and chickens, and two mules, Kate and Della, who were thought of as part of the family. A vegetable garden, pecan grove, and large smoke house rounded out the farm. The large six-room house had front and rear porches where family and friends passed the time when they were not working. Hightower's youth was a happy one by all accounts, but under the direction of his thrifty, "workaholic" father it was also filled with toil. Before he could see over the plow's cross tee, Draffus (pronounced with a short 'a' as in draft) was working in the fields from "cain to cain't" (dawn to dusk; "can see to can't see"). With his brothers and sisters he walked to school near the Pleasant Grove church; school operated from September to April. In 1916 Barbour County began consolidating its scattered one-room school houses but this development came too late for Draffus. However short his formal educational experience, he was to be a life-long reader, a bookworm who found almost any subject fascinating.

As the oldest child, Draffus was looked up to by his brothers and sisters who thought their "Bud" could do just about anything. For example in the First World War era he bought a camera from a Sears catalog and began taking snapshots. The prints and negatives that survive demonstrate a natural sense of composition and an abiding love for the people he grew up with.

The Hightowers had a large extended family and a wide circle of friends and neighbors, black and white. Some of their friends were prominent citizens of the county, others simply small farmers, and still others,

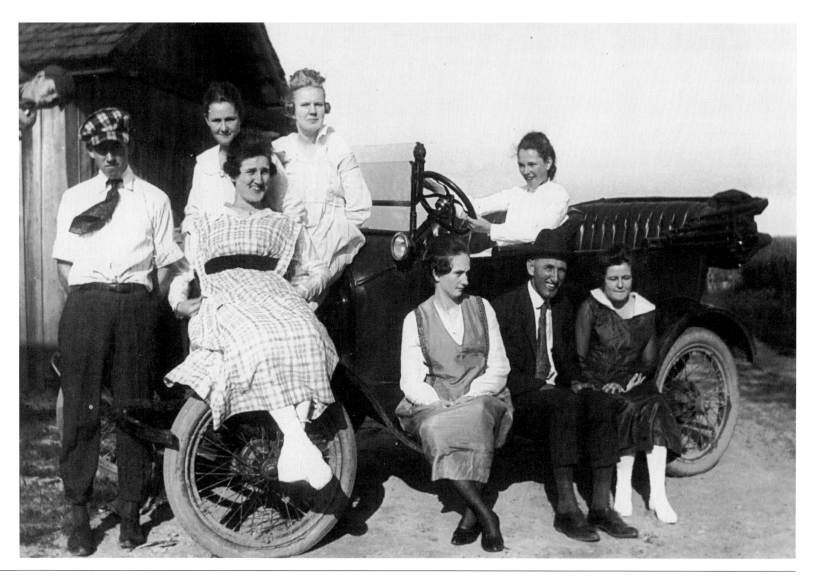

Hightower became interested in photography in the twenties, taking casual pictures of his family and friends. Even these earlier pictures show an eye for composition and an ability to capture the mood of the occasion. In this photograph most of the people, though relatives, are unidentified except Mary Hightower Bond, third from the right, sitting on the running board.

including the blacks, tenant farmers, or servants. The Hightowers did not contravene the norms of racial segregation then universal to the South, but their treatment of the African Americans they knew was kind and honorable. They also extended their hospitality to strangers who passed by their house and others who might not have been welcomed in many homes. The family was Methodist and took Christianity seriously. The children learned to be considerate of all people because "we never knew when we were attending angels unaware," as his sister Mary said.

There were light-hearted times, square dances, parlor games, and hunting for the boys. Draffus did not do these things himself, but seemed not to mind that others did and enjoyed them. Taking after his father, he shunned idleness and had adopted the habit of reading voraciously. For the rest of his life he was never far away from a book. By the time he was in his mid-teens Draffus had begun to sell vegetable and flower seeds, salves, and even books to his neighbors.

In July 1920 he and a good friend, Carl Ward, went to Sweeny Automobile College in Kansas City to learn the new trade. They were not there long. Hightower was home in October and got a job in Clayton. He worked for Robertson's Ford at first, but in 1928 he started the area's first Chevrolet dealership on North Midway Street in Clayton. While he worked at Robertson's he lived at home, riding a motorcycle into town on the treacherous dirt roads of the county.

His family had owned a Ford since 1916, but it was not his to drive back and forth, so he wrapped his tall, (6'3") lanky frame around his Harley and off he went. During his time at Robertson's Draffus met Marie (pronounced Mare-REE) Turner from White Oak Station which was about as far east of Clayton as his home on the Smuteye Road was west. Presumably, the Harley got quite a work out! They were married in 1923 and eventually built a house on North Midway Street where they would live until 1985, when they moved to a nursing home in Troy.

After 1928 Marie kept the books for Hightower Chevrolet, while Draffus sold the cars and trucks and saw to the maintenance, repair work, and parts sales. He spent long hours at his business, while she did her work at their home four or five blocks north on Midway. Although devoted to Draffus, Marie had a personality many others found difficult. She could be harsh, critical, and demanding. She was a shrewd business woman by all accounts, and more focused on amassing wealth than her husband. While Draffus's parents were hardly poor, the Turners were quite well fixed, at least as regards land ownership. However, throughout their life together Marie insisted on keeping separate accounts and filing separate tax returns. On the other hand she was well remembered for the baked goods she unfailingly prepared for church events and for her remarkable green thumb. In the spring their house is surrounded by the flowers she planted over the years. Later in life he would say that he knew

and remembered hard times and wanted to have enough to avoid them but that "there was no point in being rich." In the end the Hightowers were rich thanks primarily to Miss Marie's attention to the bottom line. Both were frugal, however. Hightower often spent hours rebuilding a car part instead of replacing it, just on principle. "Waste not want not" was no idle phrase to either Hightower.

If Miss Marie could be difficult to deal with at times, Draffus was friendly and quiet all his life. He was not a conversationalist. He said, or wrote, what had to be said and then stopped. The few bits of correspondence from Marie or Draffus which survive confirm that she was far more verbal than he, and often kind and considerate to those she was close to. He was reticent, never gossiped, and always stayed busy. When problems arose he might take some time working out a solution to them, but once decided, his course of action was not open to debate, even by Marie. He was kind and pleasant to his neighbors and customers, but was always busy, and never at a loss for things to do.

Like his father, Draffus, or D.L. as some of his friends called him, believed in paying cash for what he bought and never using credit. Perhaps that explains how he kept his car business going in the Depression when sales of cars and other durable goods virtually ceased in Alabama. Hightower weathered the storm, while Robertson's Ford did not, but there was no denying the ravages the era brought to Barbour County. Besides

the effects of the stock market crash, farmers had to deal with erosion and the boll weevil. Cotton, long the staple cash crop of the county, simply was no longer a desirable option. You could not grow it, and if you did, you could hardly sell it for a profit. Ruined, people began leaving the land and a demographic revolution in the South began.

Hightower traveled around Barbour, and neighboring counties, selling Chevy cars and trucks and he saw that the world he had loved and known was vanishing, virtually before his eyes. The sudden death of his father in 1930 must have accentuated this point. In the midst of all this he decided to take up photography seriously. He began to take pictures all over the county and in Clayton of people, places, and activities which he felt future generations would not otherwise know. He realized that the commonplace would soon be forgotten unless he photographed it. Late in his life he told Bill Bush, the son of the girl he and Marie raised as a daughter, that the key to great photography was to record things which would never be seen again. For thirty years, beginning in the early 1930s, he did just that.

Hightower never used his camera to make money, sometimes charging only for materials when asked to take pictures of weddings, funerals, and other social events. By the 1950s such requests had become so frequent and somewhat of a burden that he put his cameras away, except for very special occasions. Concentrating on recording a vanishing culture, he must have sensed that by then the process was virtually complete, and his photographic record was indeed the most persuasive argument that the vanishing world of his youth had ever existed.

Predictably for a person who used words sparingly, he kept no written records of what he photographed. For him the photographs said it all with an eloquence which words could only envy. Unfortunately, without logs or other written information many of the pictures are difficult to identify and date. Late in life he tried to do this for the prints he had given to Clayton's Town and County Library, whose very existence was largely due to his and Marie's efforts. Since he tried to do this forty years after he took the pictures, not all the information he provided is of equal accuracy. However, his words are incorporated in the picture captions of this book whenever possible, for they do give a sense of what he was trying to do.

In addition to the photos in this book he took thousands of pictures of Martha, the girl he and Marie considered their daughter, as well as her sister and friends. Martha Byrd's father had died suddenly of pneumonia in 1932 leaving a widow with a large family. People in Clayton helped out in myriad ways despite the burden of the Depression, and the Hightowers, who were childless, offered to take one of two twin girls to live with them, to be reared as their daughter. Since Mrs. Byrd, a neighbor, simply could not look after all her children and did not want to give up both twins, she agreed to have the Hightowers raise Martha. Until she married in the fifties, Martha would live as Marie and Draffus's daughter, though she still spent time with her siblings including Mary Jane, her fraternal twin. Hightower, who liked to travel, often took both sisters with him. Marie preferred to stay home and tend to business and garden. Because the pictures of Martha and others in her family were not made to document Barbour County life, few are included in this volume. For the same reason, pictures of events such as weddings and funerals are not included either. Also, these pictures are relatively unremarkable photographically. Few can stand comparison to the images recording the vanishing world he had known and the changes he saw around him.

He used a variety of sophisticated cameras and film (including infrared) in his work. For many years he did his own darkroom work, either in a back room at the dealership or a pantry off the kitchen at home. He always had a camera with him wherever he went and used it freely. He worked with roll film cameras, eventually including a Leica, and used a 4" x 5" B&J Press camera in the late 1930s and 1940s. Thanks to an industry-wide manufacturing flaw in early safety film virtually none of his sheet film negatives survive. However, his best work throughout most of the nearly thirty years he was engaged in the project was done with a 1930s Rolleiflex. This German twin-lens reflex camera was beloved by photographers all over the world

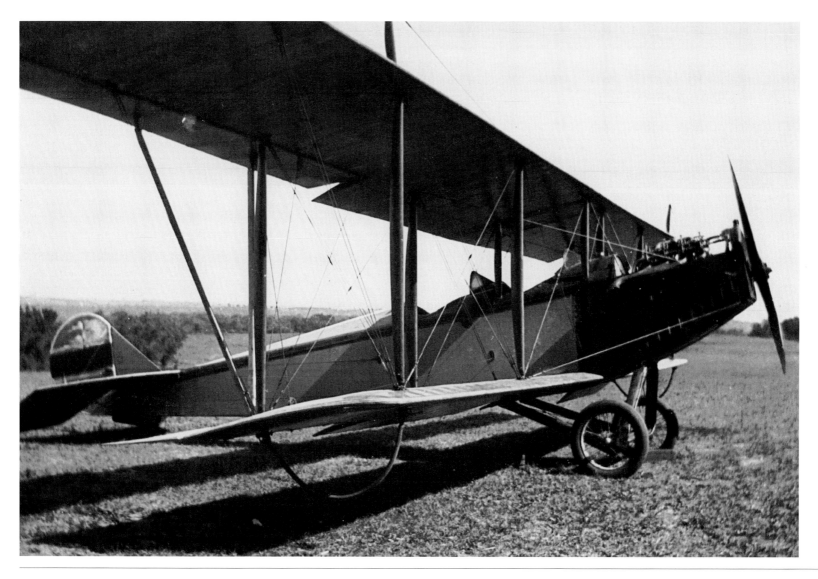

In the early 1920s Hightower went to an air show near Montgomery where his photograph of a Curtis Jenny demonstrates how sharp his sense of composition had become and how fascinated he already was with machinery. The two interests were to remain with him throughout his life.

Clayton Ala
July 30
Dear Martha
Finished the small
roll. negatives seems good
arrange to use up all
the rolls I sent but
try to take something
interesting - how about
getting up in Porch - snap
whole crowd when in
yard waiting to go in
to eat. when shooting
a good subject or scene
always make more than
one. by shifting your
Position - as this gets
it from different view
points
Been raining all day
all wet now.
Every thing about same
otherwise.
D.L.H.

Hightower sent this postcard to his foster daughter Martha on July 30, 1946 while she was in summer camp at Montreal, North Carolina.

because of the quality of its construction, the sharpness of its lens and its unobtrusive quality. The Rollei (pronounced "rolly") was used at waist level, not held up to the photographer's eye, and thus subjects often relaxed thinking no pictures were being taken. After all, the small camera might be sitting in the photographer's lap. Its Compur shutter was so quiet you could not hear when a picture was being made. The viewfinder was ground glass, presenting a beautiful image to the photographer but only if the camera was correctly focused. If not, the image was unclear and indistinct. Hightower's other cameras all used an optical viewfinder which did not have to be focused. Unfortunately the camera itself did, if you were to get a clearly focused image on the film. Looking through the thousands of negatives he made with these other cameras, it is sadly evident that good pictures were spoiled because he often did not properly focus. Because of the design of the Rollei this rarely happened. Hightower also apparently had difficulty with depth of field, which is a term for that which is acceptably sharp in a photograph in addition to the single point of focus. A function of lens focal length, aperture, and distance from camera to the point of focus, depth of field is often an important compositional tool. Hightower could have used it better. Finally, he followed the pattern common to most photographers of his day of overexposing and over-developing his film. The term "bullet-proof" comes to mind in describing the density of most of his negatives. With subsequent changes in printing paper and enlargers over the years, these older negatives offer something of a challenge to print, but this was less of a problem when Hightower made them. However, for a follower of Ansel Adams, as he certainly was, Hightower's technique was not without shortcomings.

However difficult to print, and many have been damaged in storage over the years, Hightower's negatives give incontrovertible proof that he had the eye of a great photographer. His sense of composition was simply outstanding. Composition has been defined in a variety of ways by important photographers and most agree that it consists of the ordering of the elements in a picture so as to make the most powerful impact possible on the viewer. As Edward Weston said, "Composition is a stronger way of seeing." Clearly Hightower agreed. Looking at a series of negatives, you can see him exploring angles, lighting, and composition until he has what

he wants. However, film was expensive in the Depression and Hightower was careful not to waste it on pictures until he was sure everything was just right. There was nothing casual about D.L. Hightower!

Because he was well known and well respected throughout the county no one objected to his photography. Few, if any, understood the serious purpose he had for his pictures and fewer yet could have appreciated the photographic influences his work demonstrated. Though friendly, he was no talker and he did not try to explain. His subjects went on about their lives, and he was free to get on with making his record.

One of the most fascinating questions about Hightower is what photographer's work influenced him most. Everyone knew he was a compulsive reader, always surrounded by books and magazines. However, he kept relatively few after reading them. Those he kept he carefully refrained from writing in, turning down pages, etc. Thus it is hard to know what portions of a given book or magazine particularly interested him.

However he made no secret of his admiration for the work of Ansel Adams. He had a copy of Adams' rare *Making a Photograph* (1939 ed.) as well as a variety of photographic annuals and magazines from the forties. Several books showcase works of pictorialism, a school of photography which endeavored to make a photograph look more like a charcoal drawing or painting. This was the polar opposite of Adams' sharp realism, though

both schools agreed that the best photographs were those made carefully and deliberately. Hightower's oldest surviving photo book is *The American Annual of Photography* (1926), which was a pictorialist publication, suggesting that he was interested in serious photography some years before he began to record the vanishing world of his youth.

In those books and magazines which have survived in his home are examples of the work of many of this century's greatest photographers. Adams' book includes pictures by several photographers including Dorothea Lange. An Adams article in a copy of the June 1948 issue of *Popular Photography* includes photographs by Paul Strand, Edward Steichen, Berenice Abbott, and Edward Weston, all photographers whose work would have impressed Hightower. He was a charter subscriber to *Life* magazine, saving every issue, and in its pages would have seen the best of the new photojournalism which magazines such as *Life* and cameras such as Leica and Rollei made possible. Hightower had the modern equipment, access to information about the work of major photographers, and a sense of a mission. It was a remarkable combination.

Historians have looked at and debated about the concept of "Zeitgeist" which may be translated as the spirit of the era. It is an almost mystical, and certainly subjective concept that people somehow do what they do in response to the pervasive spirit which is a distinctive hallmark of its epoch. Certainly

Hightower's work now seems an example of someone working in the spirit of his time. The New Deal photographic documentary project undertaken by the Historical Section of the Farm Security Administration focused on rural America. It employed such great photographers as Walker Evans, Dorothea Lange, and Arthur Rothstein, all of whom worked in Alabama at various times. None came to Barbour County, and thanks to the survival of Hightower's photographs they did not need to, because he was already there. Of course they did not know this at the time. However, unlike Evans, Lange, and Rothstein, he knew the people he photographed and understood their world because it was his also. Certainly unlike Evans, he loved it too. So Hightower's pictures are less an indictment and more of a memorial. Unfortunately, his pictures were not seen, except by friends, for many years. Was Hightower influenced by Walker Evans' "portraits" of mules, or his own memories of Kate and Della? Did his pictures of dog trot houses, tenant farmer's shacks and rural churches spring from seeing pictures by Evans and others or from his own experience? We will never know, but given the fact that he was both a thoughtful observer and an avid reader the answer is probably both.

For almost a decade beginning in 1936 Hightower made hundreds of candid portraits of individuals and small groups in Clayton. Most of these pictures were taken with small folding roll-film cameras or the

Leica, a few with the Rollei. Some are reminiscent of the work of Dorthea Lange but many share the character of similar pictures Walker Evans was making on the subways of New York in the late thirties. Both men used similar techniques to record unposed images of people who, in Evans' case, did not know they were being photographed. In Hightower's case the subjects may have noticed what Draffus was up to, but having long since gotten used to his passion for cameras they ignored it. It works out the same, but there is nothing to indicate whether Hightower knew of Evans' work at the time or not.

Perhaps because he had more time to record his world than any visitor would have had, Hightower's photographic record has a unique depth to it. There are multiple examples of most subjects made over a number of years in his surviving negatives and prints, so that a modern researcher can be confident that the churches that are scattered across the county played a fundamental role in the culture; that personal contact on the streets of Clayton was the basic method of exchanging information and forming opinion; and that politics were absolutely fundamental to life in Barbour County. The latter is borne out in Hightower's many pictures of gubernatorial candidates, especially native sons, hosting rallies on the courthouse steps. Hightower himself was not especially political. Though conservative, he did not talk politics, but he did record such activity, especially the first 1958 George Wallace rally. Wallace had grown up in nearby Clio and was well known throughout his home county. Hightower's pictures record this support and affection and he surely supported the grandson of horseback-riding Dr. George O. Wallace. But whether he did or not, he and his camera would certainly have been there to record such events.

Hightower's record is not perfect. He accepted the world in which he lived, its social gradations, economic distinctions, sex-linked roles and racial mores. While he made an effort to improve it in various ways, he loved his world and its people. He admired the poor tenant farmers for their ability to endure the hardships they faced as much as he respected the prominent leaders of his community. His photographs of poor people, whether black or white, are sympathetic to their humanity. He did not stereotype them. However, there are very few pictures of women in roles other than those traditionally reserved for them. Women are photographed in the home or in appropriate environments such as the school teacher's classroom or at church. Except for Martha Byrd's mother none of the candid portraits are of women. They did not sit on the liar's bench or gossip in front of the stores on Eufaula Avenue. In the end Hightower photographed a man's world, as seen by an observant and thoughtful southern white conservative. Throughout his photographic career he had only one goal, to record a vanishing world so generations to come would at least know it had once existed.

The last chapter in that photographic record was a sad one, the demolition of the antebellum courthouse which had been the center of life in Clayton since before the War. Despite being over a century old, it fell victim to progress and was demolished in 1959-60. In its place a larger modern, sterile building arose to confront the old town. The Hightowers opposed the demolition, and when he could not stop it, Draffus recorded it in a moving photo essay which spanned the months the process required. Miss Marie, who rarely allowed her picture to be made, is shown from the rear in one of these images. Her opposition seems clear in the picture, as is that of her companion. Eventually, Marie and Draffus hauled away truck loads of bricks, timbers, and even some interior cast iron columns to a site across from the Methodist Church they attended just down Midway. There, with the Hightowers' support, the Town and County Library was built, using the materials from the old courthouse. A sad chapter had a happy ending in December 1962 when the library was dedicated, and Miss Marie allowed her picture to be taken again.

Almost a decade earlier, in 1953, Hightower had given up his Chevrolet dealership, in part because of disagreements with the company and partly because he was tired of seeing people only when they had problems they wanted him to fix. As a result he traveled the county less. About the same time, he stopped taking so many pictures for

people and spent his time managing his wife's farm at White Oak Station. It is probably no coincidence that his mother died in 1953 as well. The deaths of his father and mother each seemed to signal a change in Draffus' life. He began and finished the photographic project shortly after the death of each of his parents. By the mid 1950s the world he had known and loved as a boy, a world which in his mind shared a great deal with that of the pioneers who settled the county in the 1830s, was gone. His project was done.

He went on to manage the farm and enjoy Martha's two sons, Bill and Lamar, whom he considered to be his grandchildren, until Marie's failing health necessitated her being moved to a nursing home in Troy, Alabama, in 1985. The years were financially comfortable and the Hightowers made many anonymous contributions to a variety of churches and other organizations they supported, such as the Town and County Library. However the years were overshadowed by the tragic and unsolved murder of Martha in 1965, which grieved Draffus until the day he himself died.

When, after caring for Marie for over a decade, she had to be moved to the nursing home, Draffus decided to go with her although his health was excellent. So he packed his bags and asked to be taken to live with his wife. He simply missed Marie too much. Martha's son Bill, who had lived with them in the old house on Midway and helped look after his grandmother, stayed on to run the farm for several years thereafter.

Draffus visited Clayton frequently and even collected some of his cameras to take back to the home, but he took no more pictures. He continued to read and lived, surrounded by books, caring for Marie until he weakened and died in 1993, half a year after their seventieth wedding anniversary. He was buried in the Clayton cemetery next to his Methodist church across from the library halfway between his home and the site of his Chevrolet dealership. Before going to the nursing home he gave the city his prints and negatives so that the record he had made would be preserved. Not surprisingly he also saw to it that money was provided to help accomplish this.

One last question remains, and it will probably never be answered. Did Hightower know about Eugene Atget, the man who photographed life in Paris around the turn of the century? Like Hightower, Atget loved Paris and sensed that the city he knew was rapidly being swept away. He sought to record the people and places which soon would only be a memory. He was a poor man and his work was saved after his death in 1927 by a young American photographer who knew him, Berenice Abbott. She brought back several thousand of his negatives to New York and worked tirelessly to see that he was accorded the recognition he deserved. One of her converts was Walker Evans whose style owed a considerable debt to the humble Frenchman whom he never met. Hightower knew about Abbott's own photographic work, but did he know about Atget? Today Atget is a well known figure in the development of photography, his fame a striking contrast to the obscurity in which he lived when making his remarkable photographs. The two men, so different in so many ways, both sensed that they alone could preserve the memory of a passing era and both did so. Again, perhaps we should be content to credit "Zeitgeist" for we will never know if Hightower knew of Atget's work.

Whatever influenced the quiet farm boy to make the pictures he did, the photographs themselves need no words to justify them. Like the man who made them they are too quietly remarkable for words.

About the County

The Alabama legislature created Barbour County in 1832 out of Indian lands. It also directed that a county seat be established as nearly as possible in its geographical center and be named Clayton, after a distinguished jurist and congressman from Georgia. Augustine Clayton never set foot in Barbour county or on the streets of Clayton, which did not even exist until after the Alabama Legislature directed that it should. Why the state's law makers were so intent on honoring a Georgian is now lost in the mists of time.

The county is rather large, approximately 912 square miles in area. It faces the Chattahoochee River on the east, is bounded on the north by Russell and Bullock, on the west by Pike, and on the south by Dale and Henry counties. Its land was easily cultivated by the tools and methods used by the American immigrants or their slaves. On land Creek Indians had long inhabited, these settlers planted corn and cotton. By 1850 the county was home to nearly twenty-four thousand persons. By the 1870s almost thirty thousand people lived there. The population size thereafter remained fairly constant until well into this century, falling below the latter number only after World War II, when population began a forty-year decline which appears to have ended in 1990.

Although it was the county seat, Clayton was never the county's largest city. That distinction belonged to Eufaula on the banks of the Chattahoochee River. As a center for the cotton trade since before the Civil War, Eufaula has always been the county's largest city. However, with just over four thousand people living there until World War II it was neither very large nor growing very rapidly, even by Alabama standards.

Most of Barbour County's people have lived in the countryside since its inception. Even as late as 1960 there were still twice as many people living in rural areas as there were in its incorporated towns. However, drastic changes had already occurred by that year and they had largely destroyed the world Hightower had known as a young man. His photographs span the years from the early 1930s to the early 1960s as he recorded a world he knew would soon be lost to change.

When he was a young man in the 1920s, most people lived on farms growing crops their ancestors had grown, i.e., corn and cotton. After World War I Spanish peanuts were challenging these crops, but for tenant farmers cotton would continue its dominance. In 1920 the overwhelming majority (73 percent) of the county's farmers were tenants. Since the county was established, blacks had accounted for a large percentage, and long before 1900 a majority, of the population. Few ever owned the land they farmed. Over half the white farmers owned their land whereas only 18 percent of the blacks did in 1920. With no resources, little education and a legally enforced second-class status, the county's black people could offer little help in the struggle to survive the changes that were coming. Indeed the statistics clearly demonstrate what black Barbour Countians did in response to the situation they faced. They left the county. Between 1920 and 1960 the county's population fell by some twenty percent, or six thousand people. During this period sixty-five hundred black people left and five hundred whites were added. The black exodus continued for twenty years after 1960 so that there were approximately half as many African-Americans in the county in 1980 as there had been in 1900. The county's decline in population over this century's first nine decades is virtually identical to the number of blacks leaving (10,735 vs. 11,000).

The economic realities which bore down so severely on the county's black people were no respecter of race and were felt by the whites as well. Falling cotton prices in the late 1920s reached a horrific 5 cents a pound in 1930. Cotton was almost not worth picking at that price. Of course many farmers did not have to worry about that as the boll weevil had already destroyed their crops. In 1920 Barbour County had over fifty-one thousand acres of cotton. By 1960 it had only eleven thousand. Since cotton was the traditional cash crop for most farms, a reduction of 75 percent in the land devoted to it is certainly significant.

The search for an alternative to cotton centered on peanuts. Thanks to the research of George Washington Carver, whose books Hightower had sold to his neighbors as a boy

in the 1910s, peanut production grew from 1920 onward. The county's soil and the crop's requirements were well suited to the resources of Barbour's farmers. Peanut production benefits from access to machine pickers, but much of the other work could be done by hand. During the 1940s government programs designed to increase production for wartime needs saw acreage soar, and it remained high until the 1950s when it declined. In 1920 there were nearly thirty-one thousand acres of peanuts, a number which declined only slightly until World War II. By 1944 there were fifty-two thousand acres planted. It was not until 1951 that the acreage fell to 1920 levels. In 1960 it was two-thirds of what it had been forty years earlier, though improved methods largely based on mechanization had doubled the yield per acre in the same period. By comparison cotton's yield per acre fell by almost 75 percent over those years.

The third large crop grown in this period was corn. Its acreage fell from sixty-eight thousand to thirty-nine thousand between 1920 and 1960. Corn could be used for everything from cornbread to fodder and moonshine. While it could be a cash crop most of it was consumed on the farms growing it in the 1920s. As the number of farms and farm families declined over the next forty years so too did the need for corn, except as fodder or other cash crop uses.

Basic Statistics About Clayton and Barbour County, 1900-1990

Year	Population	White	Black	Rural	Urban	Clayton	Number of Farms
1990	25,417	14,118	11,194	13,128	12,299	1,564	(1992) 305
1980	24,756	13,698	11,003	12,659	12,097	1,122	(1982) 587
1970	22,543	12,134	10,409	13,432	9,111	1,626	(1974) 711
1960	24,700	11,697	12,868	16,343	8,357	1,313	(1964) 1,284
1950	28,892	12,644	15,419	21,986	6,906	1,583	2,848
1940	32,722	15,769	18,159	26,453	6,269	1,813	3,388
1930	32,425	13,744	18,659	27,217	5,208	1,717	3,853
1920	32,067	12,624	19,429	27,128	4,125	989	4,267
1910	32,728	c. 13,500	c. 20,500	28,469	4,259	1,130	4,606
1900	35,152	c. 13,500	c. 22,000	30,620	4,532	998	4,616

Source: United States Census of Population for the years cited and United States Agricultural Census, 1992, 1982, 1974, 1969, 1952, 1942, and 1930 were used for the number of farms in the county in those years.

Of the three crops only peanut production held any hope of growth over the period. Other crops, such as soybeans, were tried, but the experiments did not produce much. Most farmers, black or white, continued to grow what they knew, hoping for better times, until they left the land altogether or died. Nonetheless, the county's population was remarkably stable at just over thirty-two thousand from World War I until 1940. There was a noticeable increase in whites and a smaller decline of black people. Urban population, i.e. Eufaula, increased 50 percent, but this was the product of a shift of only two thousand people.

The drastic changes came during the war years and afterwards when people found high-paying defense jobs in the region or by migrating to rapidly growing cities such as Atlanta. There had been no such alternatives in the 1930s. Between 1940 and 1960 the county lost a third of its total population and of its black people. The rural population's decline was even greater (38 percent). There were ten thousand fewer people in the county when John Kennedy became president than there had been when Franklin Roosevelt was elected to his third term. This pattern would continue for three more decades until in 1990 the population was nearly evenly divided between urban and rural, and for the first time since the Civil War a majority of the county's people were white.

Between 1930 and 1960, while Hightower documented the vanishing world around him, the number of farms fell from over thirty-eight hundred to less than seventeen hundred. Almost all of this drop occurred after 1940. Land in the county was turned from agriculture to timber or pasturage. Cattle and pigs, but not mules, have become numerous in recent decades. The decline has continued remorselessly since.

Throughout the decades D.L. Hightower took pictures, Clayton's population remained remarkably stable. Its population of 1,717 in 1930 had only fallen by 400 by 1960. Indeed it has gained population in recent decades, reaching 1564 in 1990. Its status as the county seat protected it from the fate of many other small southern towns which virtually ceased to exist. They died with the countryside their merchants served. Clayton gradually lost its economic independence to Eufaula as paved roads connected the two communities after World War II. They were only twenty miles apart and as many businesses moved to the larger town, Eufaula firms attracted customers from Clayton. The county seat lost its only hotel, railroad, cotton gin, and movie theater. The changes were gradual but cumulative and Clayton's future was clearly in doubt by the late fifties. Against this background the proposal to move the courthouse to Eufaula seemed a life or death decision for Clayton. To prevent the transfer, the inadequate antebellum structure was demolished and replaced with a modern facility. The county seat stayed put, but Clayton lost a beautiful building which symbolized its connection with earlier times. The courthouse's destruction marked the end of an era, and while Clayton survived, it was little more than an echo of what it had once been.

The story of Clayton and Barbour County, in the years Hightower made his pictures, has its parallels in most rural counties of the state and region. Indeed his pictures have a near-universal appeal because Barbour County's experience was so typical of the South. Though working in one county, Hightower preserved a record of vanishing southern rural culture through his photographs. The family farms and rural crossroad communities he knew are now virtually unknown. Across the region counties have seen their population decline dramatically in this century and their land increasingly given over to timber and stock raising. Crisscrossed by modern paved roads they are tranquil but deserted. Much of the life has gone out of them and they seem like weary travelers waiting for a train that never comes. Their search for an acceptable alternative to the lost world Hightower immortalized in his photographs continues.

Notes on the Sources

Most of the sources for the essay on Mr. Hightower and his wife were oral interviews with members of their family and friends who knew them well. These interviews and conversations provided a striking unaminity in the picture of Draffus and Marie that evolved. The most important interviews were those with Bill and Beverly Bush. Bill was the son of Martha, the Hightowers' foster daughter, and he lived with his grandparents for several years. The Bushes were very willing to show me anything Hightower had left in the house on North Midway that he and Marie had shared for so many years. The artifacts included an assortment of cameras and equipment, leftover film from the 1930s and 1940s, and Hightower's library. The latter is not large, but the books and magazines it contains confirm his interest in the work of the best photographers of his day. The Bushes showed me correspondence and other family papers that have survived. They let me look through a trunk full of photographs and negatives which Hightower had left for his family. In doing this I confirmed that these were indeed pictures almost entirely of family interest. Both Bill and Beverly were great sources for anecdotes and stories about Marie and Draffus Hightower.

Another valuable source of information was Jerry Vinson of Troy who is Marie Hightower's nephew. He had spent many years with both Draffus and Marie, and like Bill and Beverly Bush recognized Hightower's unique commitment to photography. He was interviewed on February 4, 1996. Conversations with the Bushes and research at their home have gone on since the summer of 1995, but they also participated in the February 3 - 7, 1996 review of Hightower photographs held primarily at the Town and County Library in Clayton. Most of the other people who looked at the pictures had stories to tell about both Marie and Draffus, all of which contributed to my sense of who they were and what sort of world they had lived in. Martha Bush's sisters were especially helpful in describing the unique connection they felt to the Hightowers.

Besides the oral information, I relied heavily on Mary Hightower Bond, *Hightower Hospitality House* (Pine Bluff, Arkansas, 1992). Mary is Draffus' younger sister. Her account of growing up in rural Barbour county in the early years of this century is priceless, and the book is filled with detailed descriptions.

Fortunately, Hightower lived long enough to see that his photographs were appreciated for the extraordinary record they are. He had several interviews in the 1980s with Louella Hobbs and in 1990 with Mary Neal Whittington and Lois Warr. In 1989 Frances Robb, having seen and appreciated his work in an exhibit at Eufaula, also interviewed him. Her record of that interview and all the information Lois Warr provided has proven invaluable. Ms. Robb noted how proud

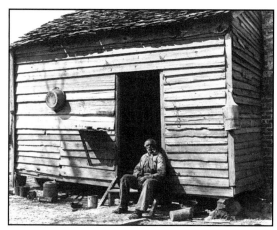

see page 124

Hightower was that she had selected two of his photographs for the exhibit and catalog *In View of Home: Alabama Landscape Photographs* (Huntsville, 1989), prepared by the Huntsville Museum of Art. She was probably the first authority on photography to recognize the importance of his work.

Over the past decade *The Clayton Record* has been an important source for information about Hightower, his photographs, and his longstanding support of the Town and County Library. Fortunately the library had saved the clippings, making it easier to find and use them. The most important issues are those published on May 11 and September 9, 1993 and April 21, 1994.

The comparisons made between Hightower and major photographers of the 1930s are based on many books. In addition to Ansel Adams' *Making a Photograph*, which he kept throughout his life, he was clearly influenced by many noted photographers. For information about these people I consulted: Walker Evans, *Photographs for the Farm Security Administration, 1935-1938* (New York, 1973); Karin Becker Ohrn, *Dorothea Lange and the Documentary Tradition* (Baton Rouge, 1980); Arthur Rothstein, *The Depression Years as Photographed by Arthur Rothstein* (New York, 1978); Margaret Bourke-White and Erskine Caldwell, *You Have Seen Their Faces* (New York, 1937); Roy Emerson Stryker and Nancy Wood, *In This Proud Land* (New York, 1973). There are many other books and magazines which provide even more examples of the work which Hightower probably saw in the

course of his project, but these are a good beginning.

The comparison with Atget is based on the following: Berenice Abbott, *The World of Atget* (New York, 1979) and John Szarkowski and Maria Morris, *The Work of Atget*, 4 vols. (New York, 1981-4). The former is more accessible, the latter a more exhaustive examination of the man's work.

Most of the essay on the county is based on United States census material. The United States Census of Population is issued two or three years after the census is taken at the start of every decade. Every census from 1920 to 1990 was consulted. The 1920 census contained historical data back to 1900. Working with the census can be frustrating because categories change as the decades pass. It is something of a challenge to get a properly comparable string of data. Besides the census of population, this account relies on the Agricultural Census for 1992, 1982, 1974, 1952, 1940, and 1930. Finally the *Barbour County, Alabama, Statistical Data* prepared by the Alabama State Planning Board (Montgomery, 1955) was very helpful. Unfortunately it was not updated after Big Jim Folsom left the governor's mansion and no subsequent issues appear.

There are two histories of Barbour County, both published before World War II: Anne K. Walker, *History of Barbour County* (Eufaula, 1941; Reprint Edition, Eufaula Heritage Association, 1967) and Mattie Thompson, *History of Barbour County* (Eufaula, 1939). Each is interesting in its own way, but a modern

study of Barbour County is long overdue.

Map data for the town of Clayton and for Barbour County were provided by the Clayton Town and County Library. That library, the Historic Chattahoochee Commission, and the Eufaula Carnegie Library have many other volumes dealing with Barbour County life but none focusing on the painful transition Hightower recorded with his camera.

D.L. Hightower's Photographs of Barbour County, Alabama, c. 1930-1965

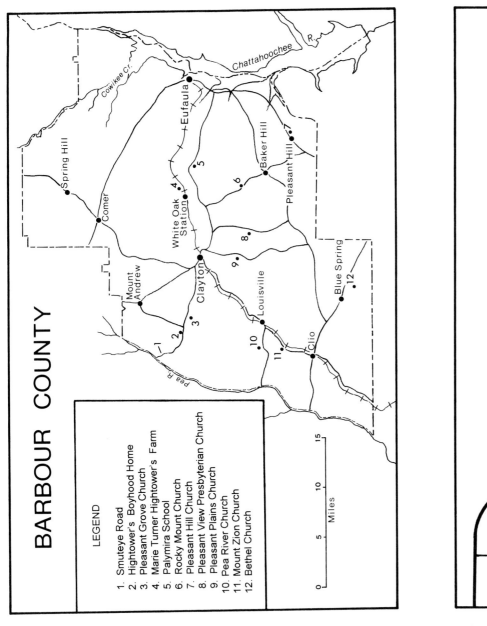

BARBOUR COUNTY

LEGEND

1. Smuteye Road
2. Hightower's Boyhood Home
3. Pleasant Grove Church
4. Marie Turner Hightower's Farm
5. Palymira School
6. Rocky Mount Church
7. Pleasant Hill Church
8. Pleasant View Presbyterian Church
9. Pleasant Plains Church
10. Pea River Church
11. Mount Zion Church
12. Bethel Church

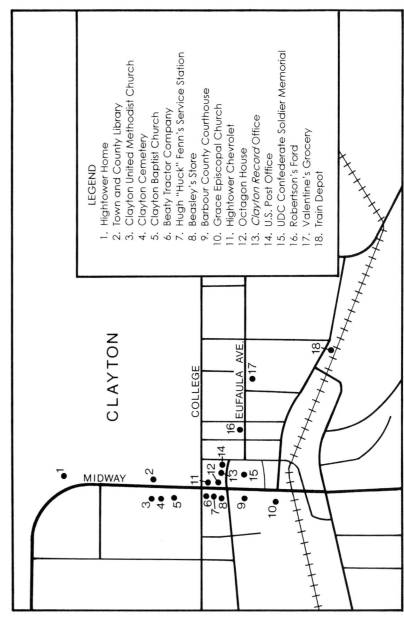

CLAYTON

LEGEND

1. Hightower Home
2. Town and County Library
3. Clayton United Methodist Church
4. Clayton Cemetery
5. Clayton Baptist Church
6. Beaty Tractor Company
7. Hugh "Huck" Fenn's Service Station
8. Beasley's Store
9. Barbour County Courthouse
10. Grace Episcopal Church
11. Hightower Chevrolet
12. Octagon House
13. *Clayton Record* Office
14. U.S. Post Office
15. UDC Confederate Soldier Memorial
16. Robertson's Ford
17. Valentine's Grocery
18. Train Depot

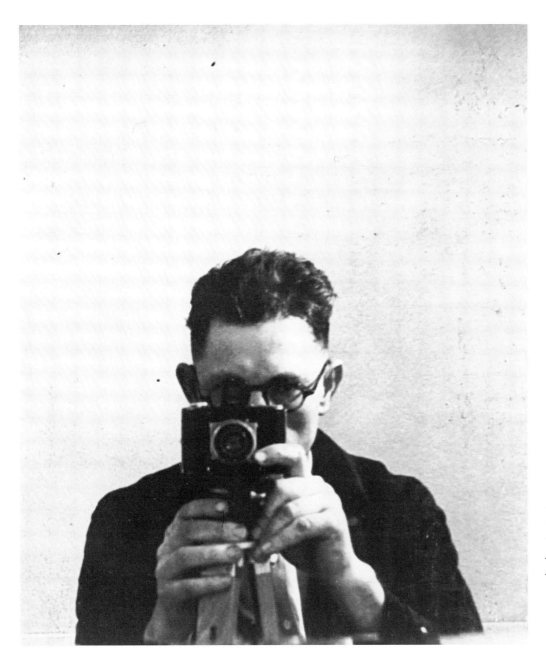

Hightower c. 1935 with one of the cameras he used for many of his candid photos during the Depression and World War II. Although for this self-portrait he is using a tripod, the folding Kodak Duo Six-20 camera was compact and designed for hand-held use.

D.L. Hightower's Photographs of Barbour County | 1

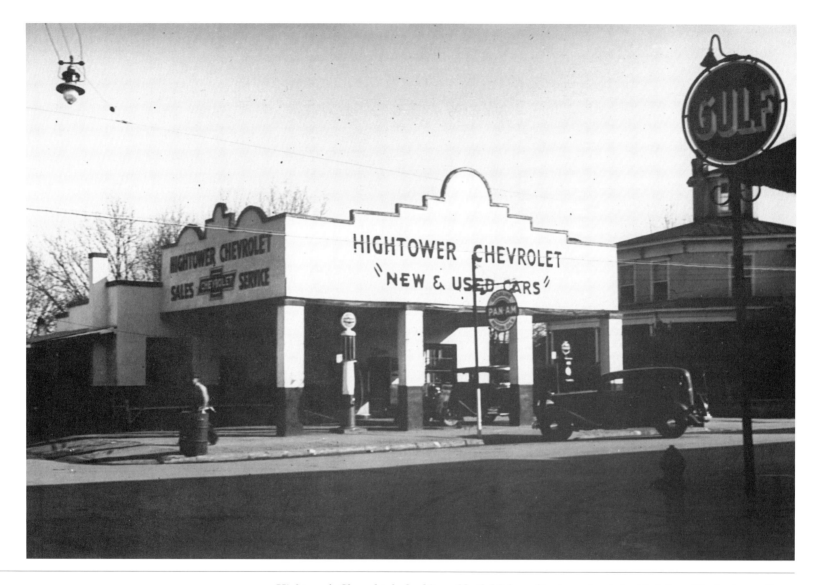

Hightower's Chevrolet dealership on North Midway Street was located a block from Clayton's courthouse square and next to the town's unusual octagonal ante-bellum home. Since Hightower was at work most of the time, many of his Clayton pictures were made in or around this spot.

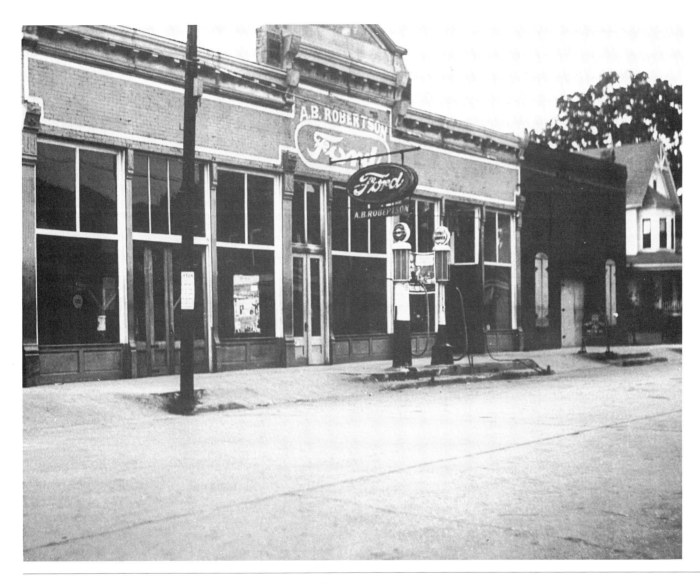

Clayton had a Ford dealership on Eufaula Avenue where Hightower first worked as a mechanic in the early twenties. Robertson's assembled and sold Fords which were shipped by rail to Clayton. After working there for several years Hightower set out on his own as Barbour County's first Chevrolet dealer in 1928.

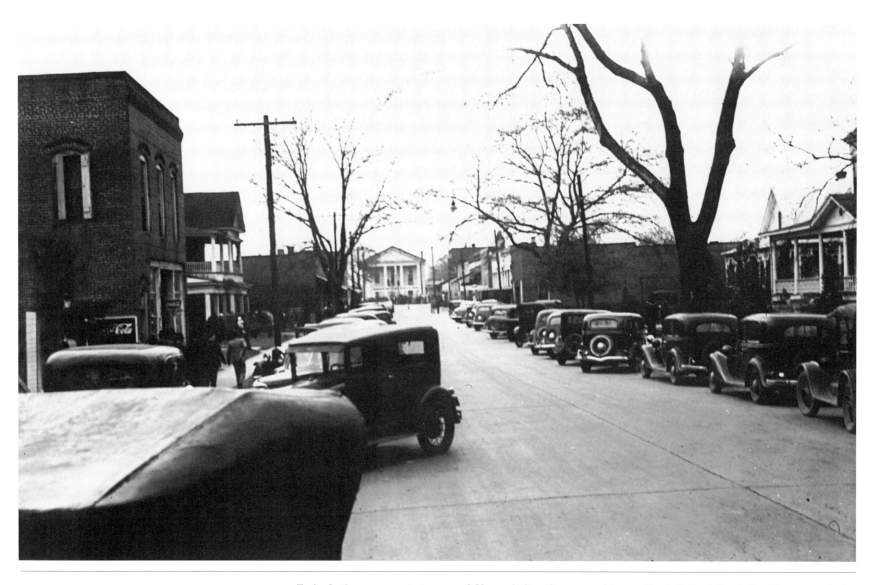

Eufaula Avenue ran past many of Clayton's finer homes, and its small retail district ended at the square facing the ante-bellum courthouse. On weekends or for special events it was a busy place and parking was at a premium even in the early years of the Depression when this photo was made.

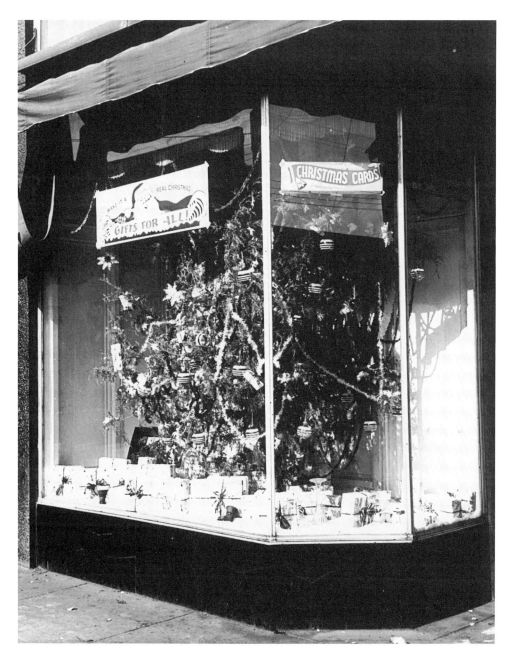

The stores on Eufaula Avenue, like stores everywhere, encouraged buyers to celebrate Christmas by purchasing presents and cards. However, elaborate decorations were not to be seen in the Depression even in Elmore's dime store on Eufaula Avenue.

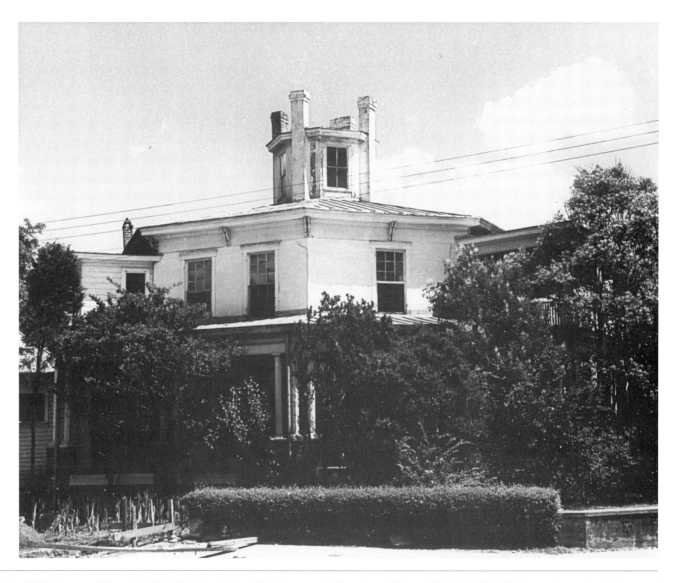

Hightower's late thirties photo of the 1859 Octagon House, built by Benjamin Franklin Petty, and then the residence of Judge Bob T. Roberts, shows the influence of major national trends in photography. An admirer of Ansel Adams, he used a Rolleiflex camera and a sky darkening filter in this and in the photograph on the facing page which was made on the square in the early fifties. Both photographs are also reminiscent of images Walker Evans made in the thirties while working for the Farm Security Administration (FSA).

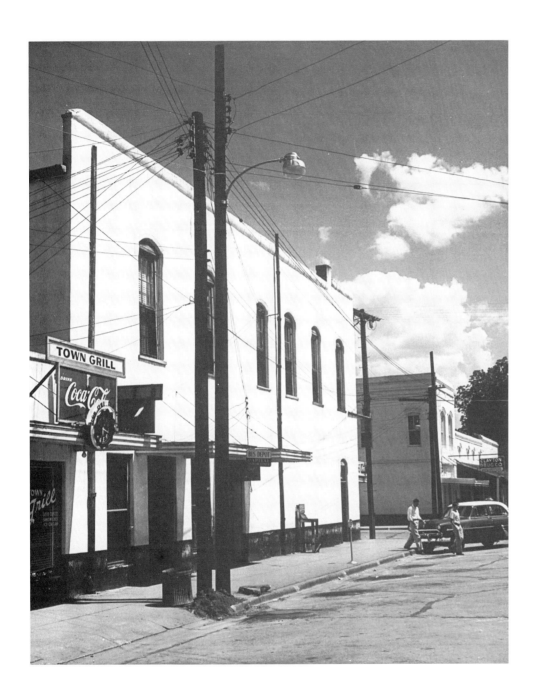

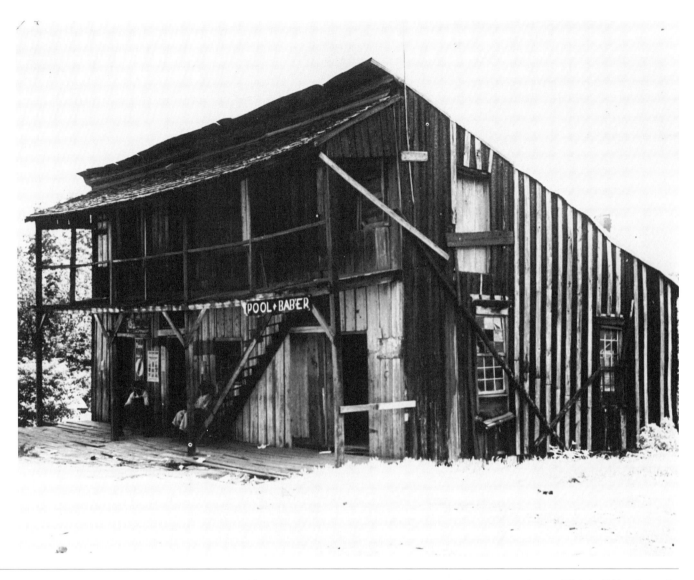

There were less memorable structures even just around the corner from the courthouse. This building housed a business which catered to blacks. It had been a tavern in pioneer days, but by 1938 when this picture was made, it had fallen on hard times.

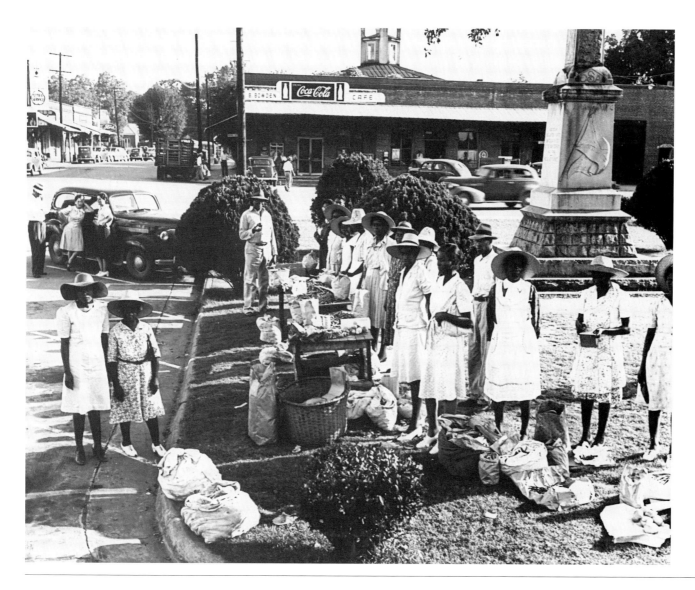

On Saturdays black women from neighboring farms would assemble on the town square to sell vegetables, meet
people, and enjoy a break from their daily routines. Perhaps ironically, their market was located at the base of the
U.D.C. monument to the Confederate soldiers of Barbour County.

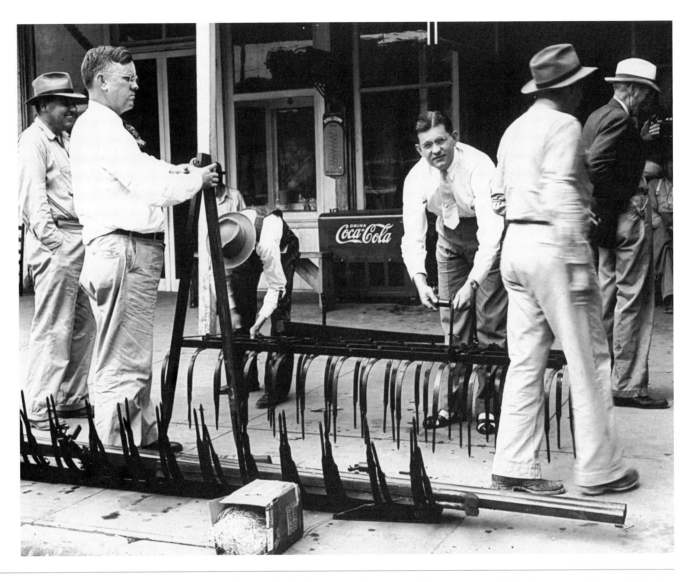

Clayton was located virtually in the geographic center of the county and its businesses supplied neighboring farmers. Beaty Tractor Company on Midway was a good example. In the photograph Mr. Robert Beaty supervises the assembly of a spring-tooth weeder used for peanut cultivation, c. 1940.

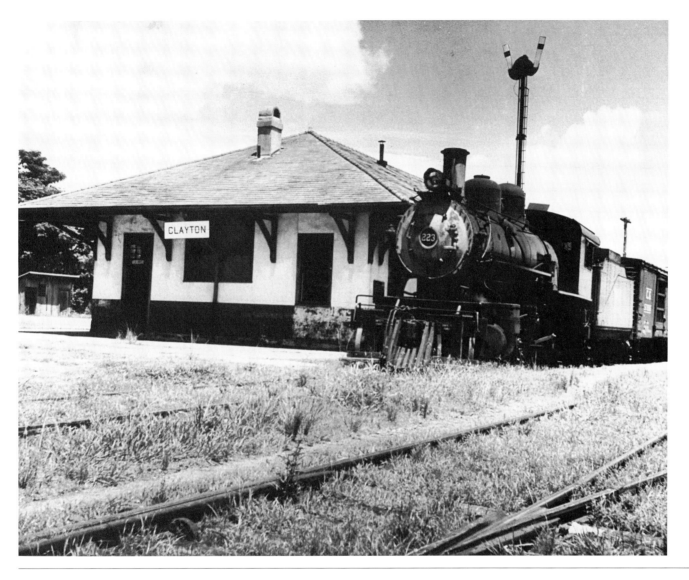

The goods Clayton's merchants sold came to them via train when this picture was taken in the thirties. There was a weekly train from Eufaula to Ozark which served the small town's needs until after World War II when service was discontinued and the tracks eventually taken up. The automobile had taken over in Barbour County and the nation.

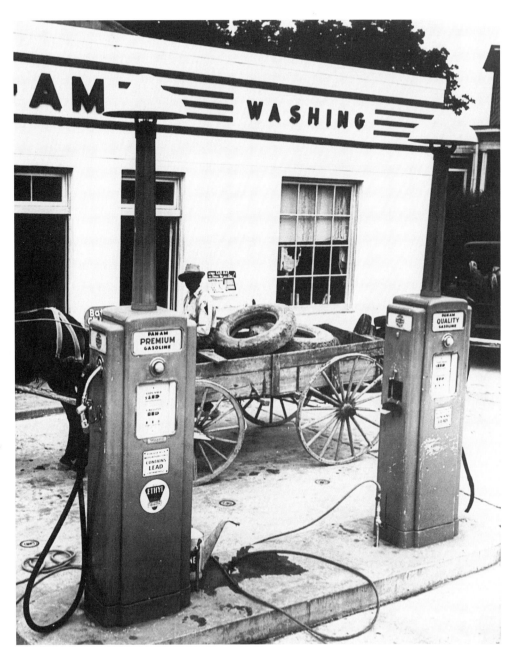

The transportation revolution which was changing the face of America was very much in evidence in Clayton and Barbour County in the thirties. Mr. Hightower visually noted the contrast between the new and the old when this wagon stopped behind the gas pumps at the Pan Am station on Midway St. This style of photographic composition emphasizing contrasts within the picture was very popular with the FSA and other photojournalists at that time.

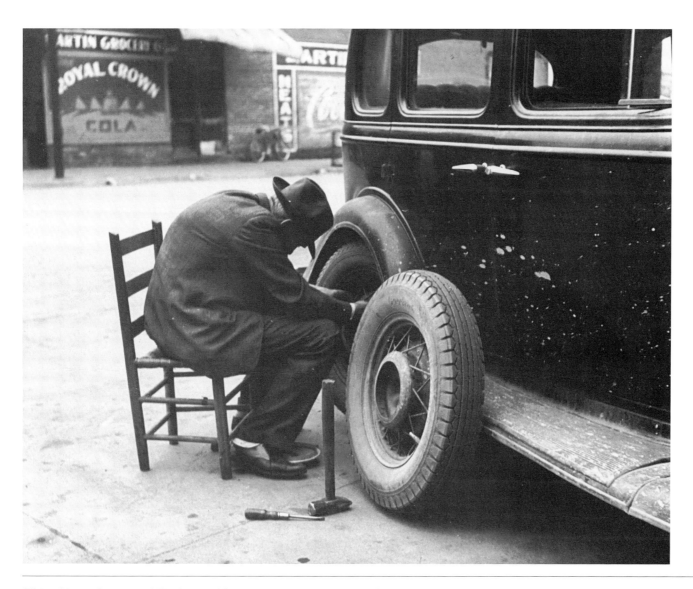

This whimsical picture of Hugh "Huck" Fenn changing a tire on a 1934 Chevrolet at his service station while sitting down reminds us that the pace of life was less hurried in the thirties.

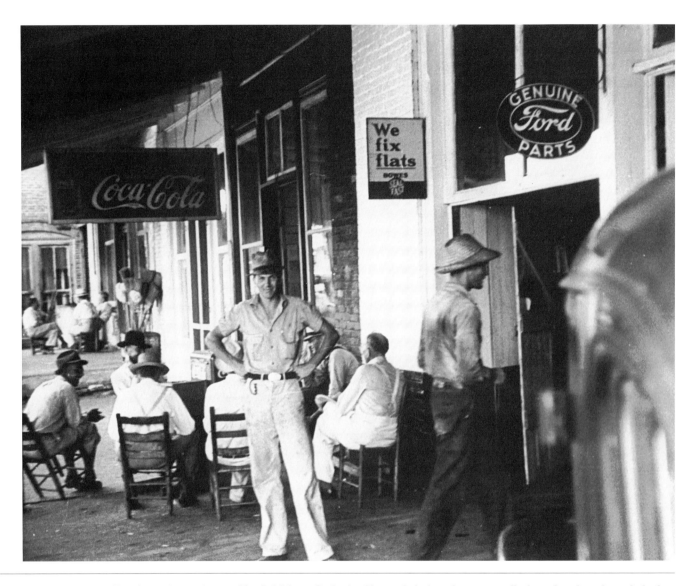

Fenn's service station on North Midway St. had tables and chairs where men talked or played cards and checkers under the roof overhanging the wide sidewalk. They could also sit on a "liars bench" (facing page) and pass the time of day. Such benches were a common feature in front of stores in Clayton. They attracted a wide cross section of the town's white male population, especially on Saturdays.

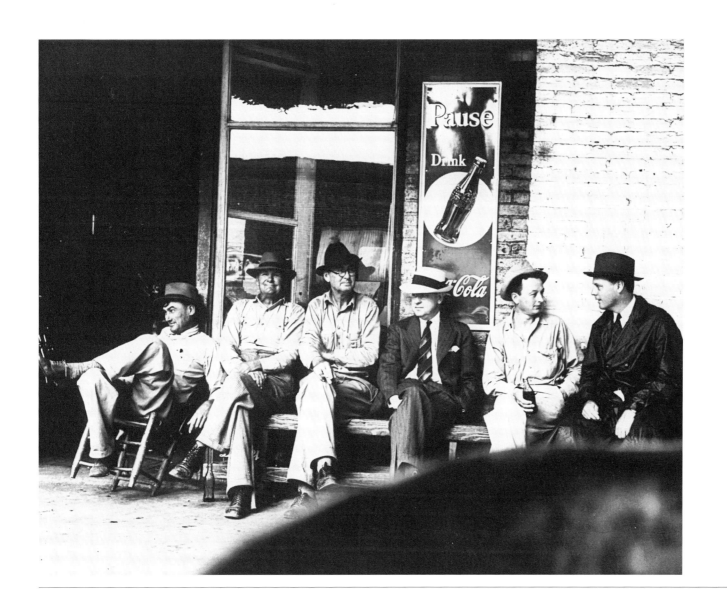

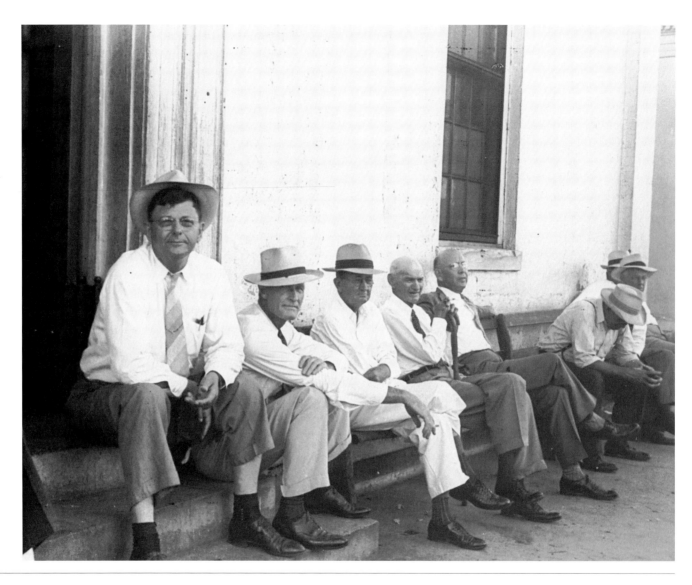

The most popular congregating spot was probably on the benches on the steps of the courthouse. Here Clayton's men met and talked about affairs of mutual interest on hot afternoons long before the age of air conditioning and e-mail. Like the other benches around town, the courthouse attracted men of all ages from all walks of life.

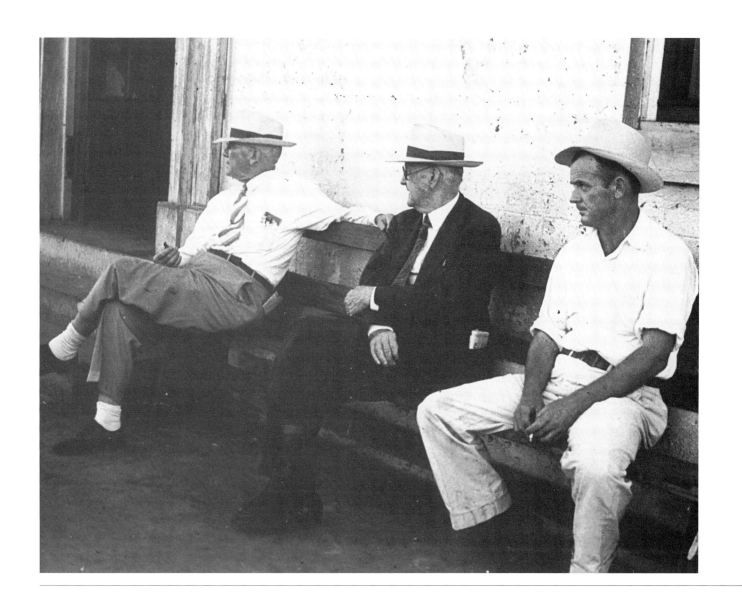

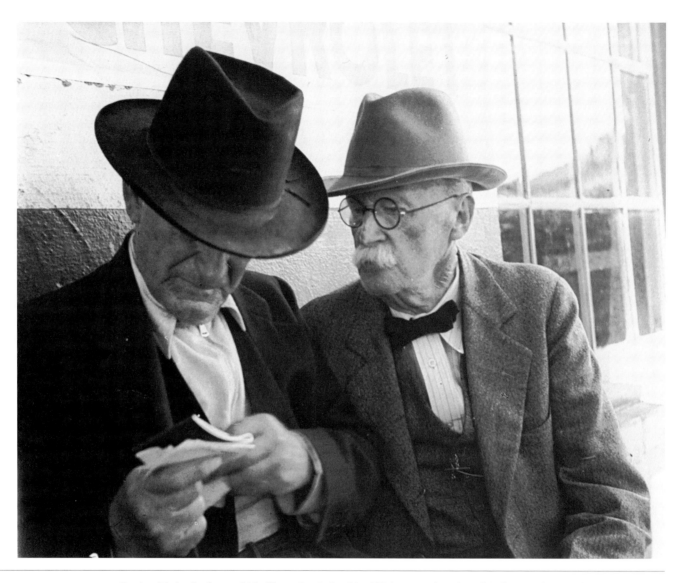

In the thirties in front of his Chevrolet dealership, Hightower often found judges and men of prominence. For example in the photograph above left Judge Fuqua and Judge Roberts talk, while on the facing page an unidentified man is speaking to George Hurst and Sam Price. Hightower was not one to pass the time in this way, but well known to one and all, he photographed with no objection from his subjects.

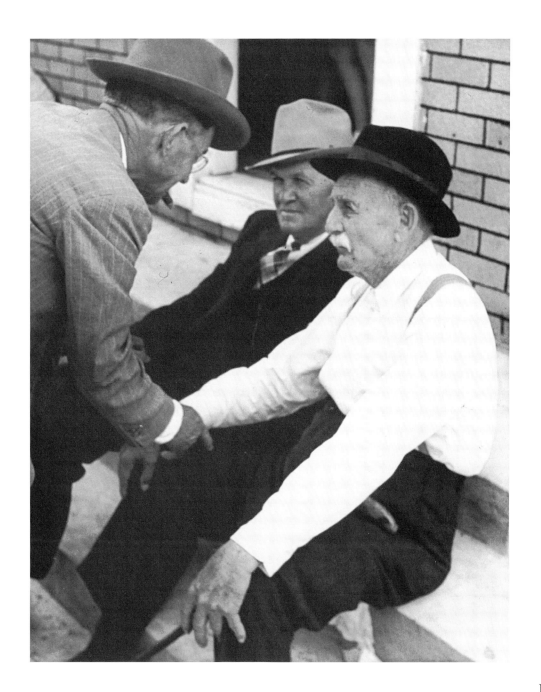

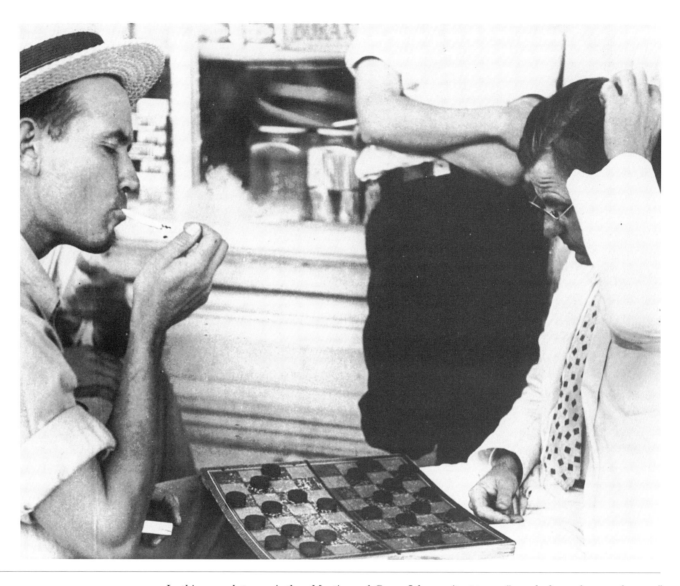

In this game between Arthur Martin and Crews Johnson it appears "somebody made a good move,"
Hightower later noted. He took this picture in front of Beasley's store; Beasley's also had a gambling room, the
"Mink Slide," in the back. The store was on the north side of the courthouse when this photograph was
made in the thirties.

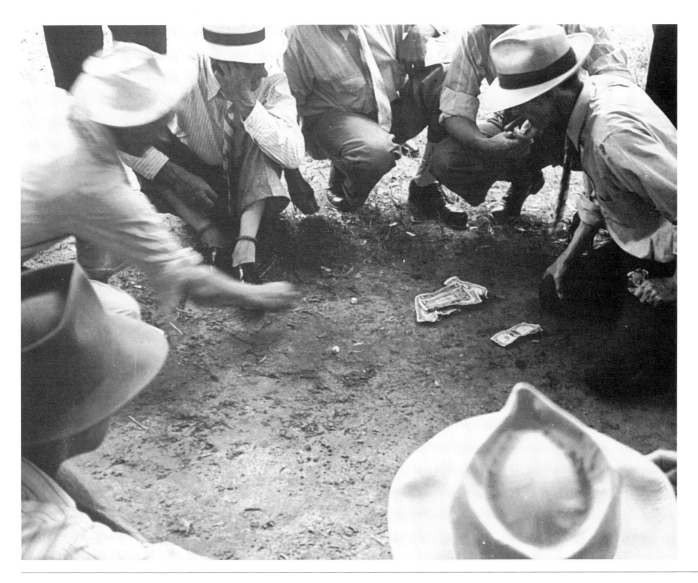

Outside the courthouse, impromptu crap games were common, especially in back of the building. Hightower carefully composed this picture so that the identity of the players is not evident.

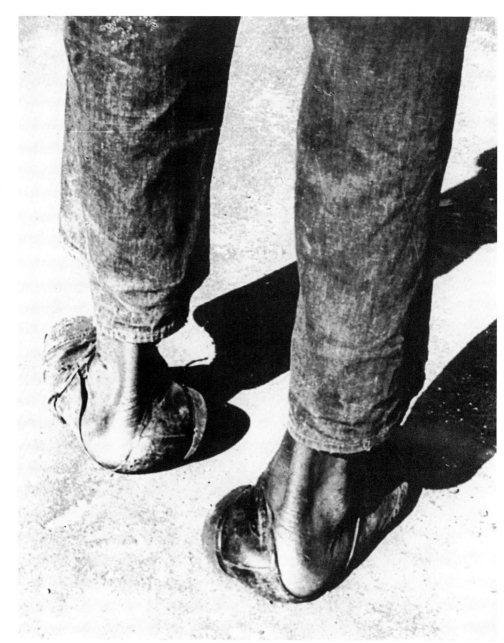

Poor people, including blacks, appear frequently as Hightower's subjects because they were a part of the world he wanted to record. A man with shoes so worn out they no longer fit his feet or a crippled dwarf wearing patched overalls standing outside his Chevy dealership both were part of the pre-war scene in Clayton. Their names are now forgotten.

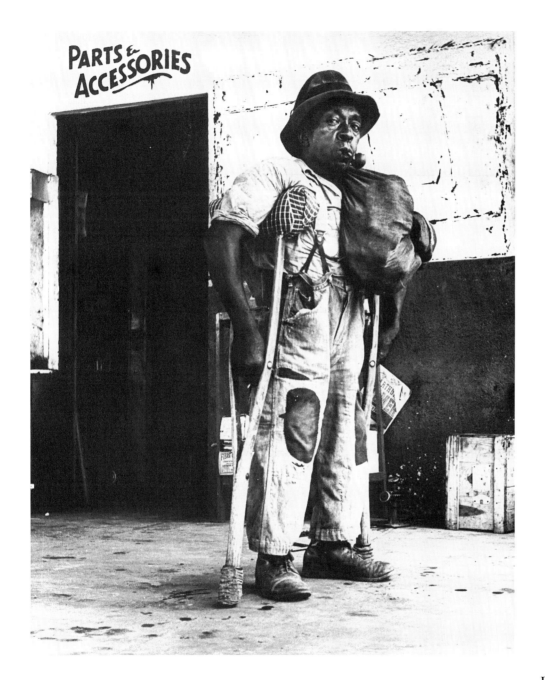

In the late thirties, at the same time that Walker Evans was making candid portraits on New York's subways, Hightower made hundreds of candid portraits of people he saw every day. His employees were hardly exempt. This is Bertram Smoot, a mechanic who worked for him for many years, walking back to work across North Midway.

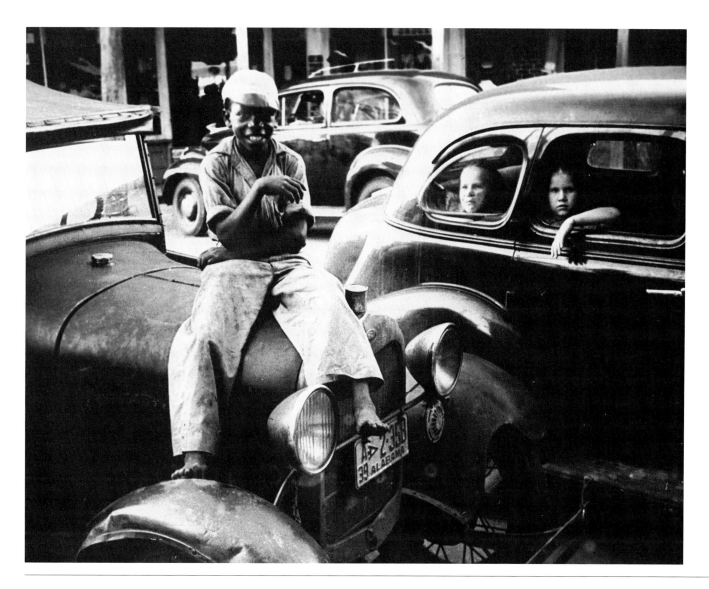

One of the more interesting candid pictures is this shot, made in 1939, of three unidentified children. The contrast between the children's two worlds separated by race and class is powerfully evident, but so is the fact that they all lived in Barbour County and accepted one anothers' existence.

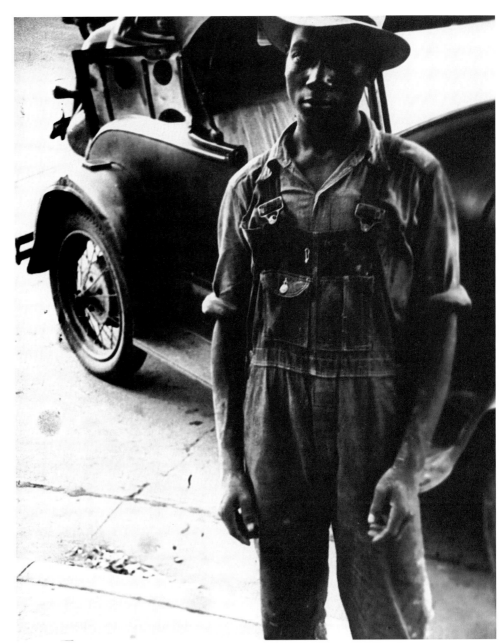

The roles blacks played in the pre-war South can be inferred from pictures such as these. On the right a Hightower employee now remembered only by his nickname, "Nook", tends a watermelon patch in front of the dealership on north Midway. The straightforward stance of the man on the left reminds us that segregation did not crush the spirit of those it sought to control.

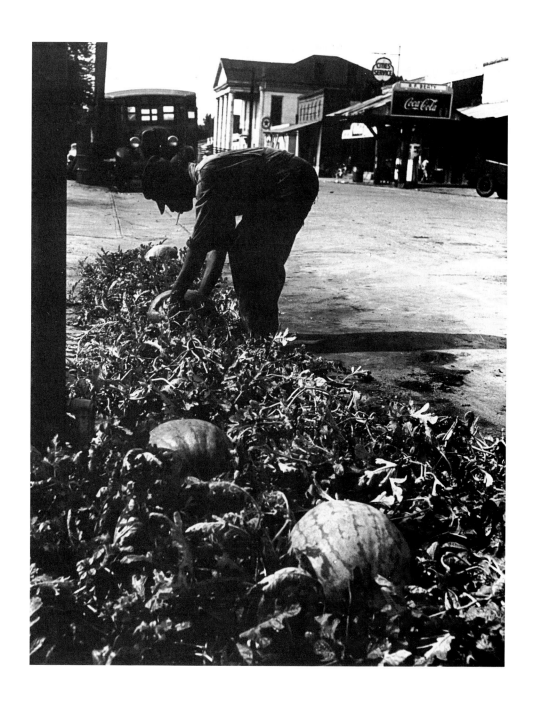

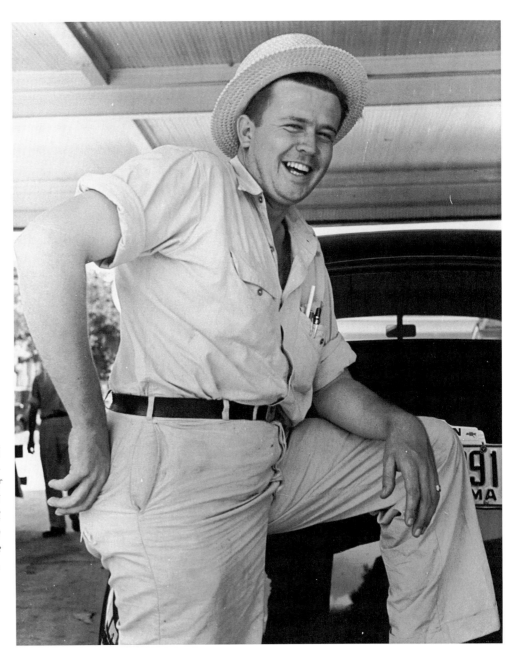

Cars provided a natural backdrop to many of Hightower's candid portraits. As he listened to his friends and neighbors, he unobtrusively took their pictures. Winn Martin is announcing the birth of his first son in 1939 while Pauline Byrd smiles shyly in her 1935 picture. Mrs. Byrd was a neighbor whose husband had died suddenly leaving her to care for six children. The community helped and with Mrs. Byrd's approval the Hightowers raised one of the children as their own daughter.

Obviously influenced by the photographs he saw in Life *and other photographic books and magazines, Hightower made these two portraits in 1935. M.T.J. Brown, this page, and Oliver O'Dell, on the right, probably knew nothing of the photographs of Dorothea Lange in San Francisco but Hightower clearly did. The masking of the eyes by the shadow of the hat brim accentuated by the strong sunlight was a key feature of some of Lange's early Depression-era work.*

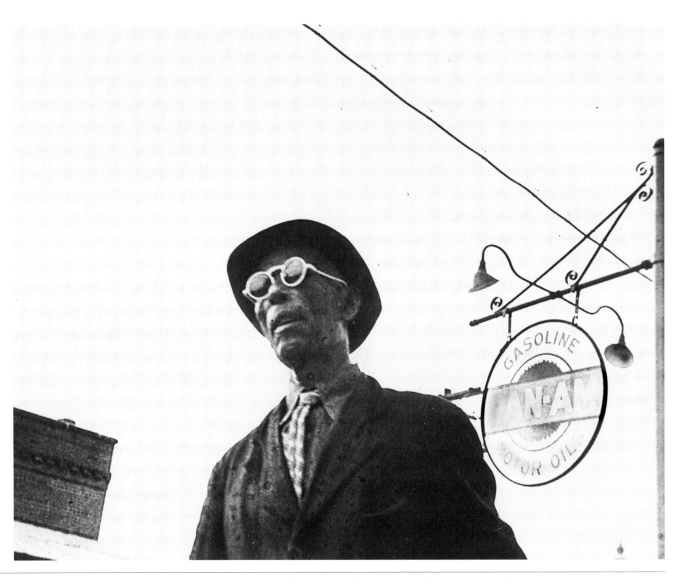

The variety of men on the streets of Clayton kept Hightower involved in his candid street portrait work for many years. Both of these pictures were made in the late thirties. Above is a miniature camera shot of Brasier Davis, a preacher at Jones Chapel, a black congregation on nearby College Street. On the right is a Rolleiflex portrait of Griff Leonard, an old man who kept body and soul together by taking odd jobs and accepting charity.

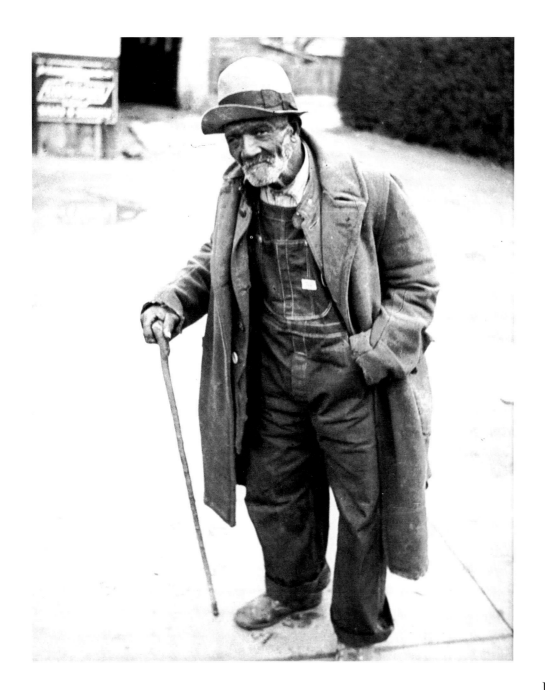

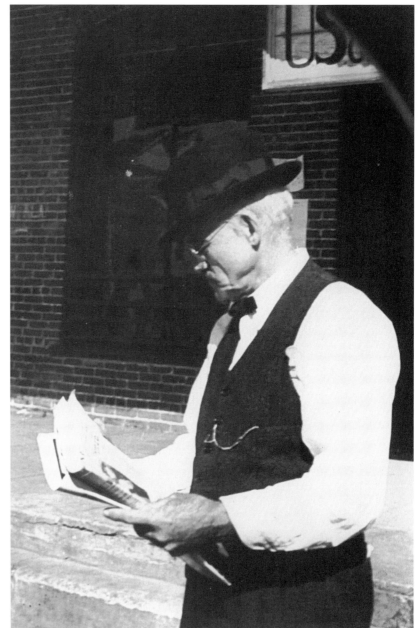

Hightower photographed two of Clayton's more prosperous citizens, Charlie Clark and Charlie Valentine, the latter on the bench in front of his grocery on Eufaula Avenue. The Valentine photograph is a carefully composed study of the man and his business. Clark was crossing the street reading the Clayton Record *when Hightower quietly took the picture with his miniature camera.*

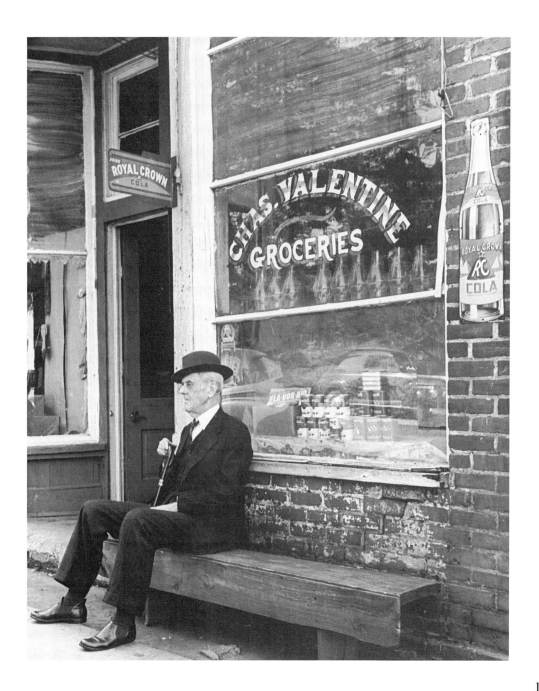

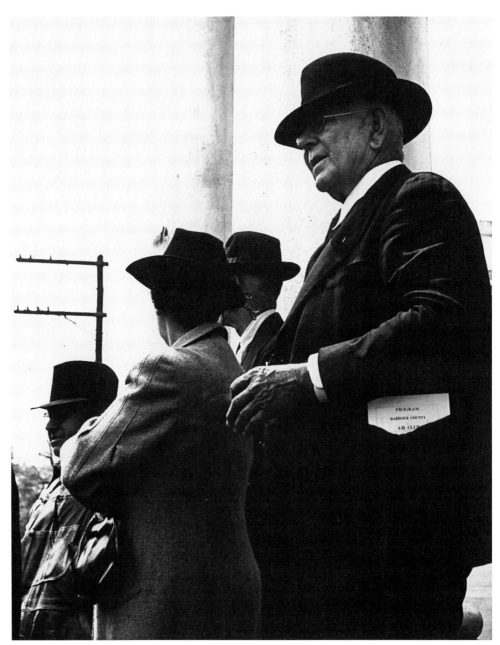

Hightower often photographed his subjects from below so as to make them seem more important, more monumental. In the picture above men are standing on the courthouse steps for a pre-war 4-H show. Their hats almost seem to provide a disguise and make the composition more interesting, but on the right Tom Searcy, the tax collector, is recognizable. On the facing page J.E. Daniel and his wife intently watch a football game as Hightower photographed them and not the game.

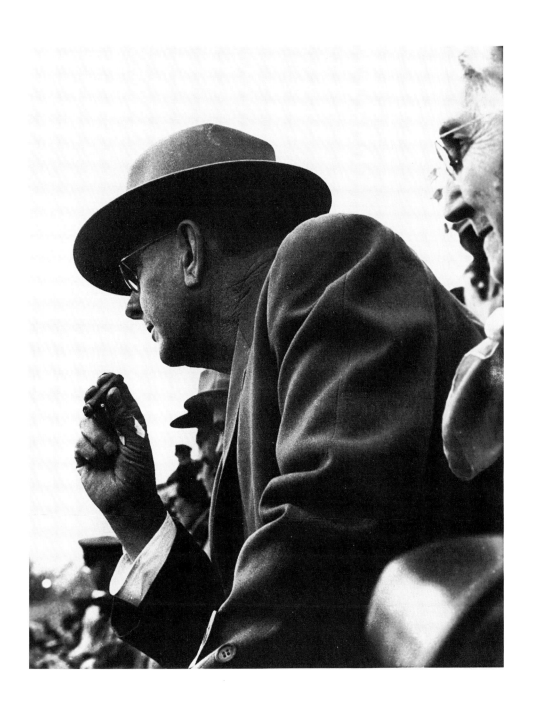

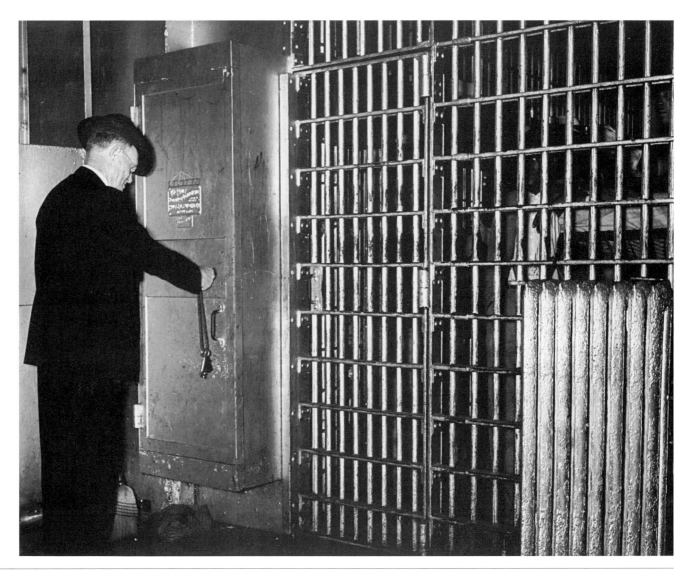

Hightower made pictures of people in their own environments as well as in public places. Above the long-serving sheriff, R. Pitt Williams, locks his courthouse jail in the thirties while a decade later Judge J.S. Williams prepares for a pending case in his office. In both photos Hightower skillfully used the environment to define the man.

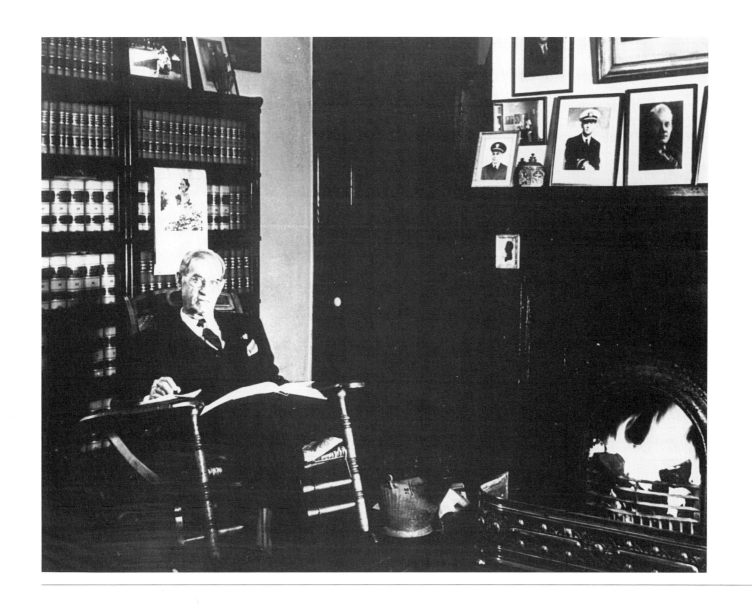

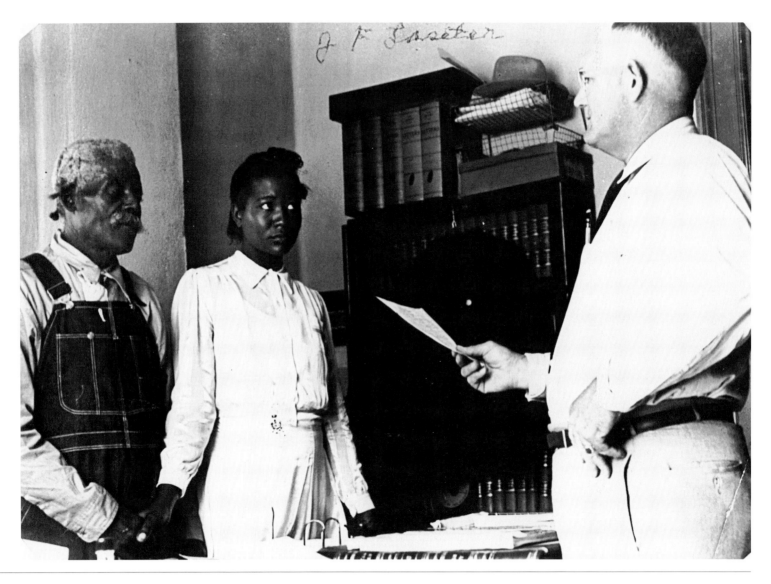

Hightower liked to record unusual events. In this picture Probate Judge J. Foy Lasiter is marrying a ninety-year-old man and a twenty-year-old woman in the late thirties. Hightower's photograph takes no stand on the event, simply recording it honestly, perhaps with a touch of humor.

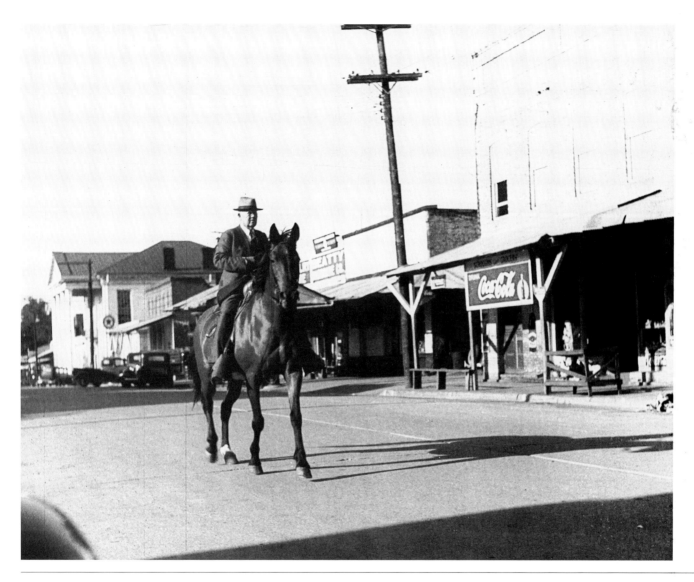

One of Clayton's more prominent citizens was Dr. George O. Wallace, grandfather of the future governor.
Dr. Wallace was a physician and former probate judge who liked to ride his horse around town for pleasure. By
the time Hightower made this picture in 1944 Dr. Wallace no longer used his horse to make
house calls, but still actively practiced medicine.

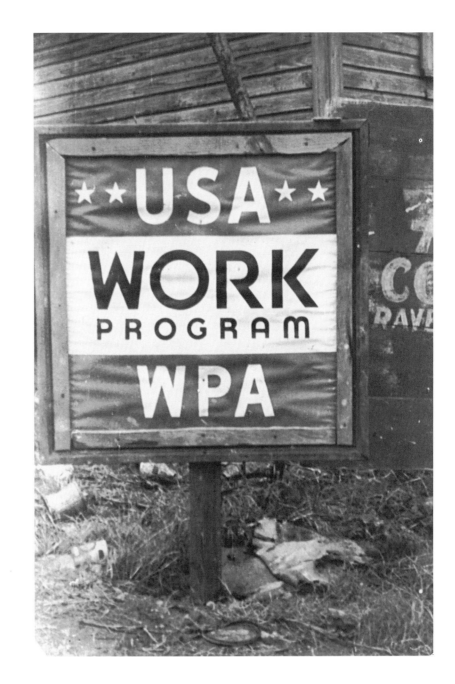

Hightower rarely discussed politics, though he was quietly conservative in his views, but when a New Deal WPA project came to town he treated it as another event to be recorded. The WPA was preparing College Street for paving in 1935 when he took these pictures.

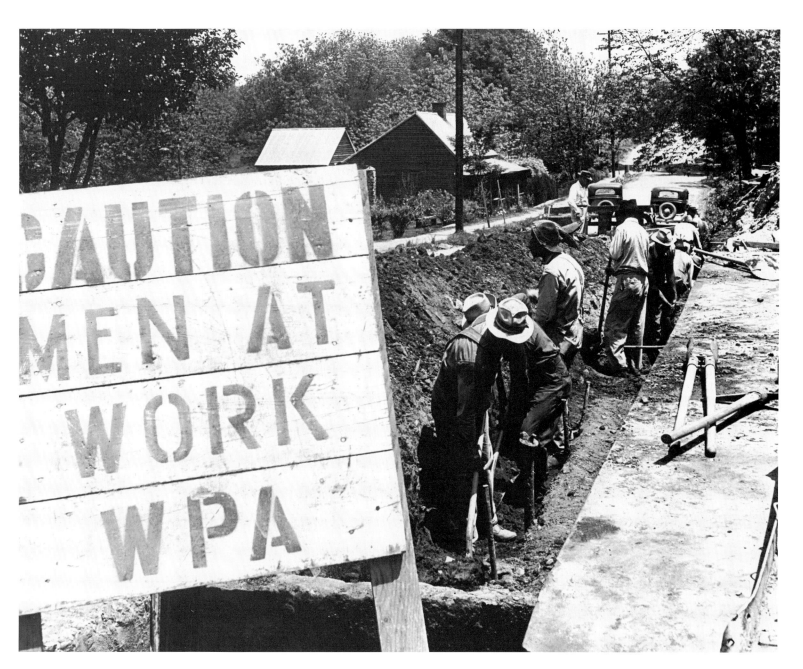

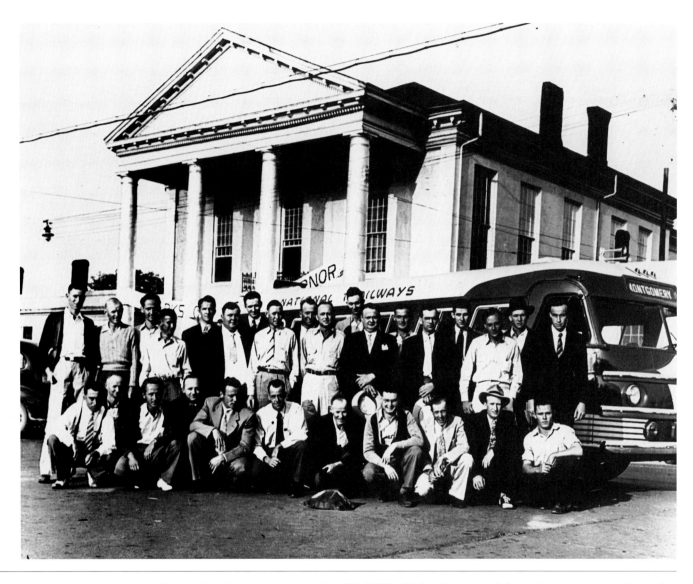

Both black and white men were drafted in World War II, but they entered the service separately and served in segregated units. Hightower recorded these two groups on their way to induction from Clayton's town square. Many such busloads left the square throughout the war years.

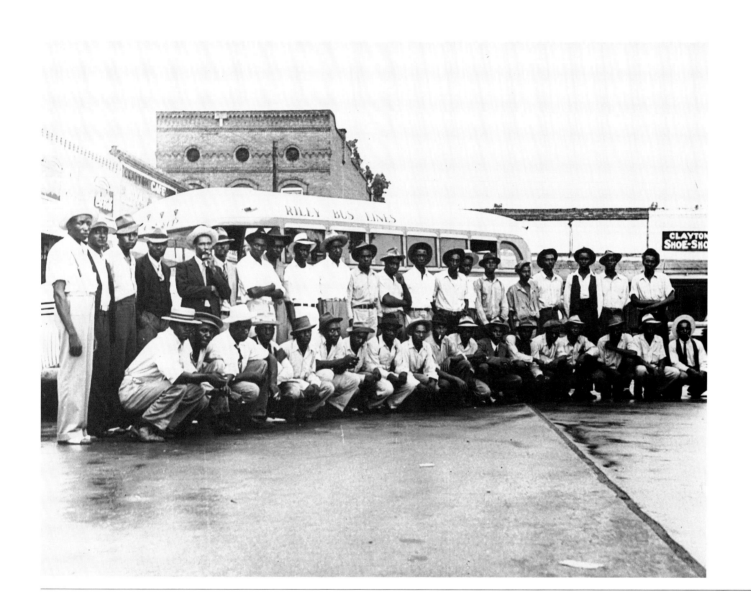

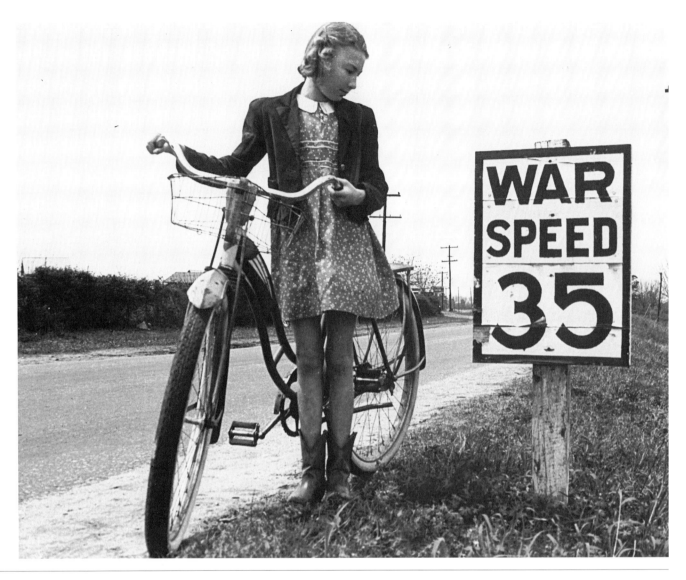

Even for women and children left behind during the conflict, the war was never far from their thoughts. In the photo above Hightower's foster daughter, Martha, pauses by a sign for the 35 mph war speed limit which was designed to conserve tires and fuel. On the right the women of Clayton assist a Red Cross blood drive when it came to Clayton from Atlanta.

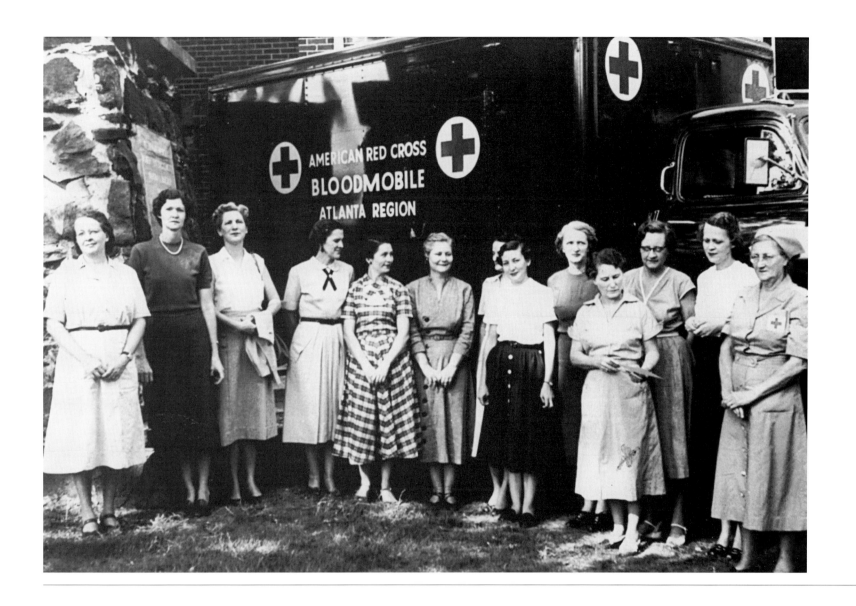

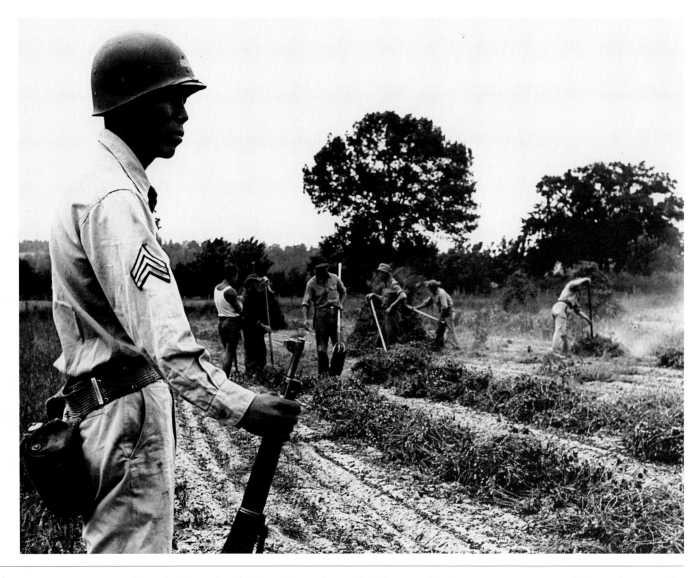

Since the Depression Barbour County farmers had been moving from cotton to peanuts. This trend was accelerated during the war with very generous programs of federal price supports. But there were not enough men left to care for and harvest the crop, so German POWs were brought in to do the work, in this case, guarded by a Japanese-American soldier. After a day's work there was still time for an impromptu POW band to play as the photo on the facing page shows.

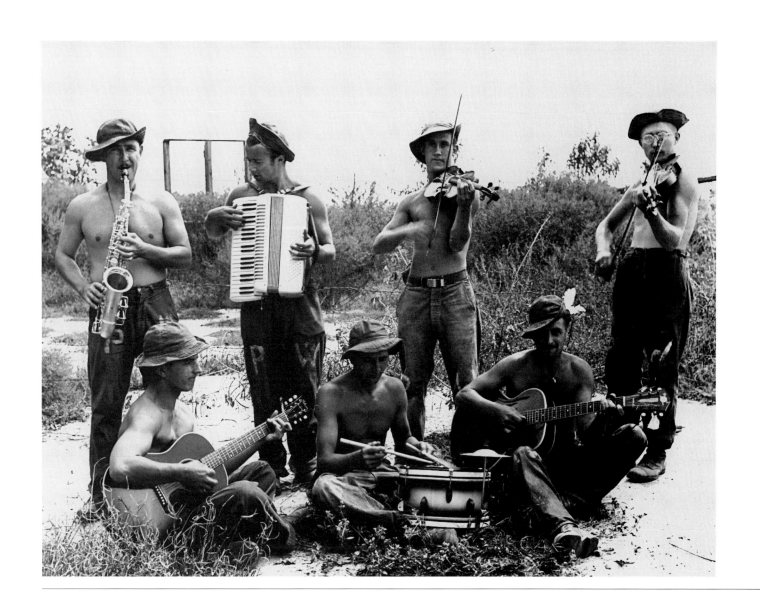

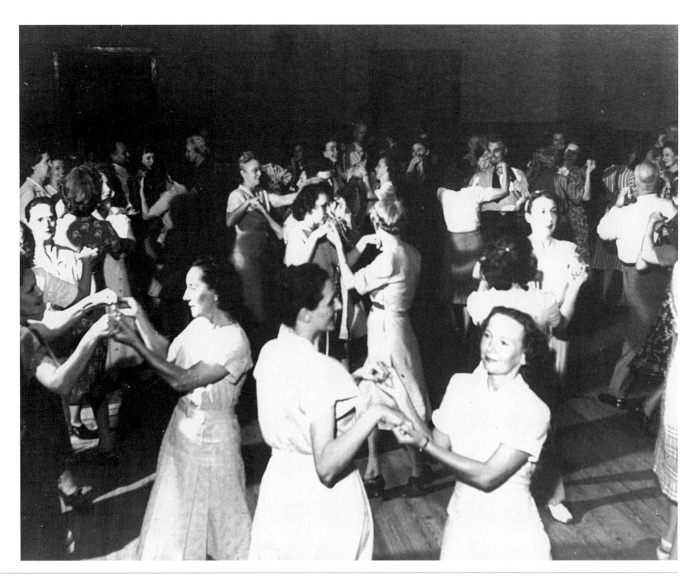

Hightower noted that "while the boys were off at war" girls had to dance with each other. Teachers and some pupils at Midway High School demonstrate this in a 1942 dance held at the school.

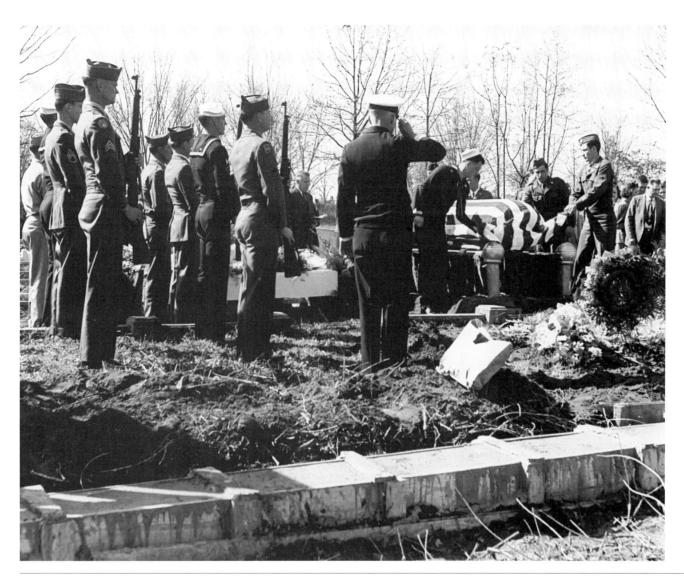

Clayton was not spared the grimmer side of war. James Reid Dykas was shot down while serving in the 462 AAF Bomb Squadron in 1943 over Germany and taken prisoner. He never fully recovered from his wartime experiences. In 1949 he died and was buried with full military honors in Clayton's cemetery.

As war clouds gathered before Pearl Harbor and war news gradually eclipsed other events, Hightower's interest in the local scene never flagged. On the eve of war he took this picture of a serious fire at the Robert Petty home near his own house. Accounts of such events were an important ingredient in the weekly Clayton Record. *It was published from offices on the town square by Bill Gammell, whose artifact collection often decorated its front window. His family had owned the paper since 1915.*

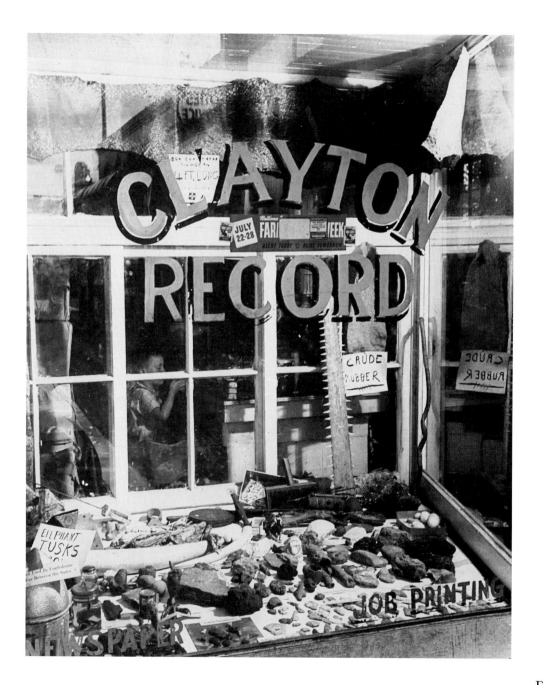

On the day the Japanese surrendered, Hightower went to the Record office to photograph the preparation of the paper announcing the war's end. In the picture above Mr. Gammell is sorting papers for delivery while on the facing page his grandson, Tom Parish, Jr., is holding a copy of the paper announcing the momentous news which at his age he probably did not understand.

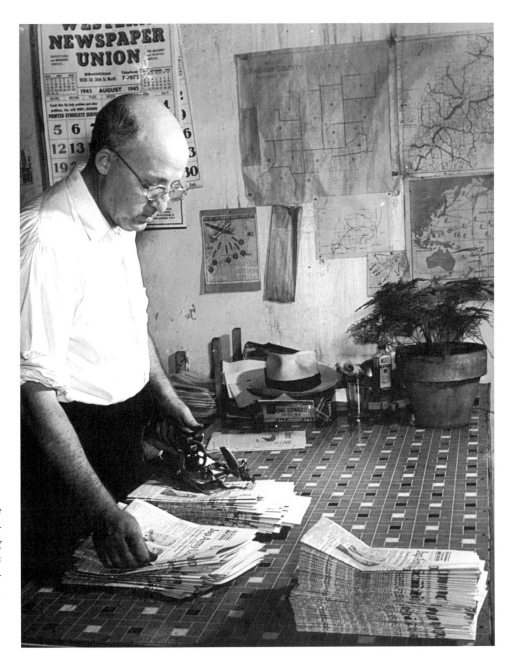

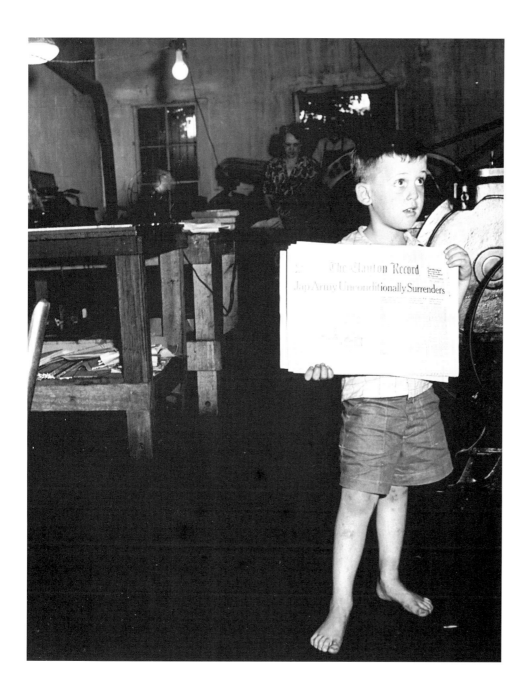

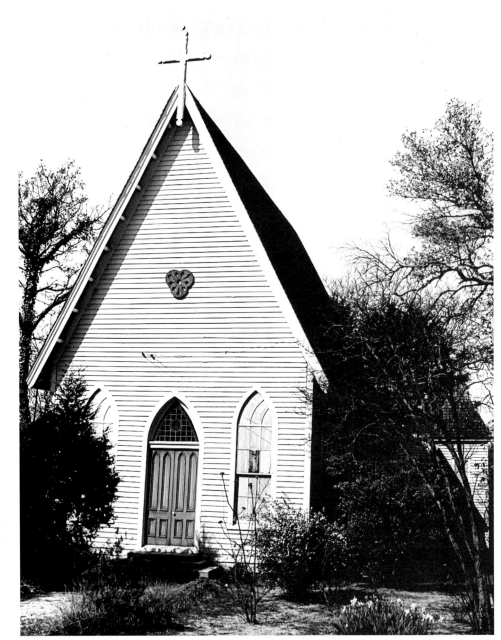

Clayton and Barbour County are home to an overwhelmingly Protestant Christian population, black or white. Baptists, Methodists, and Presbyterians predominated. There was a small, but predictably influential, Episcopal congregation at Grace Church in Clayton (this page) while the larger Clayton Methodist Church (right) down Midway was located a few blocks north.

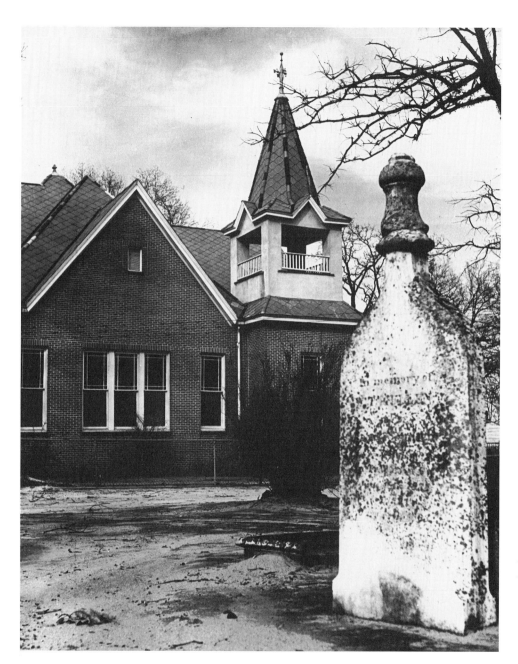

The Methodist Church had a cemetery with the unique whisky monument clearly visible from the church. It marked the final resting place of an alcoholic and was placed there by his wife. Both photographs suggest that Hightower was influenced by the photographs of Ansel Adams and others who were defining straight photography in the thirties.

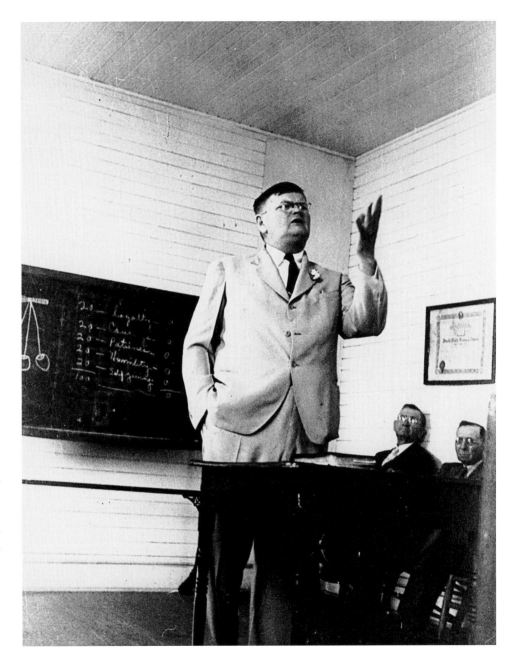

In 1935 Hightower took this candid shot of his Sunday School teacher, Harvey Caraway, at the Clayton Methodist Church. Given the limitations of film sensitivity to light and maximum lens apertures then available, it is noteworthy that he got the picture at all. The use of a low angle and capturing the dramatic gesture are both hallmarks of the best photojournalists of that era.

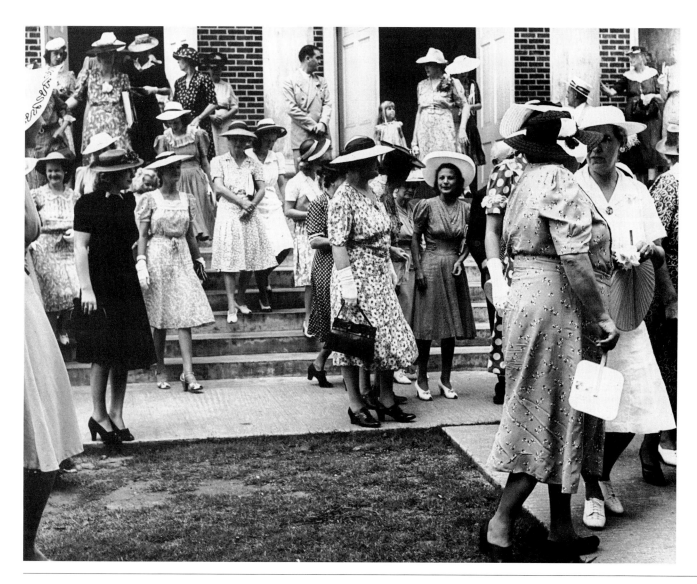

In Clayton, and in most of America, Sunday morning church services were social events as well as religious occasions. In this post-war picture the women of the Clayton Baptist Church are dressed in their best, as they would be every Sunday, some with fans to help beat the heat in the days before air conditioning.

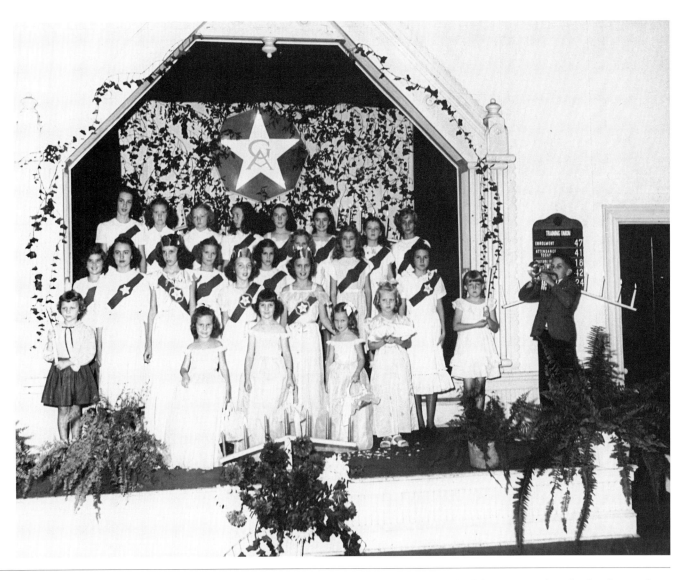

All churches made a special effort to reach children and involve them in the life of the congregation. In the picture above, which was made in 1947 at the Clayton Baptist Church, the Girls Auxiliary presents a program for an audience predominantly composed of their family members. On the right youngsters line up to go into the sanctuary for Vacation Bible School in the summer of that year. Years later several remembered singing "Onward Christian Soldiers" as they entered.

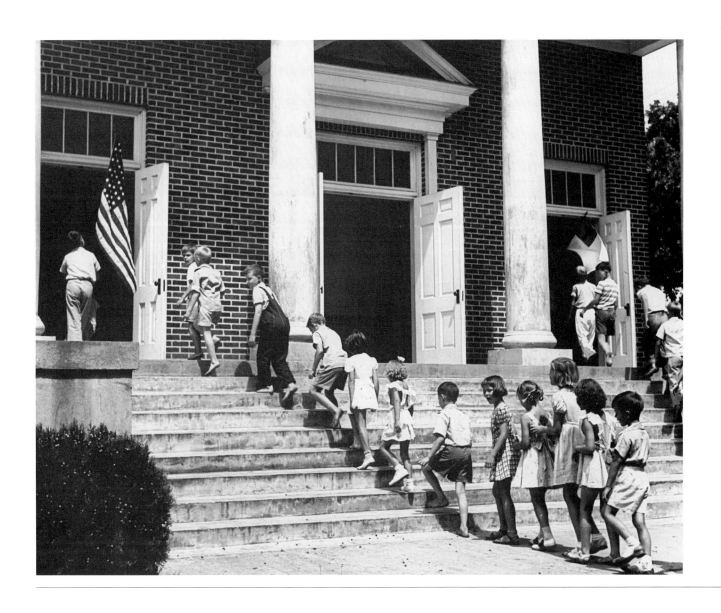

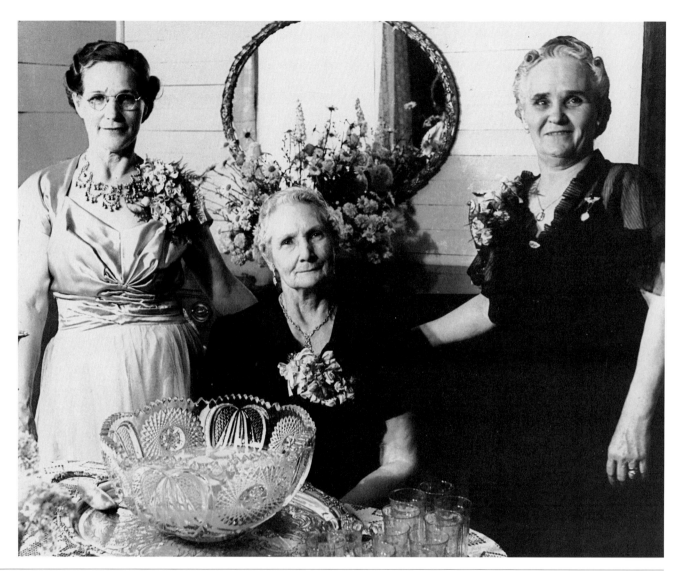

Hightower was regularly asked to take pictures at formal occasions and in doing so left a clear record of the activities of the female members of the town's prominent families. As records of costume and decoration the photos are priceless. In the picture above the hostesses (left to right, Mrs. M.D. Shirley, Lillie Bush Stewart, and Leona Turner) of a reception at Judge Williams' home pose for the photographer. In the picture on the right a large group prepares for another reception at Tom Parish's house on Eufaula Street.

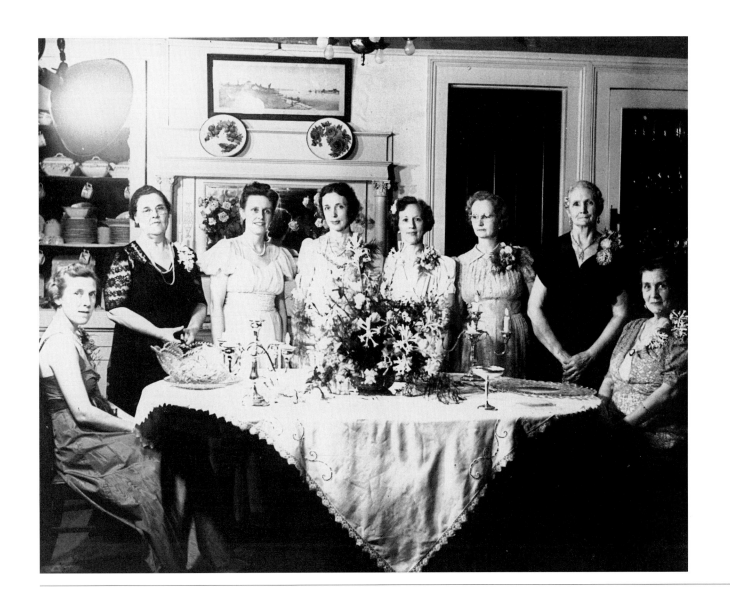

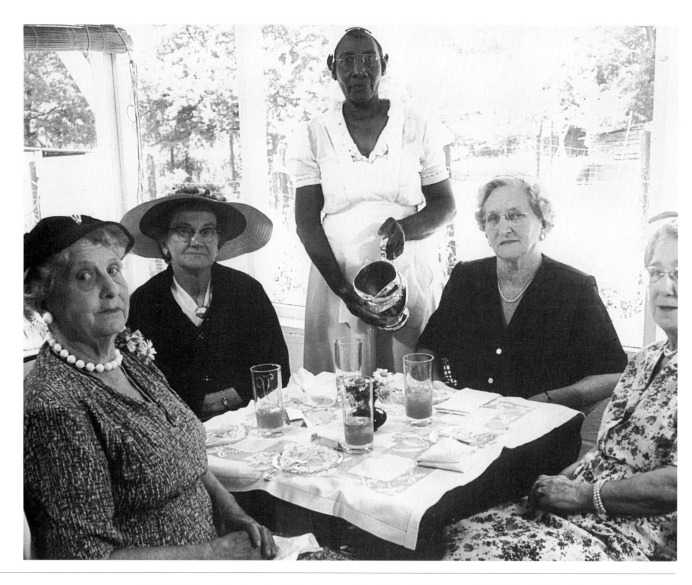

In the photograph above the ladies have gathered for a bridge party in the late 1940s. Victoria Lingo, Pearl Adams, Mrs. C.E. Collier, and Gertrude Martin are being served by Charity Reaves. Black domestic help was felt to be a necessity in the larger white households. In the facing photo Leona Ojachet takes Rebecca Parish, born in 1949, out for a stroll. Servants such as these women often stayed with the same white family for many years, reflecting the conservative social structure of small southern towns such as Clayton.

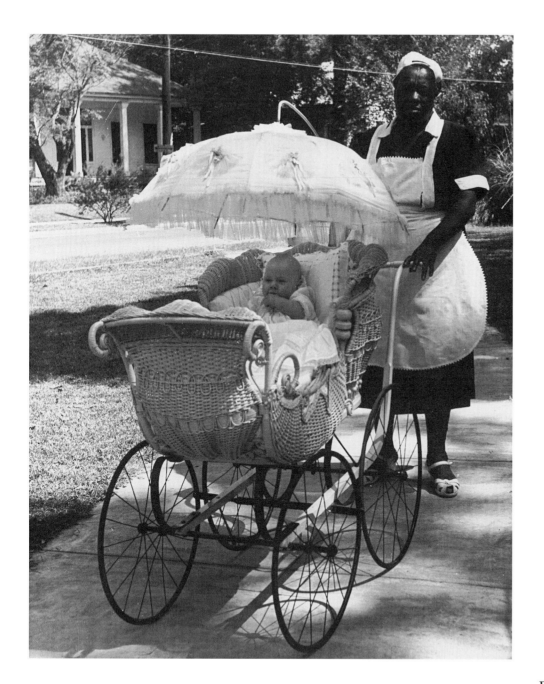

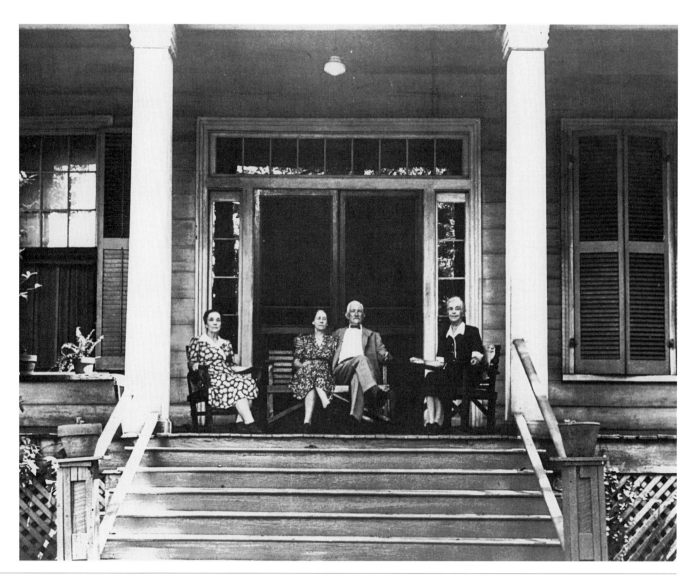

Hightower's pictures of the Winn house on Eufaula Avenue made in the late thirties and of the Fenn home on Poor House Road in 1945 are reminiscent of Walker Evans' picture of old homes in the Depression era. Like so many of Evans' pictures, the aging structures seem to dominate the people living in them.

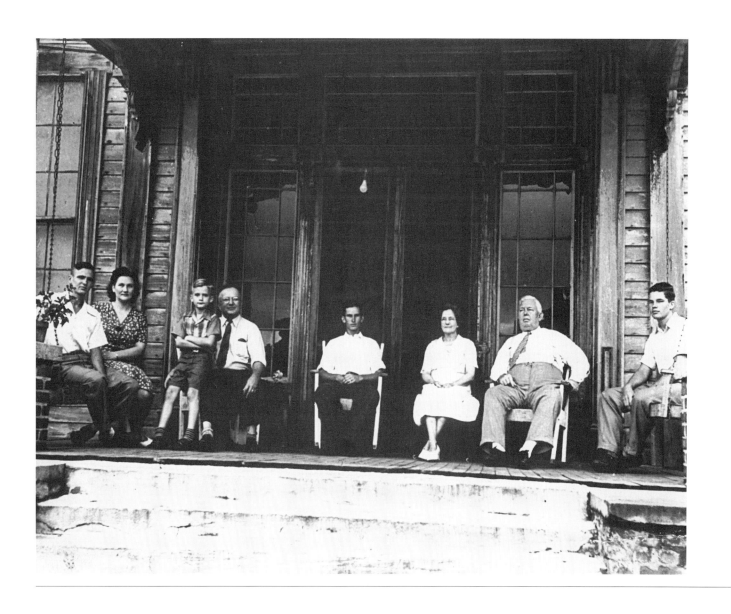

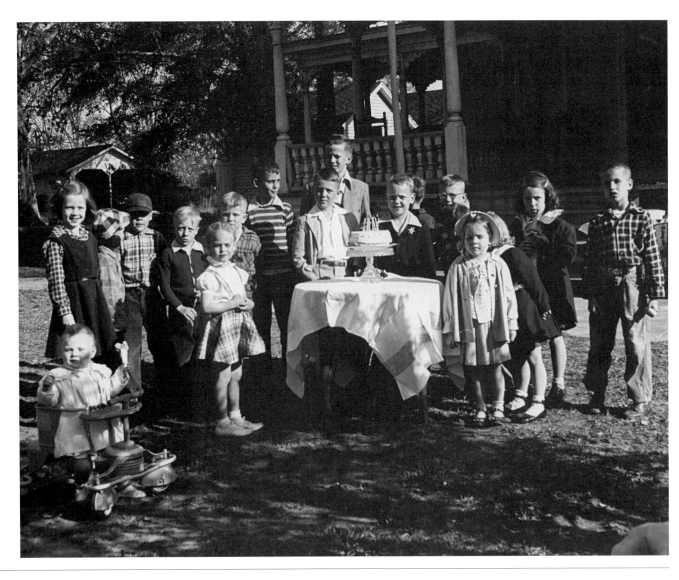

As he did for receptions and teas, Hightower often took pictures of birthday parties at the big houses. In the picture above Ed Parish, grandson of the Clayton Record's owner, poses for a birthday photo, c. 1950. In the 1954 picture on the right Rebecca Parish, Lynn Robertson, and Harriet Scroggins pose holding hands. It was Rebecca's birthday. The girls seem to be virtual icons of another era.

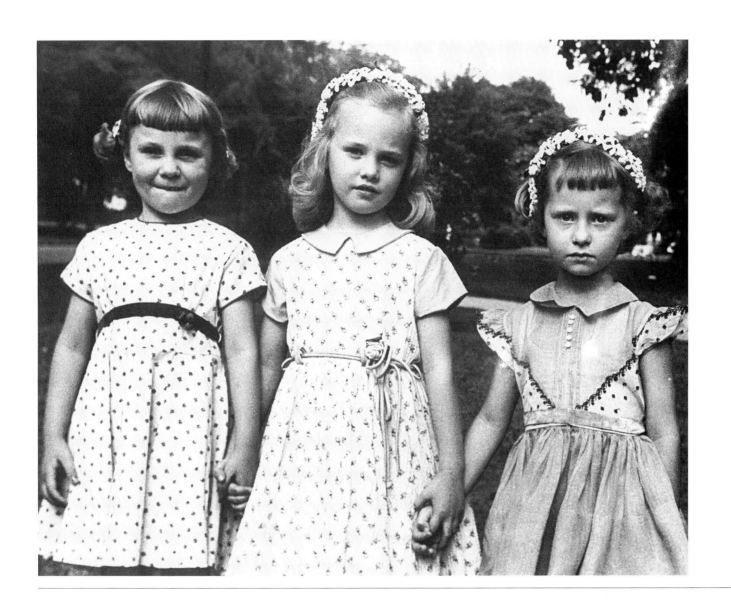

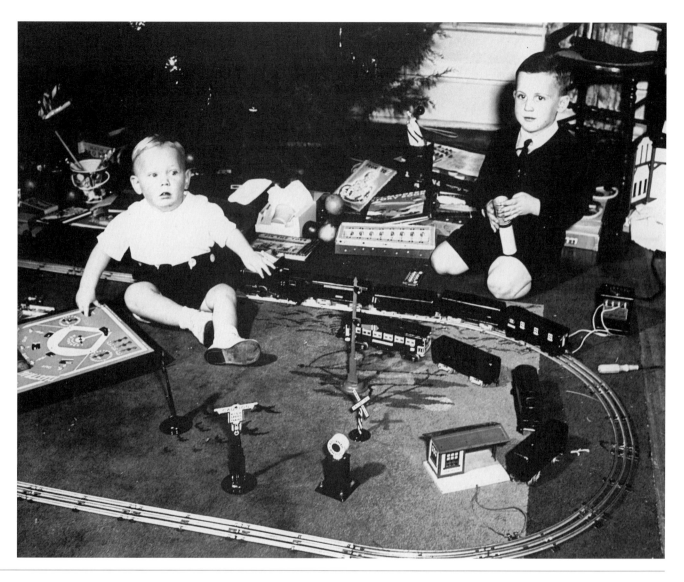

In the late forties Hightower photographed Ed and Tom Parish at their home on Christmas day. He took Tom's picture again at Christmas in the mid-fifties. The presents the boys got were everything a young fellow in America could dream of in those days. Unfortunately only a few Barbour County families had the means to be so generous to their children.

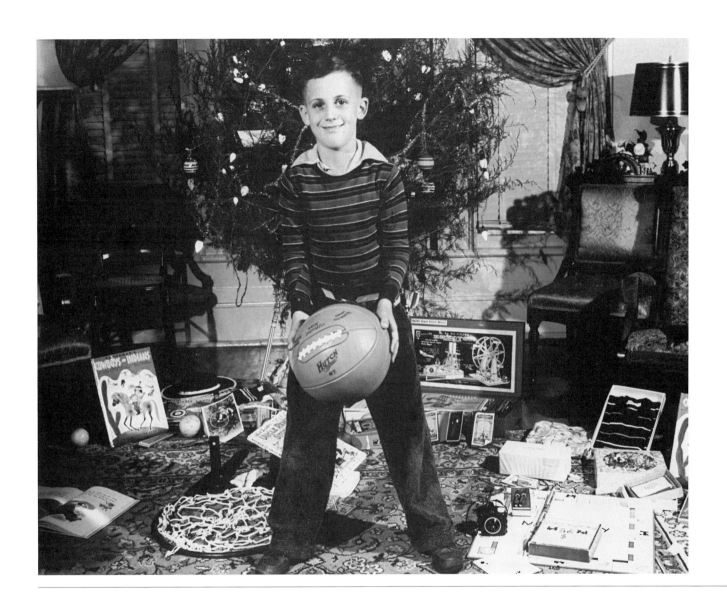

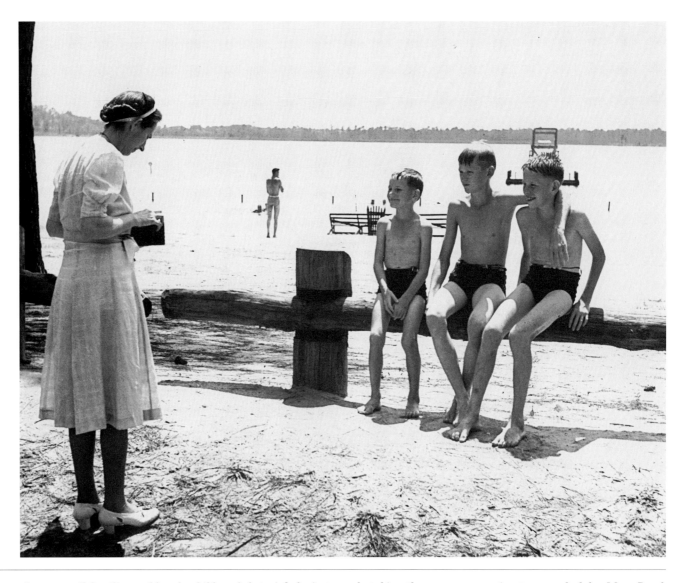

There were other ways all families could make children feel special, for instance by taking them on an excursion to a nearby lake. Mary Bond, Mr. Hightower's sister, is taking a picture of (left to right) Beeman Bond, Sidney Walker, and Layton Bond at Lake Tholoco near Camp Rucker before the war. It was a family outing, so Hightower took lots of pictures including the one on the facing page of his family members. The war would interrupt these activities and they would never completely recover in the post-war world as families scattered.

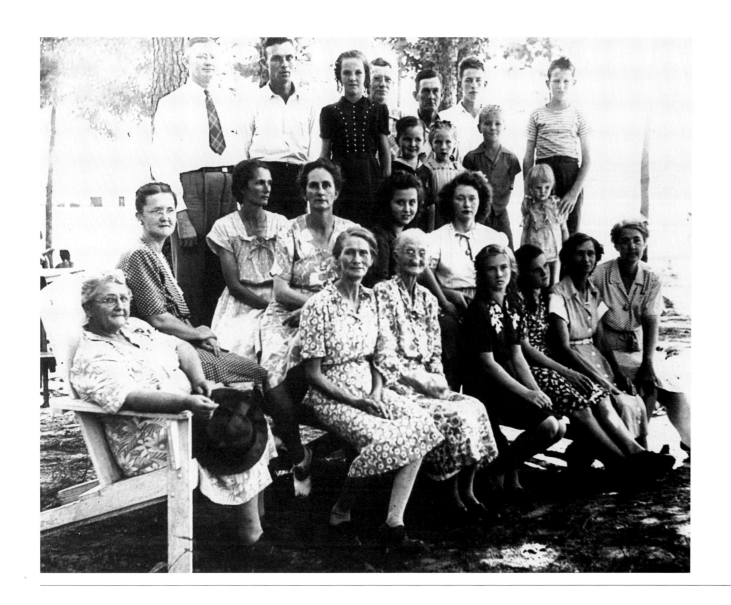

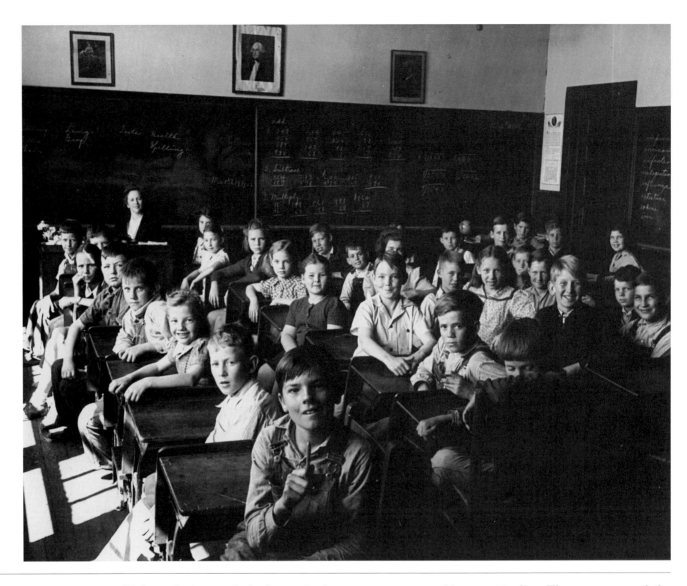

Hightower's pictures of school rooms in the war years are among his most appealing. The once-common clothes the students wore and the design and decoration of the rooms are simply no longer to be seen. The 1942 photo above shows Mrs. Mary Emma Watson's 4th grade class while on the facing page we see Mrs. Elizabeth Parish's 5th graders in 1943. Hightower's foster daughter, Martha, and her twin sister Mary Jane were in both classes.

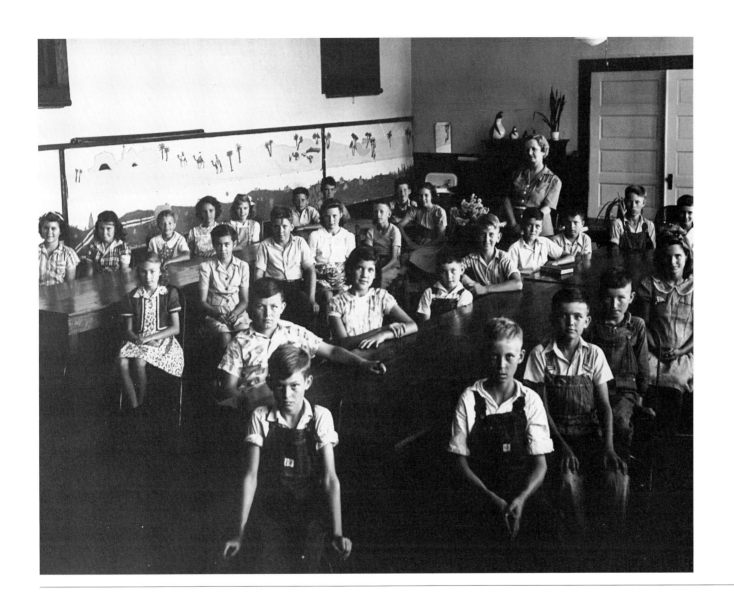

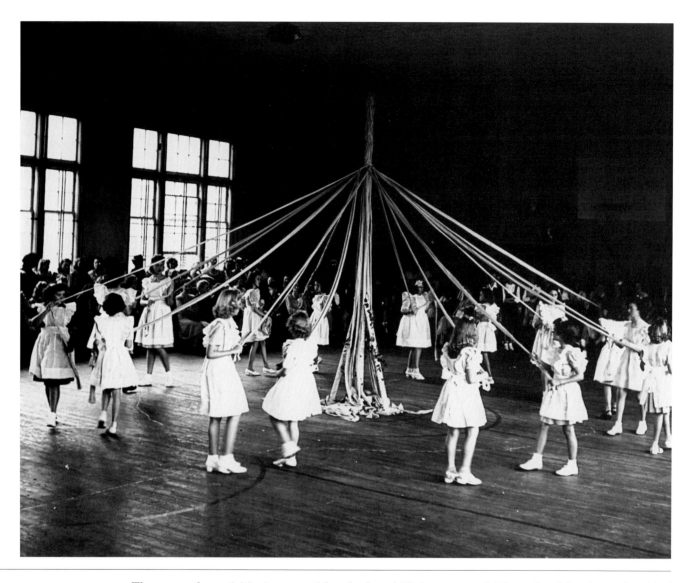

There were other activities in many of the schools and Hightower recorded them also. After the war he visited Louisville Elementary School to watch the spring pageant which included winding of the maypole and a lively dance demonstration by girls in pioneer dress.

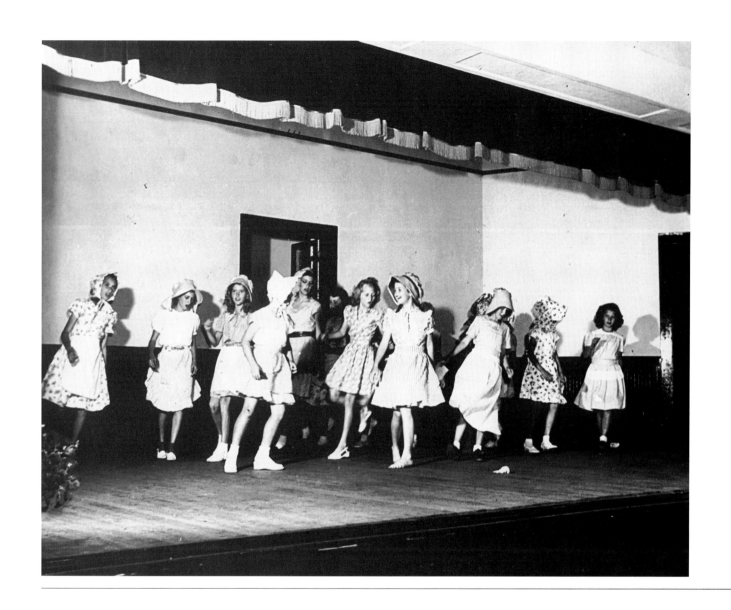

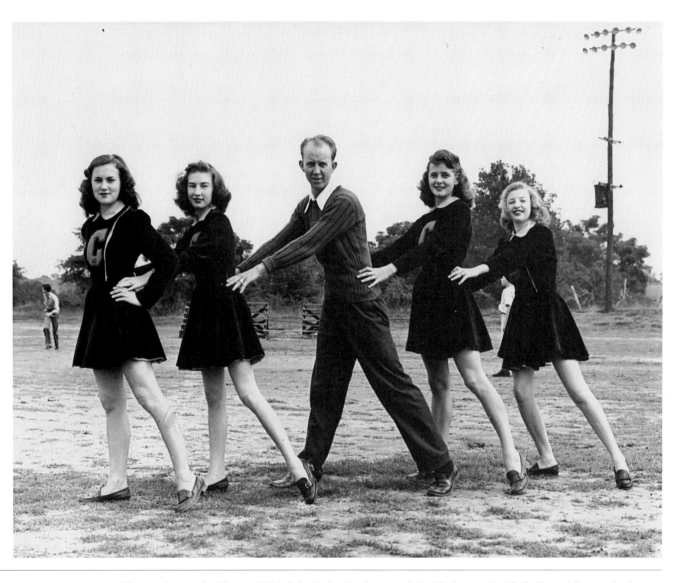

Closer to home, the Clayton High School cheerleaders posed for Hightower in 1948. From left to right they are Jeanette Warr, Martha Byrd, Val Hurst, Ann Floyd Martin, and Mary Jane Byrd. By the fifties (right) the cheerleaders were all female, including Terry Taylor, the football coach's little daughter, but they certainly projected the enthusiasm which they hoped would be contagious.

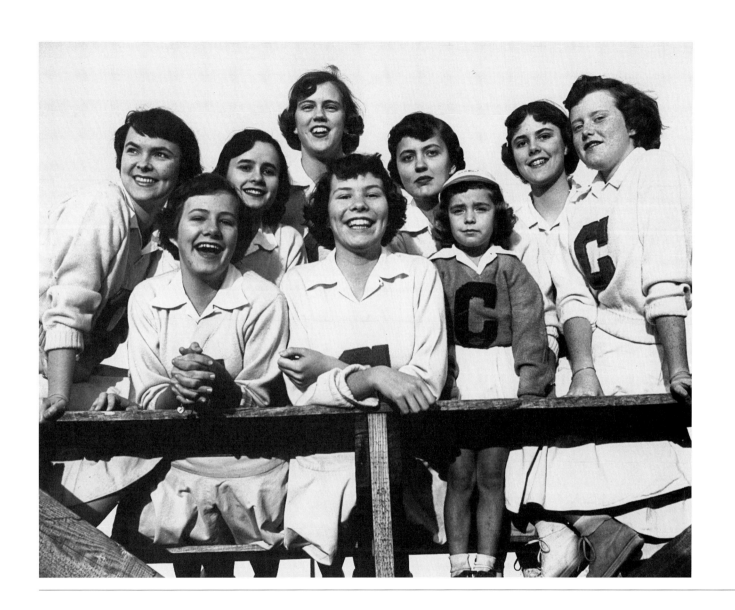

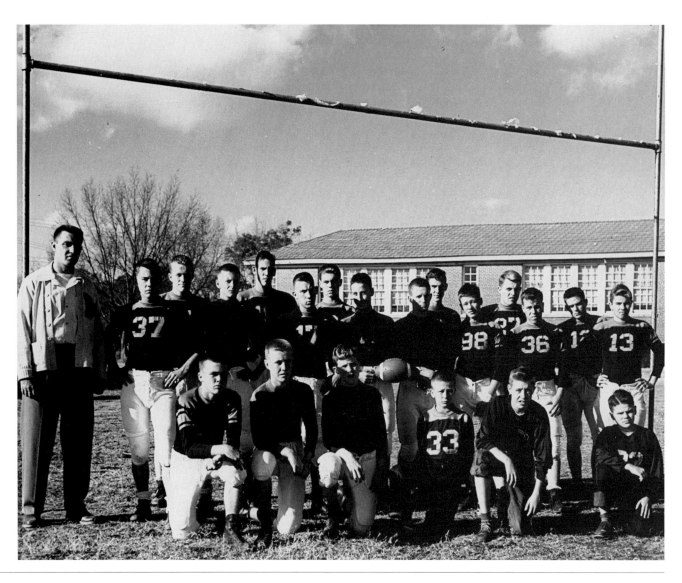

What would the post-war American high school experience be without a football team? Coached by Tom Taylor, the 1949-50 Clayton High School squad included boys from the town and adjacent rural areas. Several of its members, including Jere Beasley (seventh player from the left, back row), went on to play prominent roles in their community and state, but not in football.

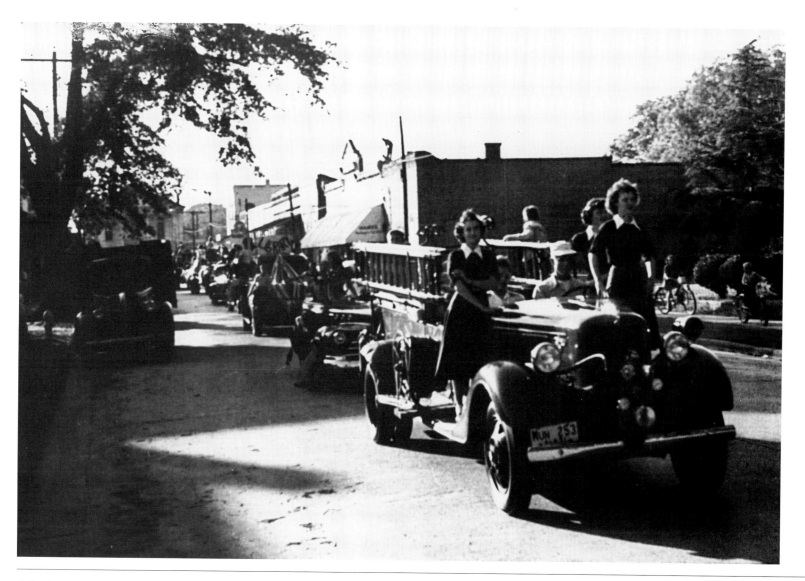

School activities occasionally spilled over into Clayton's streets as in this case of a parade promoting the football team. It was making its way out Eufaula Avenue toward the school. Cheerleaders Martha Martin and Martha Daniel are standing on the running boards of the fire truck.

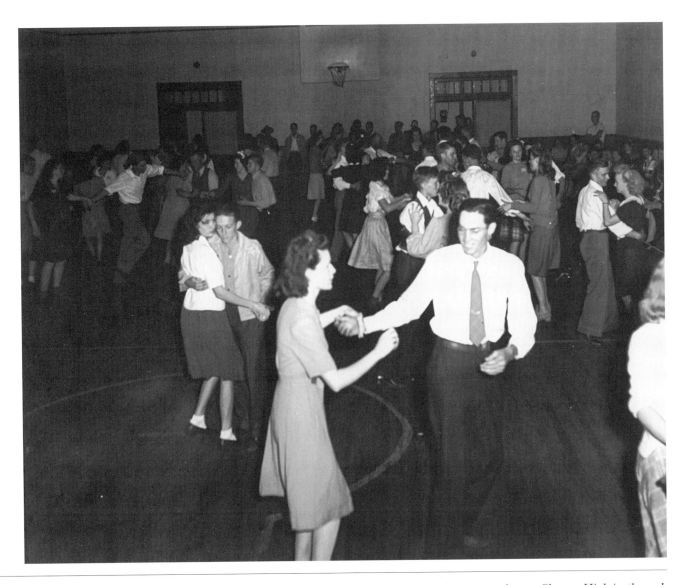

Dances held on campus were one of a high school's most appealing attractions. These pictures were taken at Clayton High in the early forties (above) and the early fifties (right). In the right hand picture Martha Byrd is dancing with her brother, Chick, to music from the Wurlitzer juke box in the background.

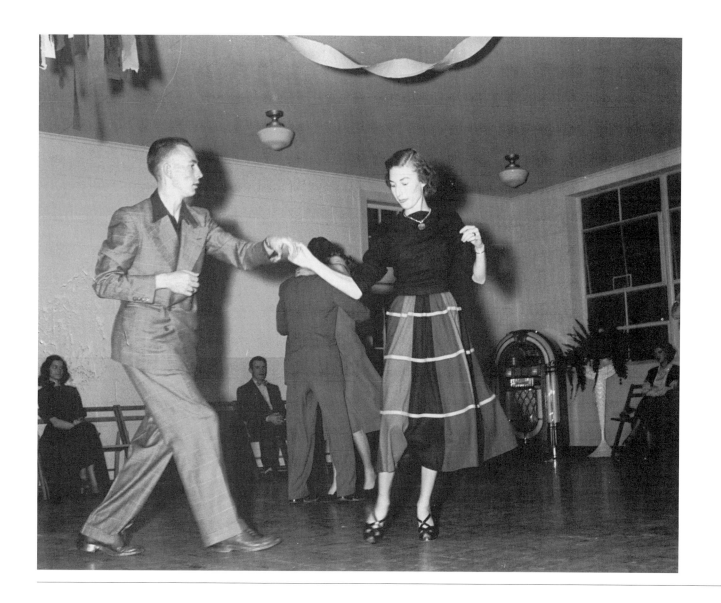

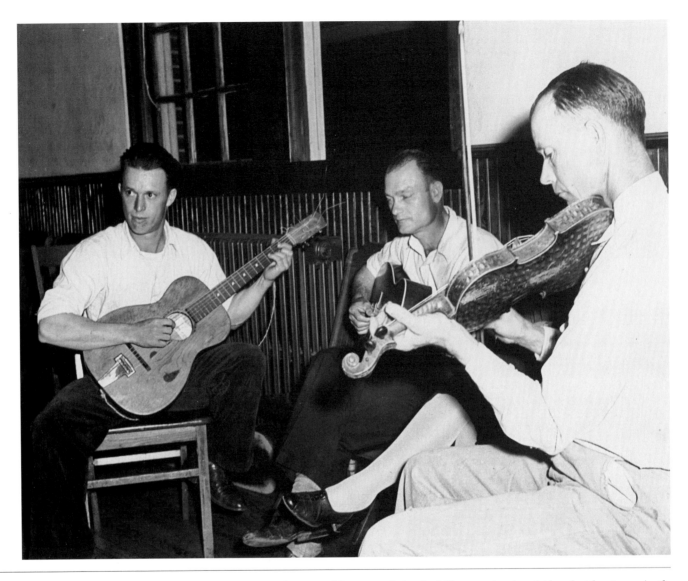

While records became the normal source of dance music in the fifties, a string band played at least once in the late forties at the high school. The musicians were (left to right) Jake Granthom, Alvin Bynum, and Foy Carrol.

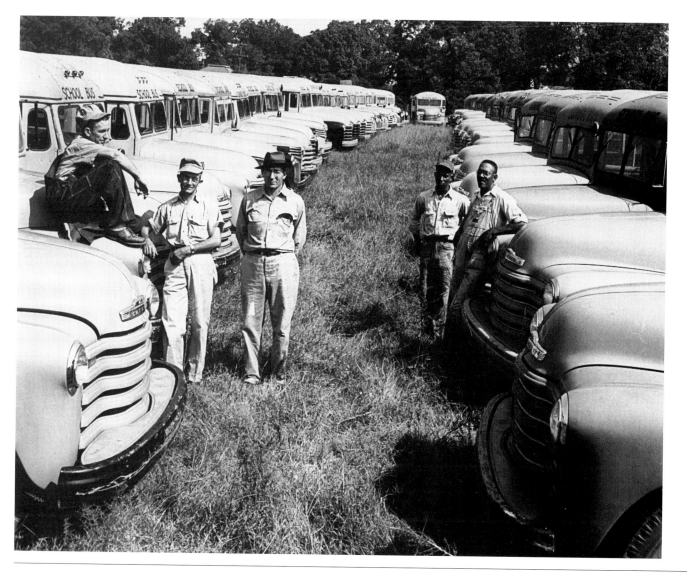

Long before the days of school integration, consolidated schools such as Clayton High depended on a fleet of buses to bring students in from the country. In this picture Hightower made c. 1952, the vehicles are in summer storage behind the school. The personnel who looked after this fleet were from the left Henry Westbrook, Royce O'Dell, the supervisor, and Gaston Thompson. On the far right is Robert Banks, bare headed in bib overalls.

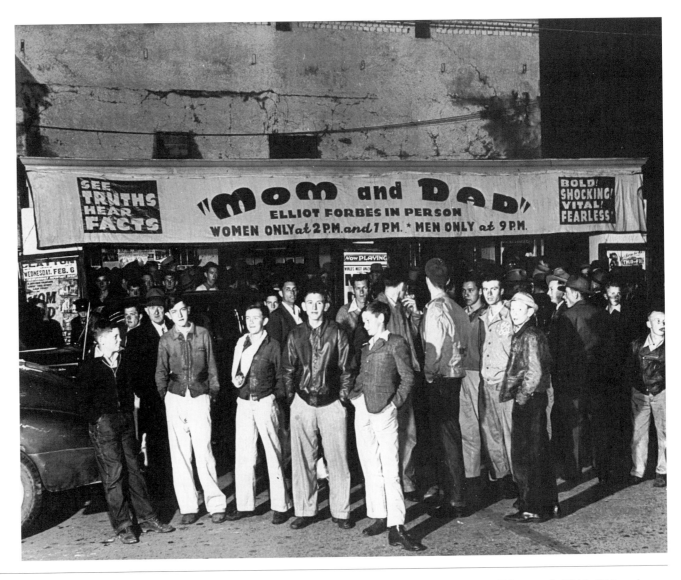

"Mom and Dad," a sex education film, came to the Clayton Theatre on February 6, 1946. Girls only were admitted to the 3 and 7 p.m. showing, and boys only at 9:00 p.m. Hightower recorded the crowd at the girls' matinee and boys' night time show. The latter didn't seem to mind being photographed, and even posed, but the girls were shyer and most turned away from the camera.

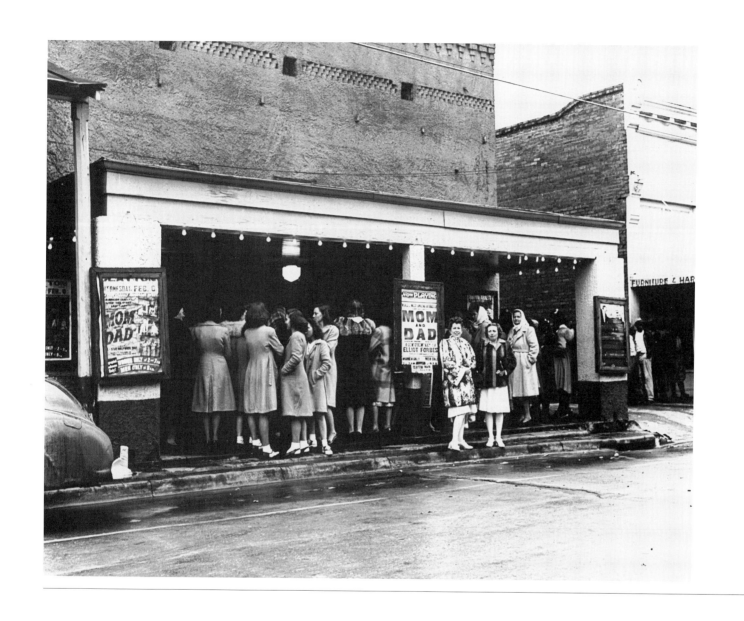

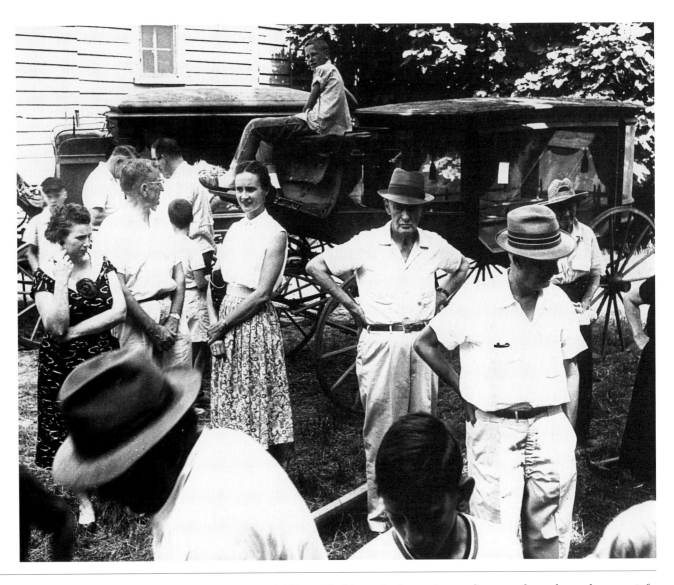

From time to time auctions were held but only this one had two nineteenth-century horse-drawn hearses up for sale. The main purpose of the sale was to sell an old house and property but the hearses gave notice of the passing of an era. One of them was purchased by Bill Blair at this auction in 1958 and is now on display at the Pike County Pioneer Museum in Troy, Alabama.

If that auction marked the passing of an era, the two-and-a-half-day long convoy of military equipment signaled the arrival of a new one characterized by the Korean conflict and the Cold War. This army convoy went to Fort Benning from Fort Rucker, passing through Clayton while boys watched from the streets or the balcony on the old courthouse.

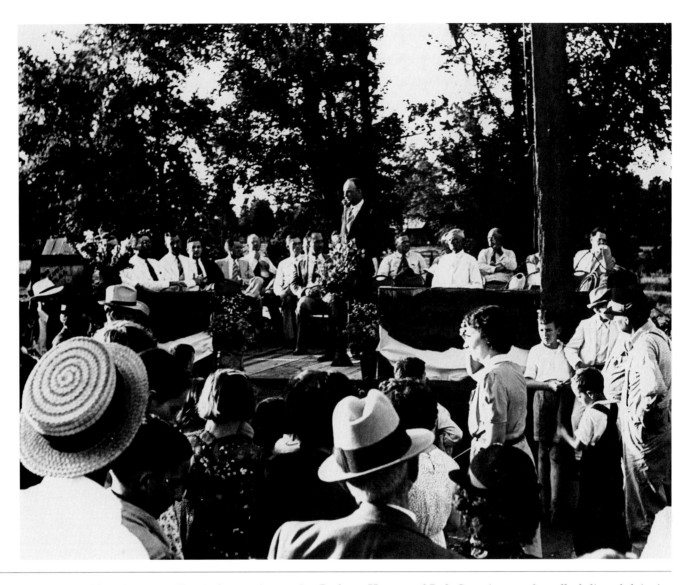

In June 1939 the Pea River Electric Cooperative, serving Barbour, Henry, and Dale Counties, was formally dedicated, bringing electricity to many farms in the region. Made possible by the New Deal REA program, it was another example of the benefits successful political activities and influential politicians could bring. Barbour County was certainly no stranger to either. The co-op's Board of Directors are listening to Preston Clayton speak. A prominent politician, he was the state senator from Barbour County.

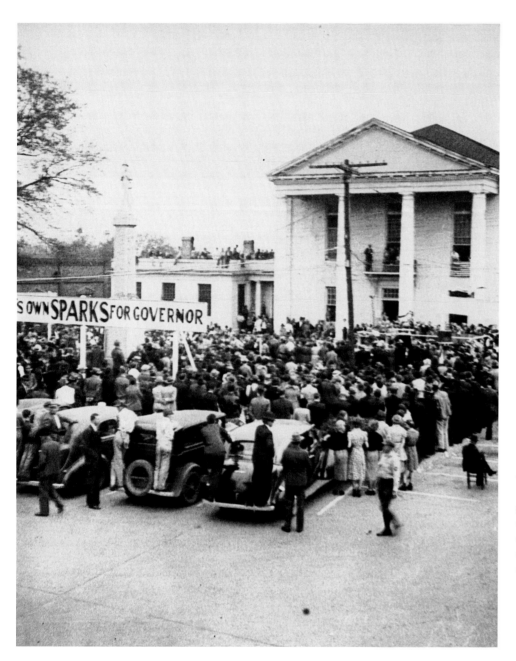

In 1942 Chauncey Sparks, a native of Barbour County, came to Clayton to hold a rally at the courthouse. Subsequently elected governor, he was the fourth Barbour Countian to be elected to the state's highest office. On this occasion the crowd would probably have been larger were it not for wartime gas rationing, men being drafted away into service, and people moving off to work in defense plants.

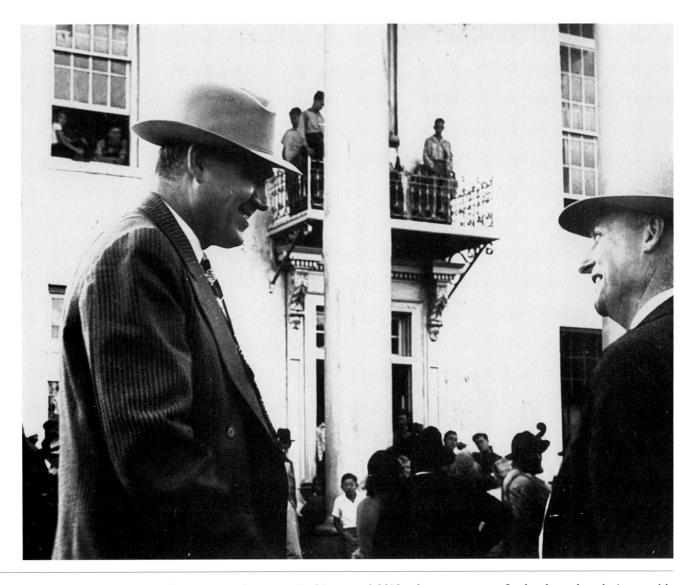

In 1946 Big Jim Folsom came to Clayton's courthouse steps in his successful bid to become governor. In the photo above he is greeted by State Senator Preston Clayton. In the facing picture his band, the Strawberry Pickers, warms up the crowd. Folsom was very popular in Barbour County, at least during his first term in office.

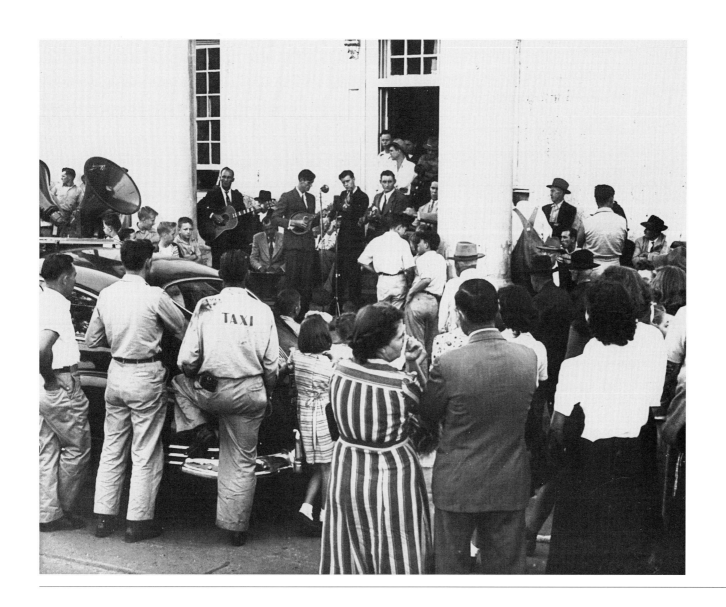

No politician was ever more popular in the county than native son George Corley Wallace. When he ran for governor in 1958 his friends and supporters prepared a giant barbecue, shown above, and jammed the courthouse square for his rally where Minnie Pearl entertained them before Wallace spoke (right).

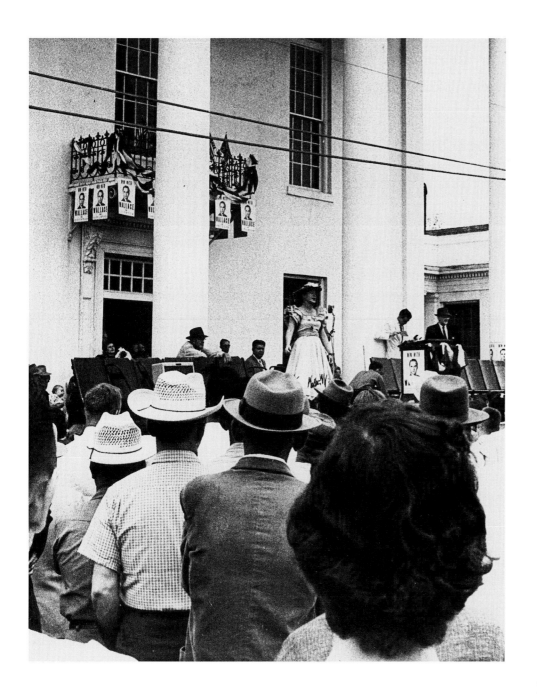

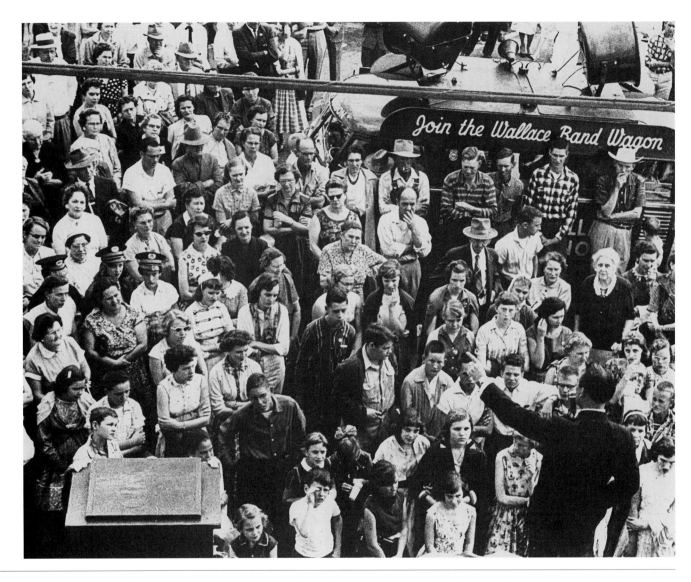

No rally ever brought as many people to Clayton's square and Hightower's pictures show us the rapt attention paid Wallace by his hometown supporters. His law office was across the street from the courthouse and he had grown up in the town which he represented in the state legislature when this picture was made.

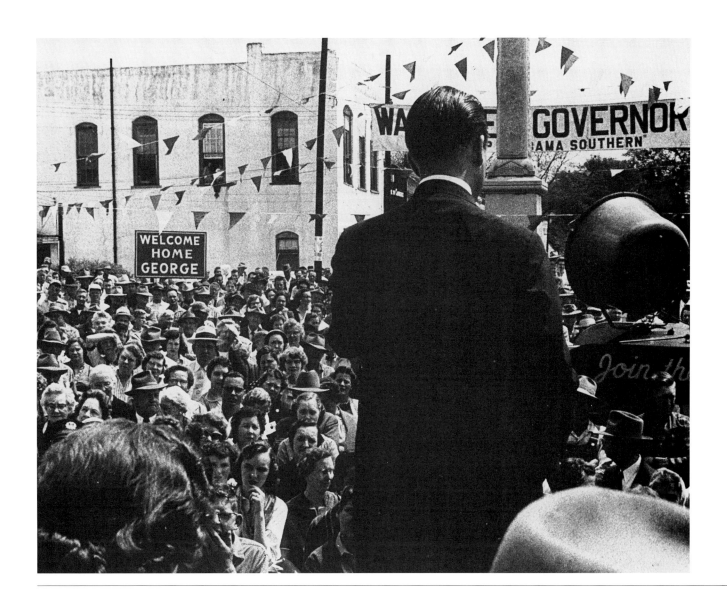

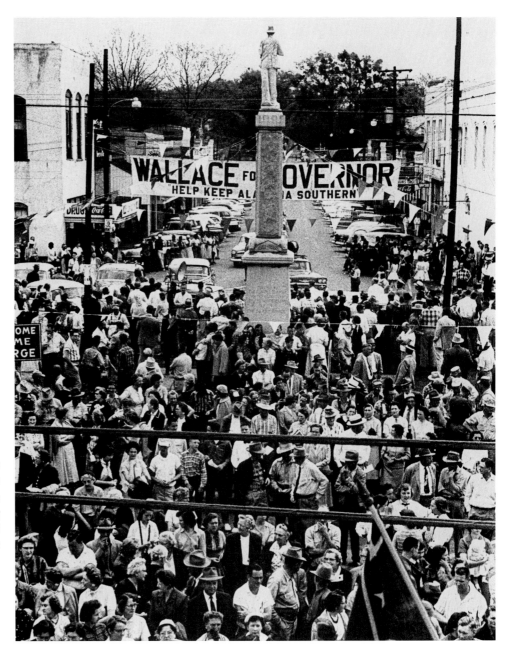

Although he was defeated in 1958 by his more conservative and racist opponent, John Patterson, the ingredients of Wallace's eventual rise to dominance in Alabama are evident these pictures. The battle flag of the Confederacy, the slogan urging voters to "keep Alabama Southern," and his populist oratorical style are all there. He knew how to reach people from the small towns and countryside.

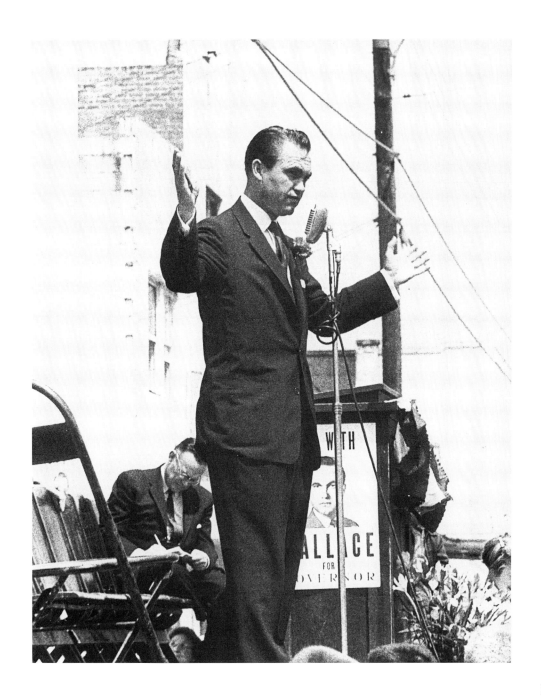

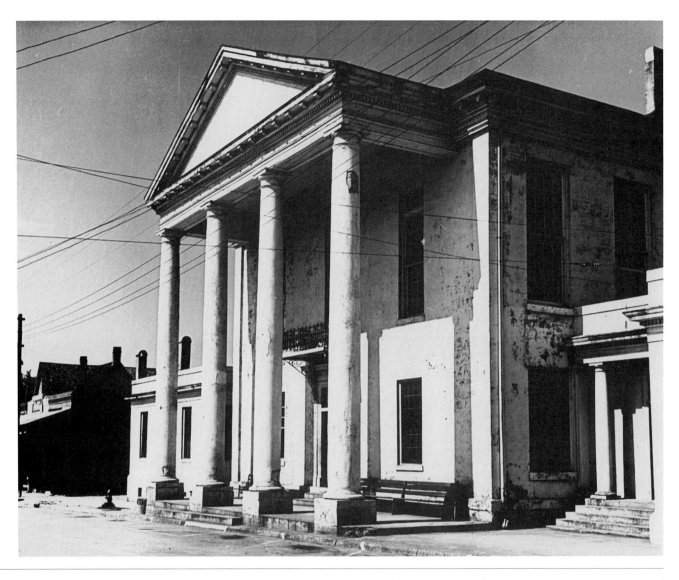

A prominent feature in so many of Hightower's photographs, the antebellum courthouse was demolished in 1959-60 to make room for a larger and more modern building. Hightower and his wife were opposed to this destruction and he recorded the passing of the old building in a series of moving photographs. Ansel Adams might have made the striking picture above of the old courthouse which still had its appeal despite being gutted. On the facing page the replacement nears completion. It confronts the Confederate monument on the square with which it seems to have nothing in common.

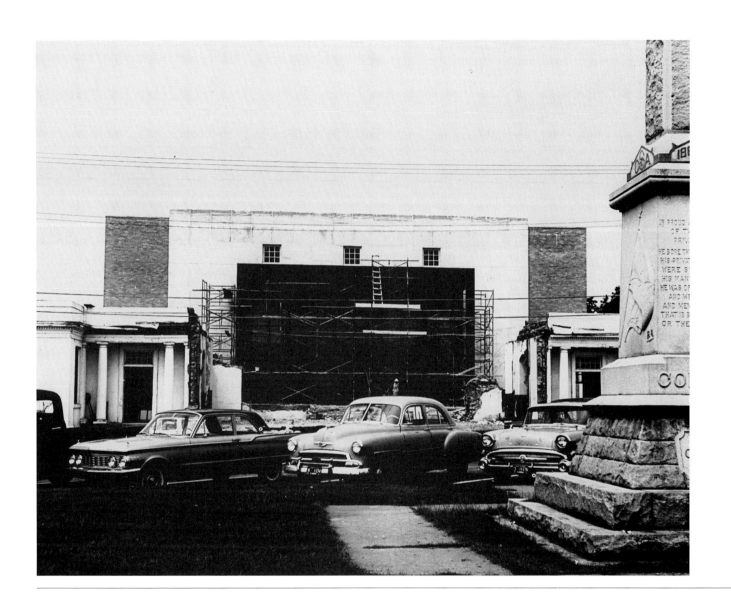

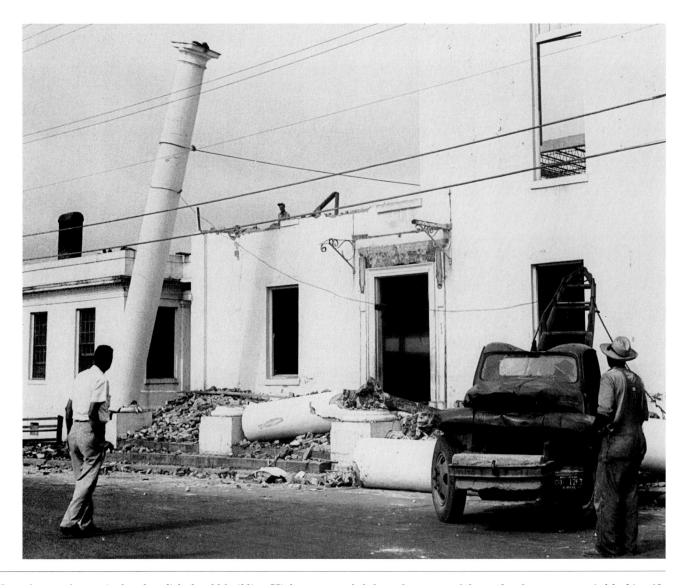

Over the months required to demolish the old building Hightower recorded the sad progress of the work, often accompanied by his wife, Marie, and her friend, Mrs. Ben Baker. On the facing page Mrs. Hightower is on the right, Mrs. Baker on the left. In the picture above the historic columns were simply pulled down and destroyed as initially no effort was made to salvage anything.

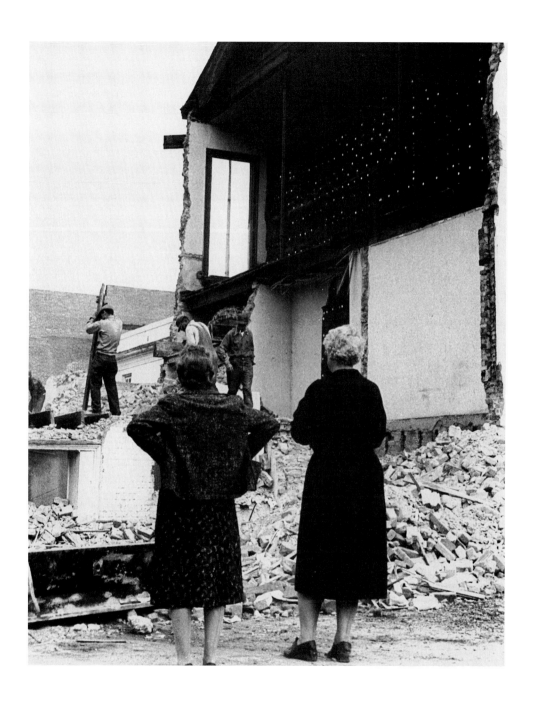

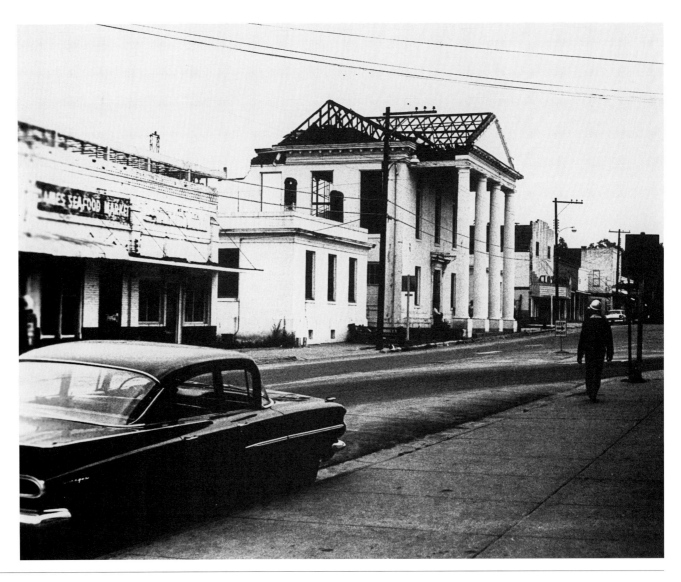

The Hightowers and Mrs. Baker hit on a plan to save antebellum bricks and other materials from the demolished structure, haul them away, clean them and use them to build a new library. Mr. Hightower, then nearing his 60th birthday, did much of the work himself while photographing the building's demolition.

In December 1962 a new public library was dedicated on North Midway Street about three blocks north of the courthouse. The bricks, lumber, columns and fence all came from the old courthouse. The iron columns were from inside the old building. The new library's existence was a tribute to the ladies standing on its front porch (left to right, Lucille Martin, Alice Norton, Mrs. Ben Baker, Marie Hightower) and to the man taking the picture, Draffus Hightower. Shortly before he died, the Hightowers gave an additional $10,000 to expand the structure.

Hightower had seen sweeping changes in his world since the twenties when he rode his Harley into Clayton from his family's farm on the Smuteye Road. Then he worked at Robertson's Ford dealership as a mechanic. His record of those changes expresses his manner of quiet and thoughtful observation. His interest in the antique music box, shown on the facing page, like his interest in preserving a photographic record of the world he knew was passing, was quiet but determined.

Born and raised west of Clayton, married to a woman who inherited a large tract of land east of the town, and selling Chevy cars and trucks to farmers across the county, Hightower spent a lot of time in the countryside where change in the thirties and forties was rapidly obliterating the world of his youth. Few farmers used broad axes to split timbers for siding or fences as the pioneers had done. Split rail fences were replaced by barbed wire. Inspired by the work of major photographers of the thirties, Hightower set out to record the passing scene in pictures such as these.

Hightower photographed the details of pioneer log cabins or the simple lines of the Palymira School located eight miles east of Clayton using compositional techniques that remind one of the work of Walker Evans or Margaret Bourke-White.

In the thirties, Hightower photographed a team of mules because they were and had been an essential ingredient in the life of rural Alabama. His photograph of a sow that appears to be smiling as she nurses her piglets suggests that the photographer had a sense of humor, too.

Hightower successfully recorded the natural beauty of the countryside, whether swans on Robertson's mill pond or the Comer Road (right), an important farm-to-market connection winding along under moss-covered trees. He was never without his camera.

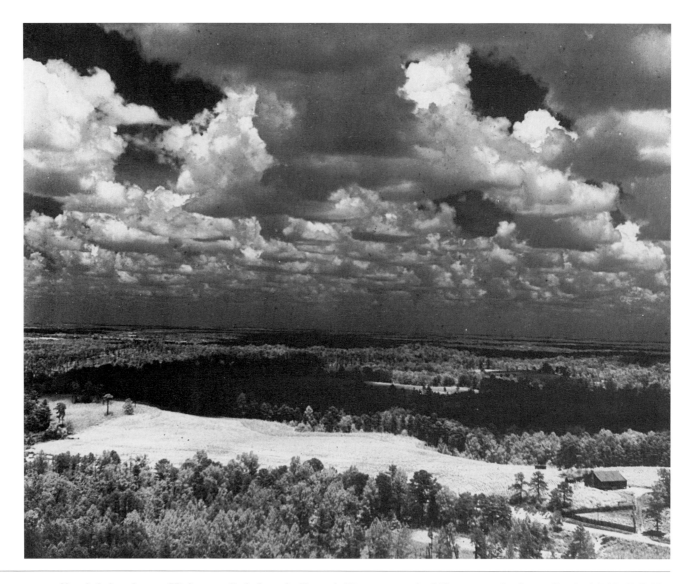

Shortly before the war Hightower climbed up the Kennedy Firetower north of Clayton on the Comer Road with his Rolleiflex loaded with infrared film and took this dramatic picture of the sky and the land, very much as Ansel Adams was doing in the western United States. Farms are neatly separated by stands of timber as far as the eye can see. When asked why he chose to go all the way up the tower, he told his grandson he wanted to get close to the sky.

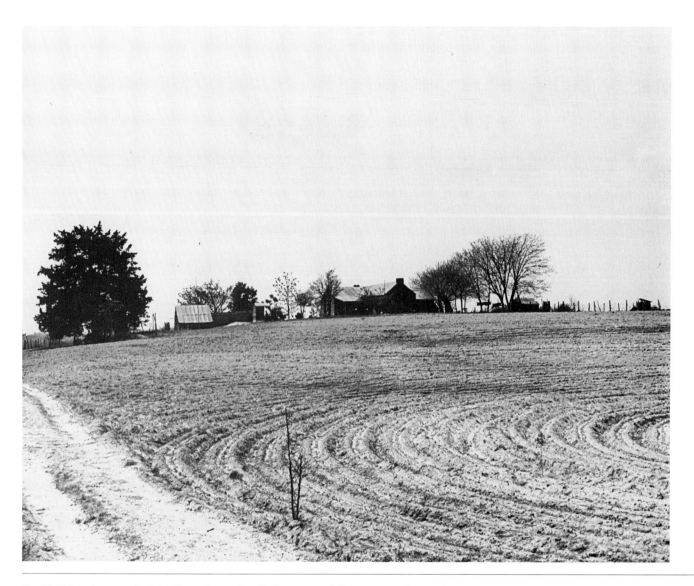

In 1940 he photographed the Beauchamp family farm east of Clayton near his wife's land at White Oak Springs. The Beauchamps had farmed this soil since 1855 and were one of the county's oldest families.

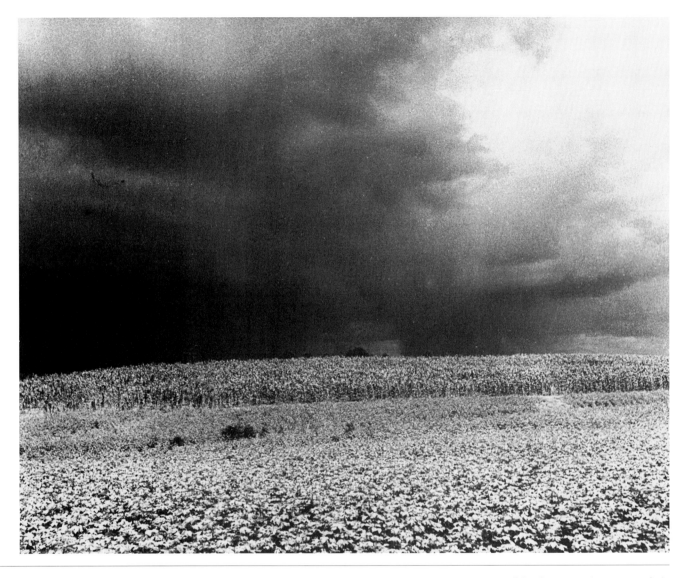

Once asked what he would do if he had to start all over, Hightower replied, "be a meteorologist." In these two pictures, made in the thirties, we see his fascination with weather and clouds and his love of the land. In the picture above, the clouds are about to open up on a field of cotton in the foreground and corn farther back. On the facing page, Spanish peanuts are growing as a storm approaches. In the forties peanuts would replace cotton and corn as Barbour County's most valuable crop.

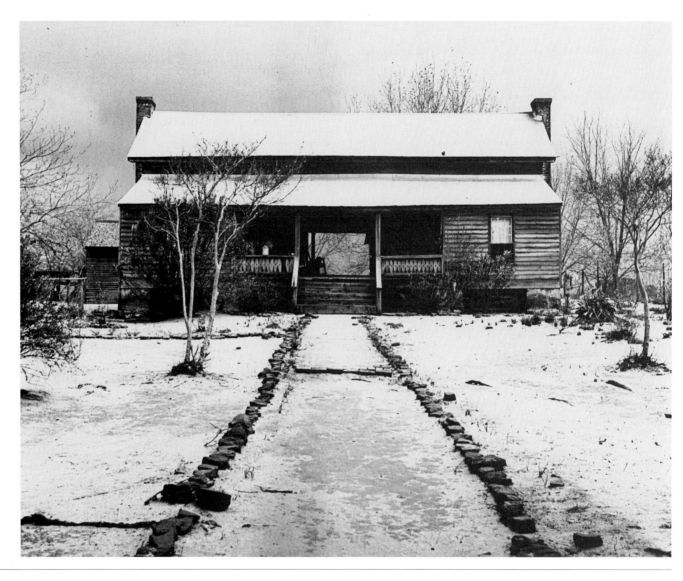

A common farm house plan was the "double pen" or "dog-trot" found throughout Alabama and the South. The dog-trot / breezeway which ran through the house from front porch to back helped with ventilation in the summer. However, on a snowy winter's day such as this that asset is of questionable value. The Martin-Clark house in Cotton Hill built c. 1850 was owned by Marie Hightower's uncle. It was the scene of many family gatherings before it burned down in 1960. Hightower photographed it several times.

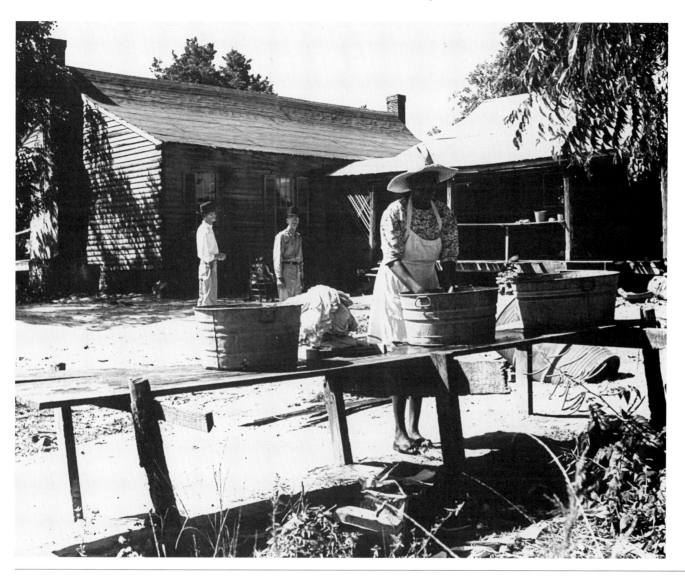

Even after World War II, running water, indoor plumbing and electricity were still things to come someday for most people in rural Barbour County. The woman does the wash outside with no labor-saving devices, just as she has always done. The scene is the Bishop family home near White Oak Station east of Clayton shortly after the war.

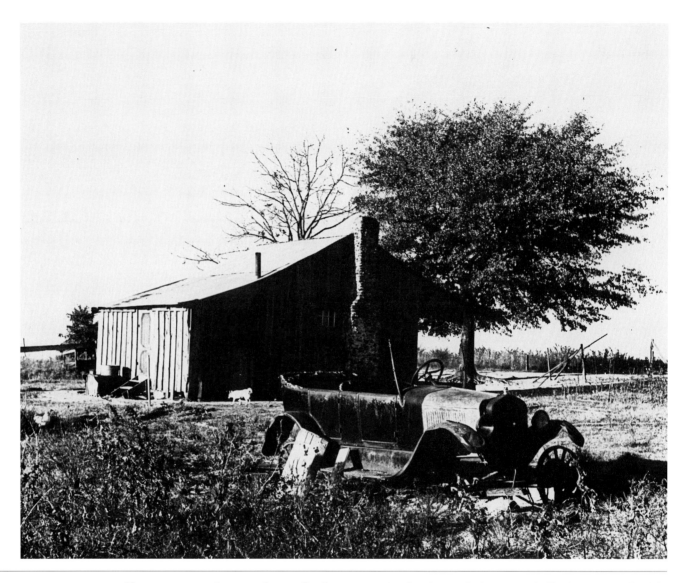

Share croppers and tenant farmers lived even more simply, often with the rusting hulk of a wornout Ford for yard decoration. This house is built in the "College Method" using rough sawed vertical planks and narrow strips or battens. The collapse of King Cotton in the thirties hit tenant farmers hardest since that was really the only cash crop they knew how to grow. Most of Barbour County's farmers were tenants at that time.

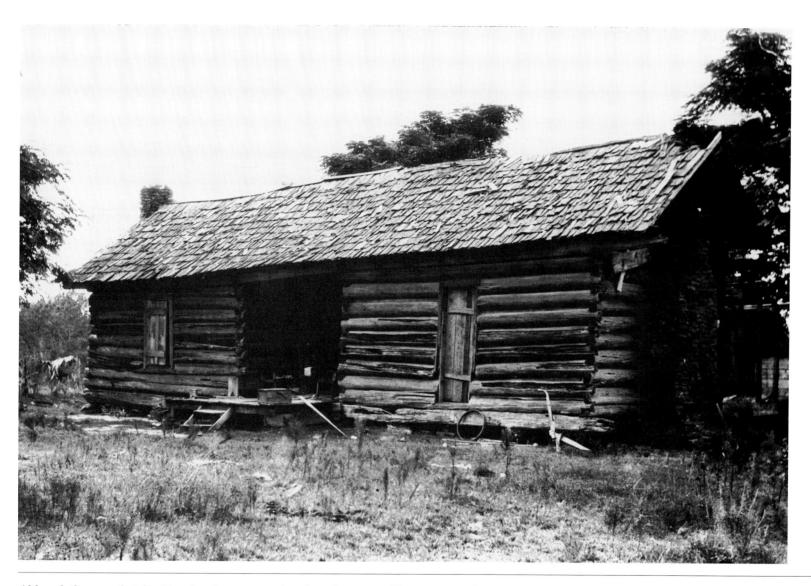

Although they were fast disappearing due to age and neglect, there were still a great many log cabins in Barbour County in the thirties. This place was infamous because it was the home of a black man who shot and killed his stepdaughter there and a white man in a neighboring home in 1903. Whether because of that or the Depression, it was abandoned by the time Hightower made this picture.

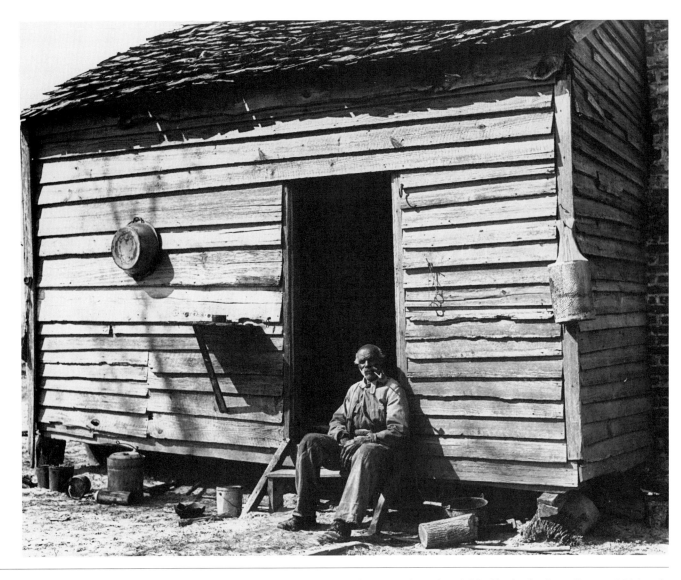

Most black farmers were tenants and they occupied the lowest rung on the economic and social ladder in Barbour County. Neither the wisdom of age nor the vigor of youth were enough to overcome their economic status or the racism institutionalized throughout the South by segregation. Nonetheless, if there was poverty and racism there was also ample evidence of wisdom and vigor. Neither the old man nor the family on the facing page are identified though the latter lived about four miles east of Clayton, c. 1940.

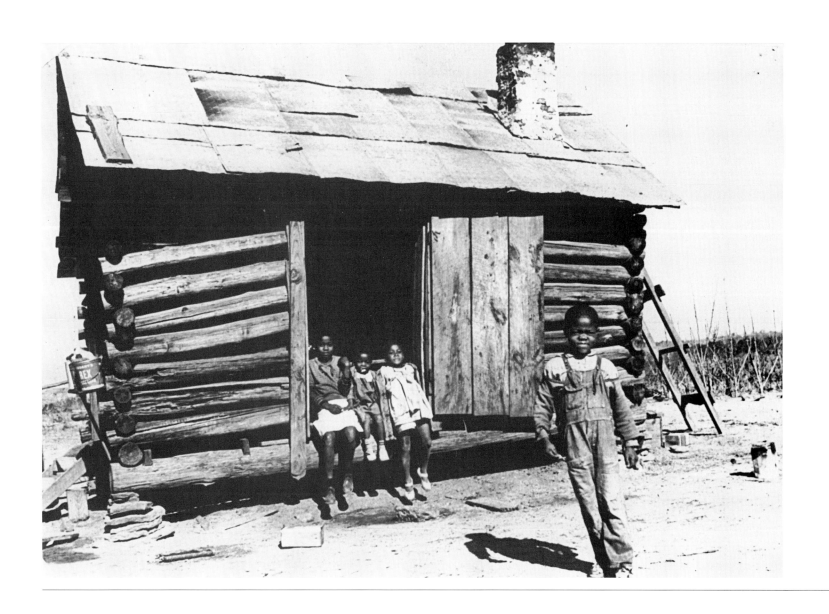

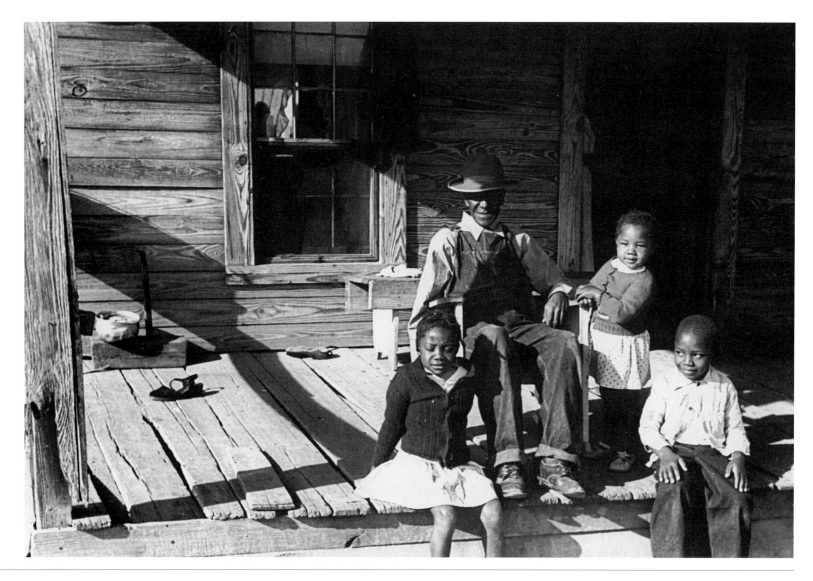

In pictures which match anything nationally-known photographers took, Hightower made a sympathetic record of the unnamed family above while on the facing page he captured Sally Skipper scratching her pet pig at her home, east of the county seat on the Baker Hill Road. He recorded these people as people regardless of race and later noted that he felt respect for them because of the adversities with which they regularly coped.

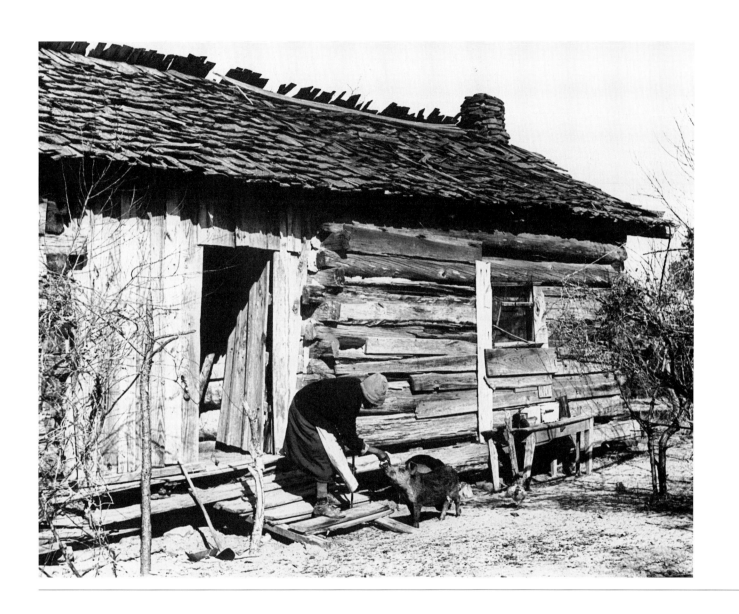

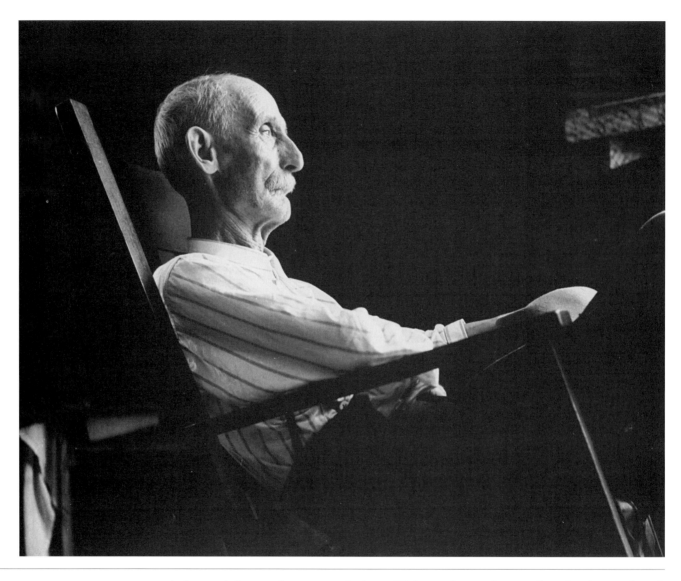

As he traveled across the county on business, Hightower frequently stopped to take pictures of people or places that caught his eye. Neither the man above nor the woman on the facing page are identified by name. Hightower was interested in such people becauese they epitomized the best of the old world which he saw was coming to an end.

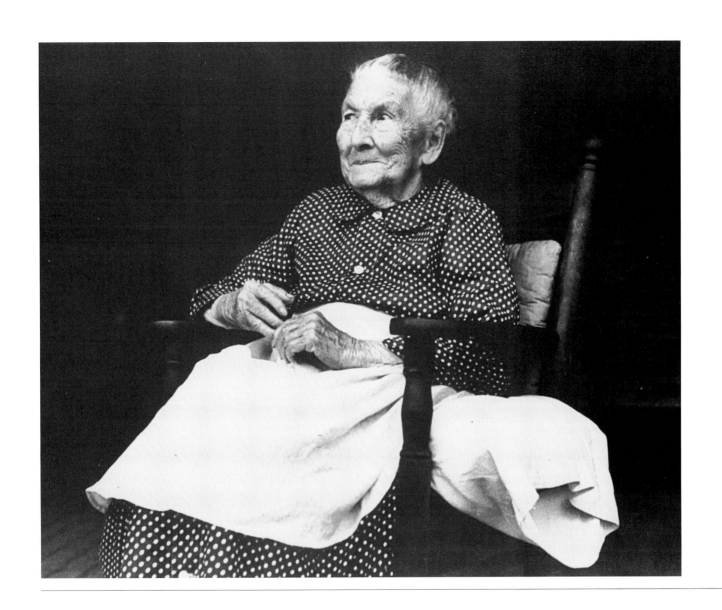

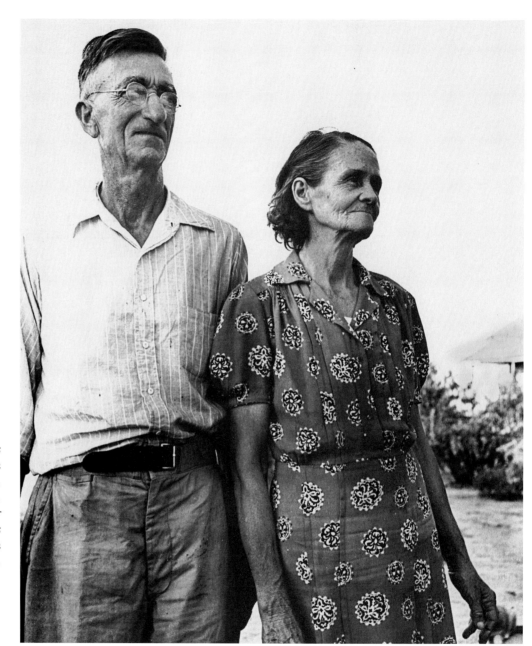

Grant Wood's painting, "American Gothic," is echoed in this picture of a careworn and unidentified farm couple whom Hightower photographed during his travels. On the facing page is a portrait of Nancy Bennett Weston, who lived from 1850 to 1946. He photographed her at her home near Louisville during the war, while her grandson was serving in combat in the South Pacific. She lived long enough to see him safely home after the war.

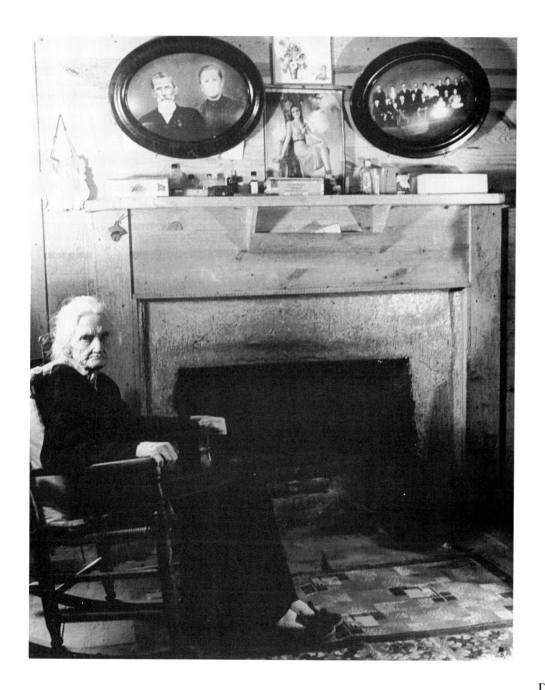

Hightower took as much care photographing the old black man whose name is now forgotten as he did his own mother. Both people are portrayed as monumental figures who have triumphed over a hard life spent working the land. Lizzie Hightower was photographed in 1933 in front of the family home on the Smuteye Road, whereas the old tenant farmer is shown isolated against a dramatically filtered sky. Both pictures reflect the influence of the best of photography in the thirties, the sort of images he saw weekly on the pages of Life.

This picture could have as easily been taken in West Africa, but it was made in pre-war Barbour County. Women walking to town with loads balanced on their heads were once a common sight in the county, but only Hightower recorded one photographically. He knew the coming of the automobile was bound to end the practice which had once been so widespread.

Hightower was fascinated by people from all walks of life. These farmers, probably attending a livestock show in the thirties, caught his attention, perhaps because they were the pillars of the world he saw was vanishing. None of their names was recorded.

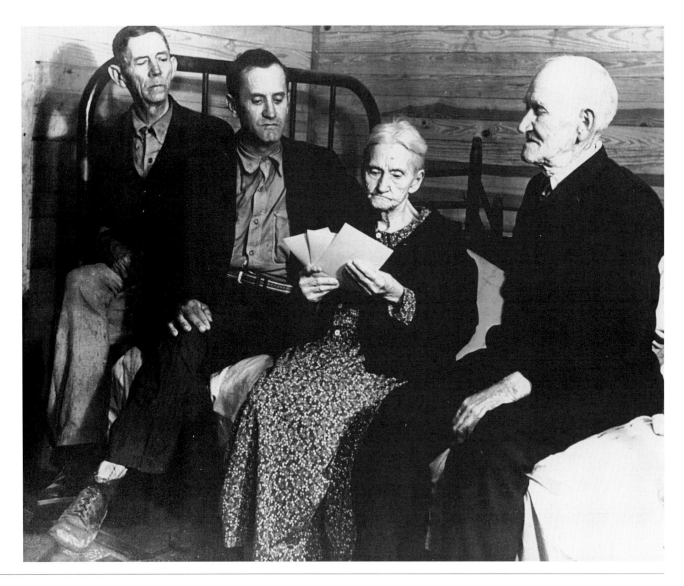

Sometimes family ties were a source of comfort as for the ninety-year-old woman above. She is surrounded by her three sons while looking at some of Hightower's pictures c. 1940. On the other hand some events are beyond consolation. The women in the picture on the facing page had given birth to quadruplets, all of whom died despite professional medical care. The Singleton family lived near Cook's Ford when this sad picture was made.

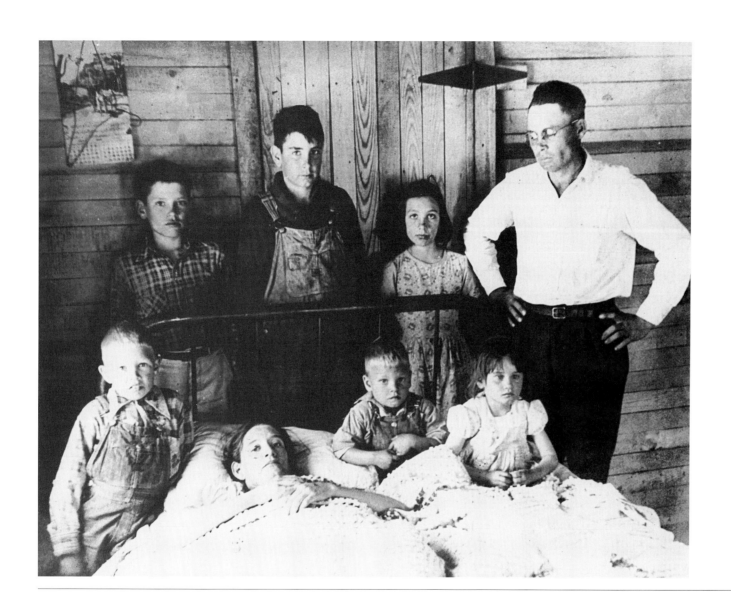

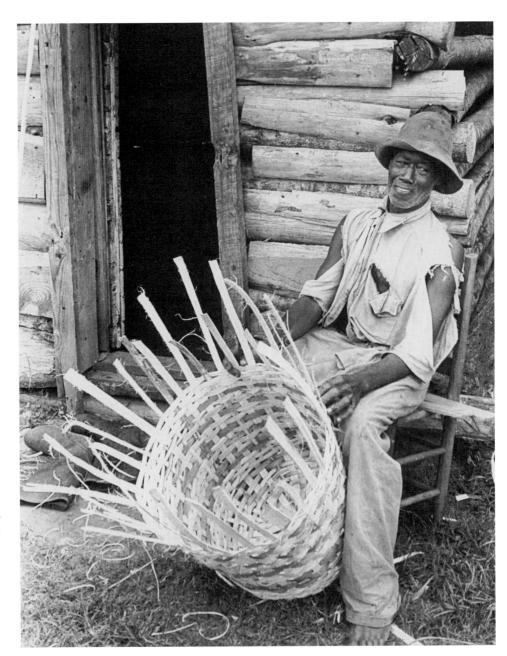

Hightower was drawn to people who practised skills from another era. He visited this White Oak cotton basket maker, who probably lived in nearby Pike County, to record his work. On a more mundane level he recorded an unidentified young man shelling corn by hand so it could be subsequently ground into meal. Both pictures were made in the forties, of practices soon to be largely forgotten.

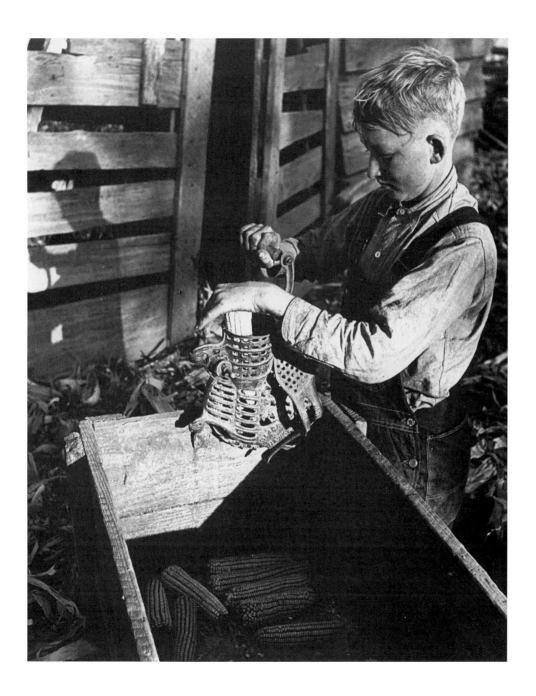

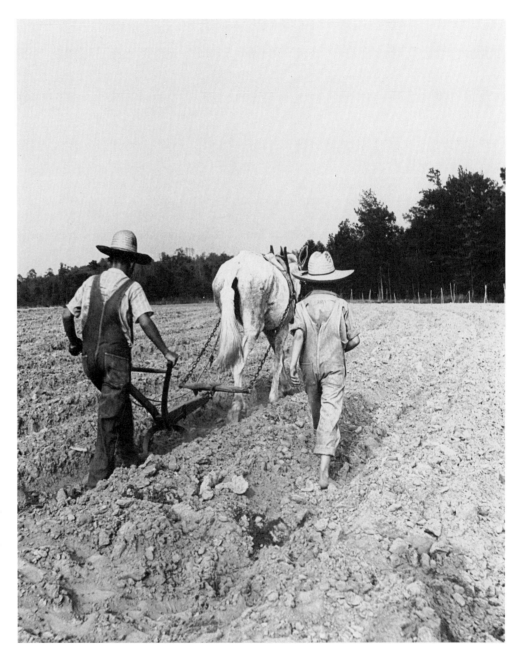

Plowing a mule to plant corn or cotton was a common springtime sight even in the forties. In the picture above a white boy walks along beside a black youngster as he plows. Hightower hoped this picture of two friends would show that a spirit of racial tolerance existed in the old order. On the facing page a barefoot young man received an award while standing proudly in the field he is preparing. Both plowboys are using light, singletree plows whose design was older than Barbour County itself.

To Remember a Vanishing World

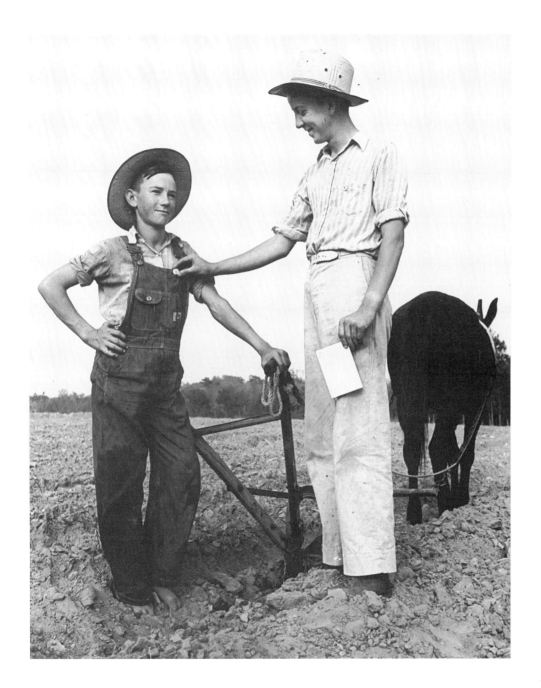

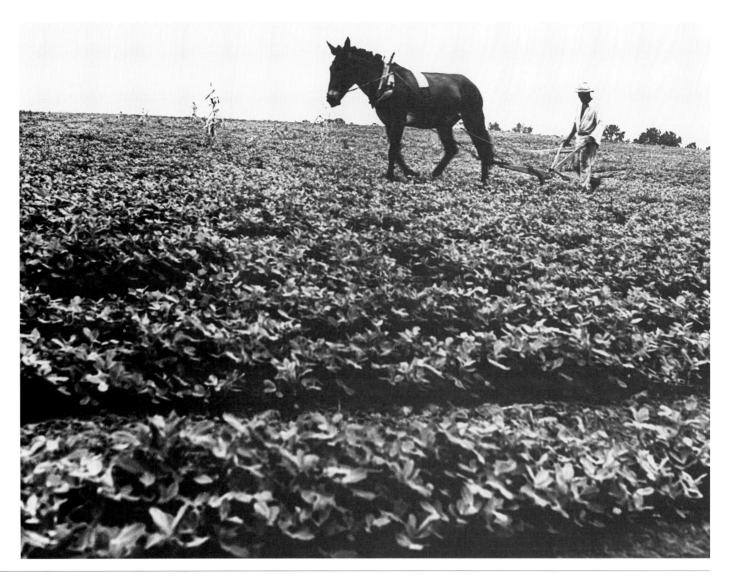

This man is plowing a field in a most traditional manner but planting the new crop, peanuts, instead of cotton, in the thirties. On the facing page a rare triple mule team pulls a disc harrow used to prepare a field for a variety of crops including peanuts. The disc harrow was not used until the forties in Barbour County.

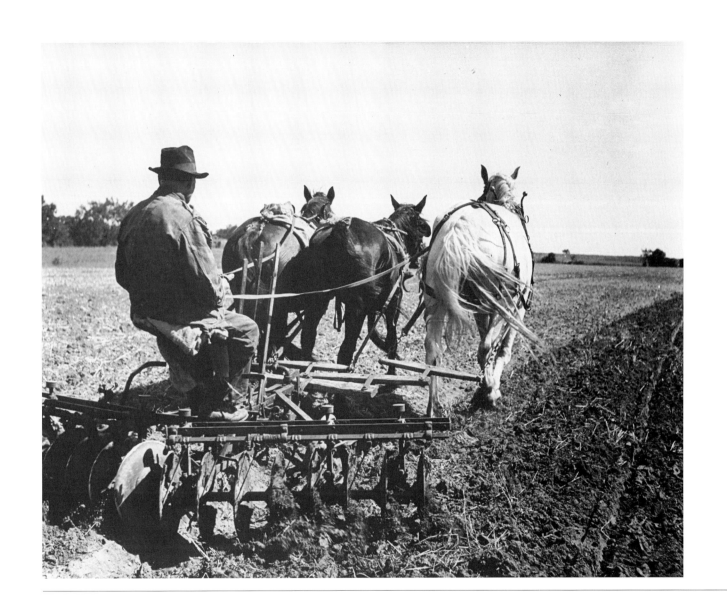

Modern farming methods would rely on tractors, not mules, operated by well-capitalized families with larger acreage. As people left the land after 1930 those who remained, especially young men like George Johnston shown here c. 1940, must have wondered what their own future would be.

As Douglas Benton demonstrated, the fish were still biting, whatever other changes were coming to rural Alabama. Proud of his large mouth bass, he posed one evening, apparently on Hightower's front porch. One could always go hunting when the fish wouldn't bite, but even with these delights, by the time this picture was made, people were leaving rural Barbour County in steadily growing numbers.

The 4-H club was the largest organization for white farm children in the thirties and forties throughout rural America. Barbour County was no exception. In the picture above entrants are being judged at the Louisville stockyard while on the facing page a young man waits confidently for the judging at the "Fat Calf" show in front of Clayton's courthouse shortly before World War II.

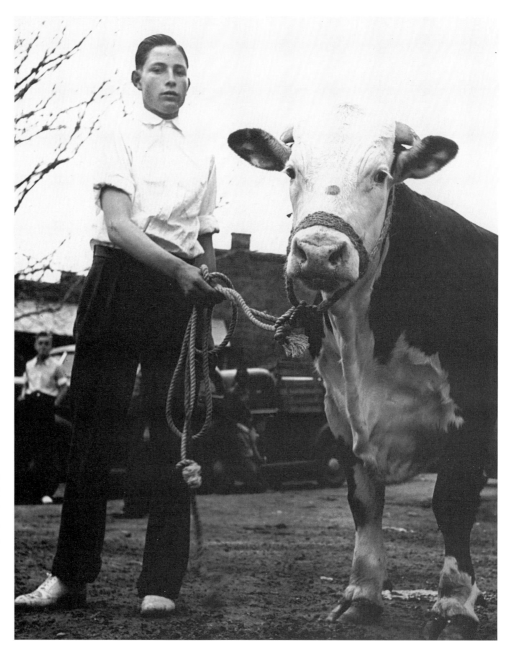

Occasionally Hightower's work had its surprises, even recording a 4-H show. Floyd Faircloth's pride and joy apparently got spooked and went for the photographer when he tried to take a second picture. No harm was done though no further low-angle shots, such as this, probably taken in a kneeling position, were made that day either.

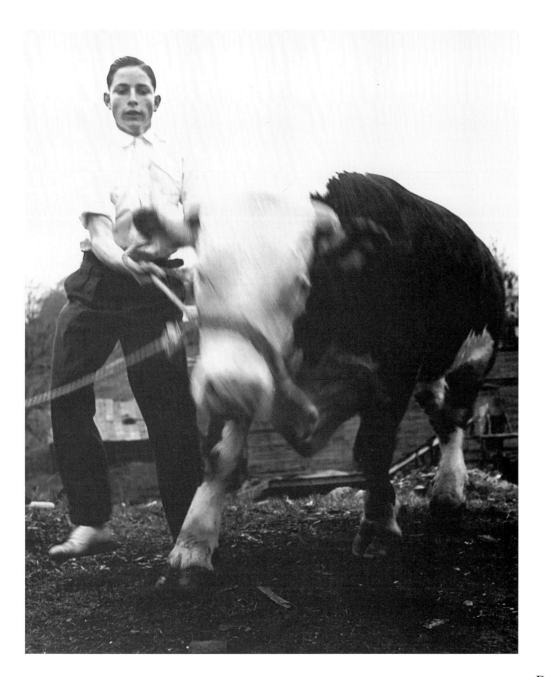

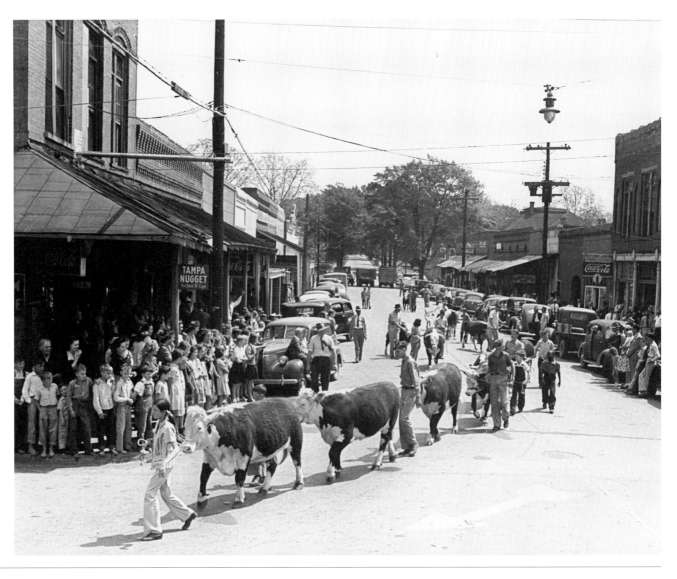

When the 4-Hers paraded down Eufaula Street to the square, pausing to have a group picture made, it seemed that the whole community had turned out to watch. Although black farmers made up a majority of the rural population then, they are conspicuous by their absence, save for a single boy walking with his white friend in the parade.

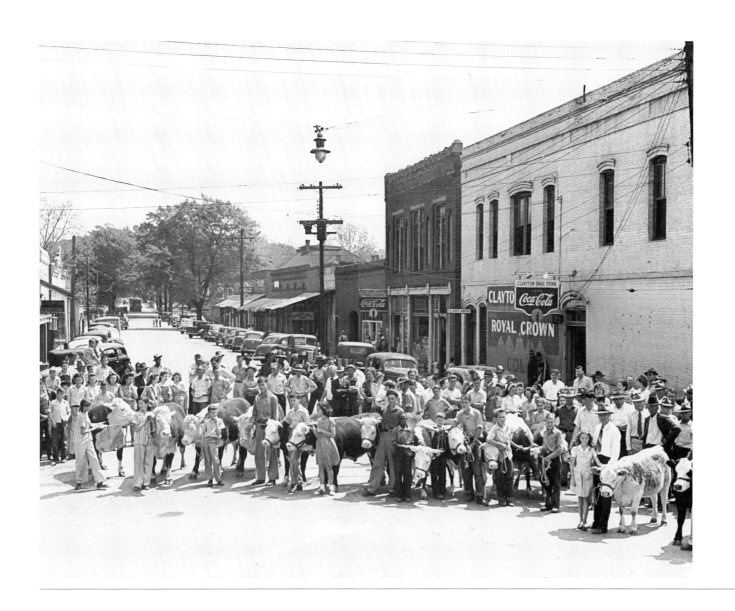

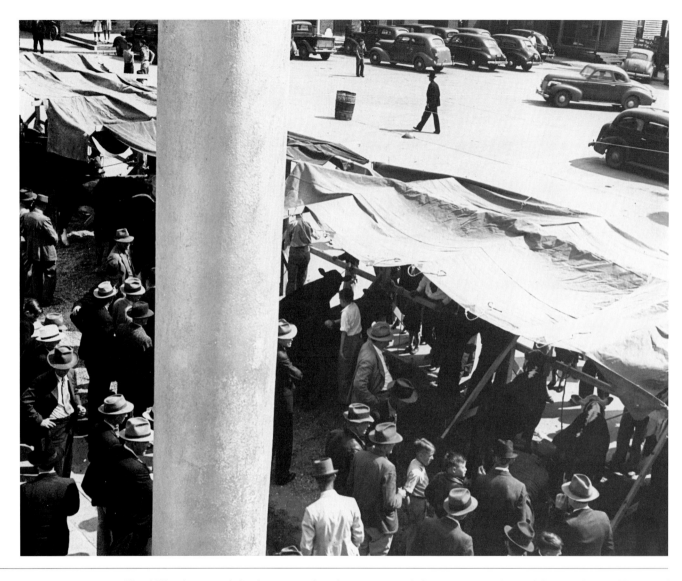

The 4-H judging and display occurred under temporary shelters put up in front of the courthouse. The crowd at this c. 1938 show was large and appears relatively prosperous. In the photograph on the facing page prizes are being awarded. From these pictures one would never know of the wrenching years Barbour County farmers had so recently endured.

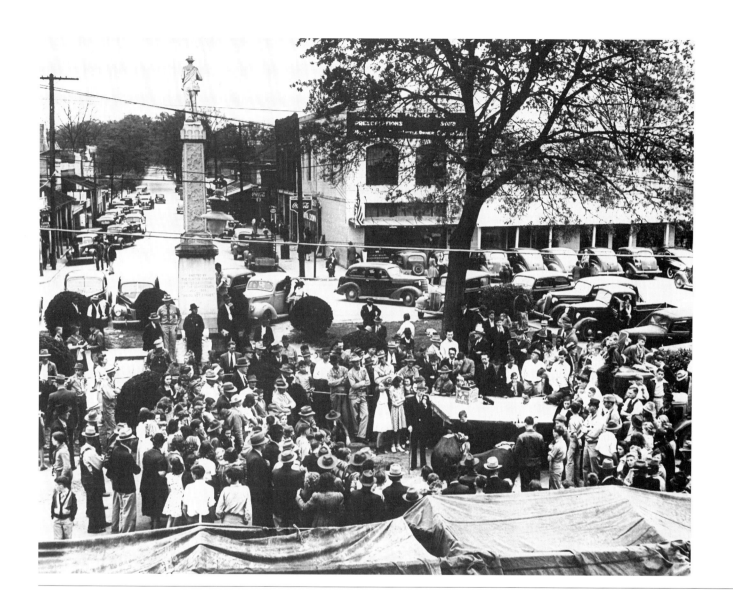

In the mid thirties an exploratory well was drilled on the Robertson family land south of Clayton. Hightower made several trips down to the site recording both the oil field roustabouts at work and the carnival-like gathering when folks came to see what was going on. There was a Coca Cola® vendor and plenty of parking, but unfortunately no oil. Barbour County would have to look elsewhere to save its rural economy.

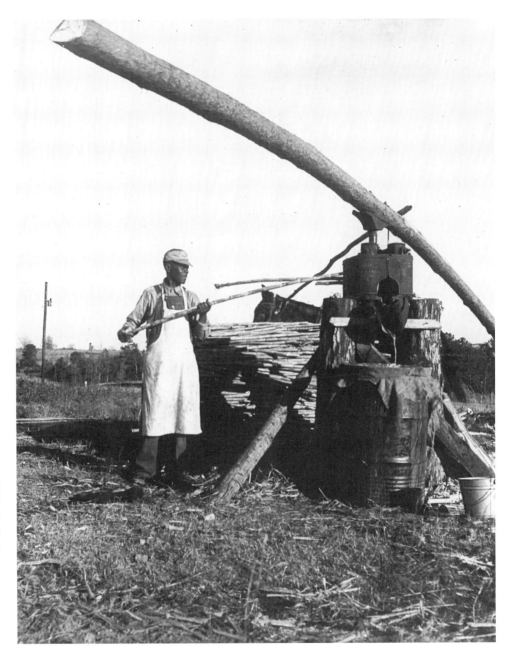

Hightower noted that once almost every farm had a cane mill to make its own sugar. Besides sugar the squeezing process yielded black cane syrup which was a feature of every table, to be used on the "cat face" biscuits which were the pride of farm households. Like most cane mills this one relied on a mule harnessed to a boom to provide power.

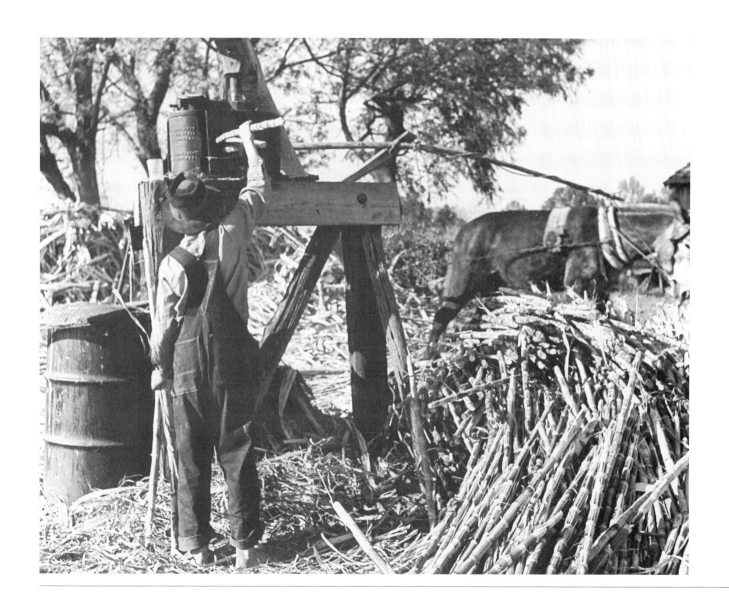

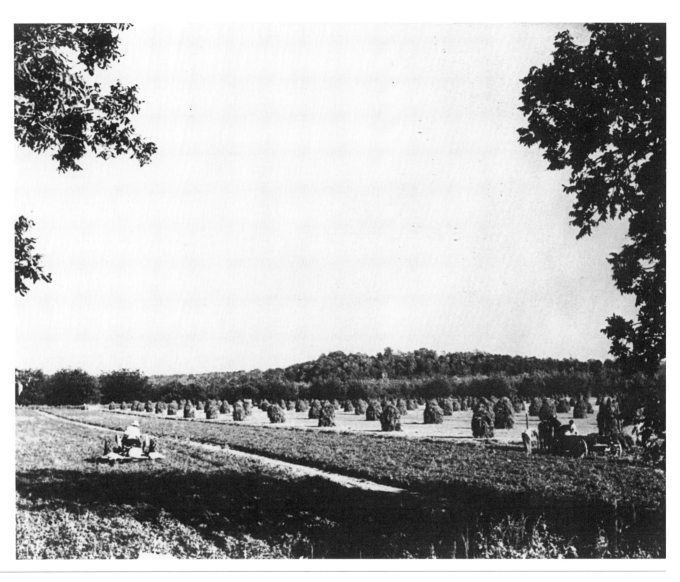

Peanuts, underwritten by government subsidies, were the only new crop whose production grew during the thirties and forties in Barbour County. While there was still a lot of hand labor associated with harvesting, the crop was ideally suited to mechanized cultivation and processing. In the picture above, a tractor cultivates a field adjacent to the stacks of harvested peanuts. On the facing page men fork whole peanut bushes into the picker which is powered by a tractor via a drive belt. The picker moved from stack to stack processing the harvested nuts. Such an operation demanded land and capital investment.

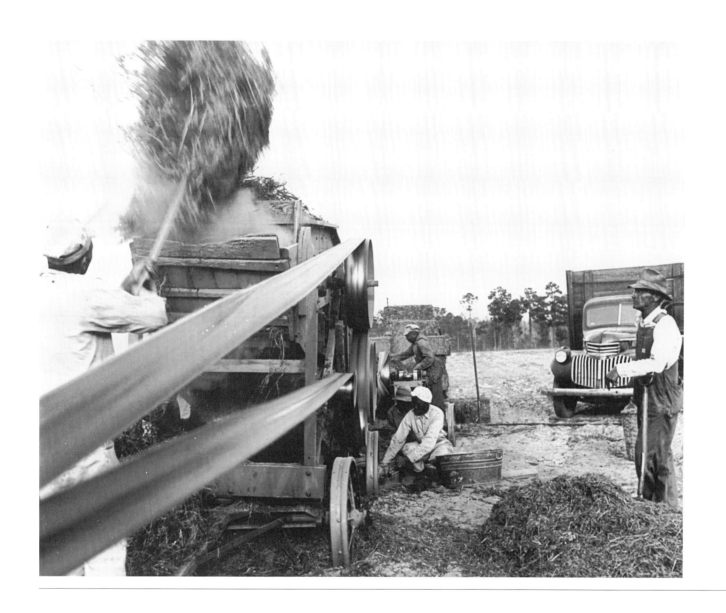

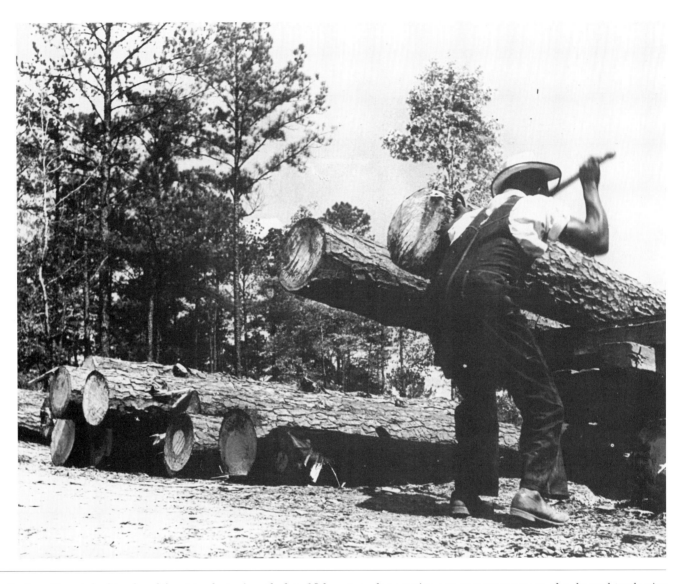

Barbour County had produced forest products since the late 19th century, but wartime government contracts also boosted production mightily. "Log rolling," shown above, was a skill combining strength and years of experience which Hightower recorded graphically. As logs were rolled into place, the saw mill took over stripping bark to prepare for cutting into lumber. The photo on the facing page is of M.D. Shirley's portable mill which worked at the cut site so that only sawn lumber had to be transported out of the woods.

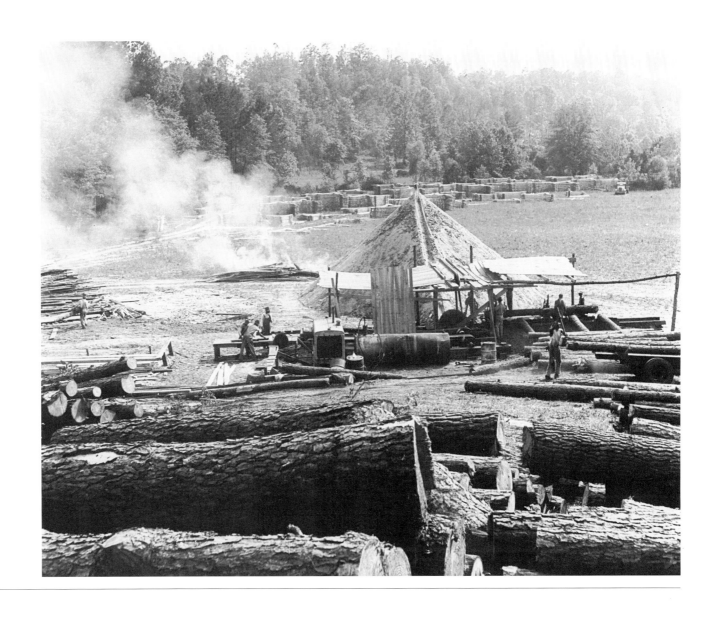

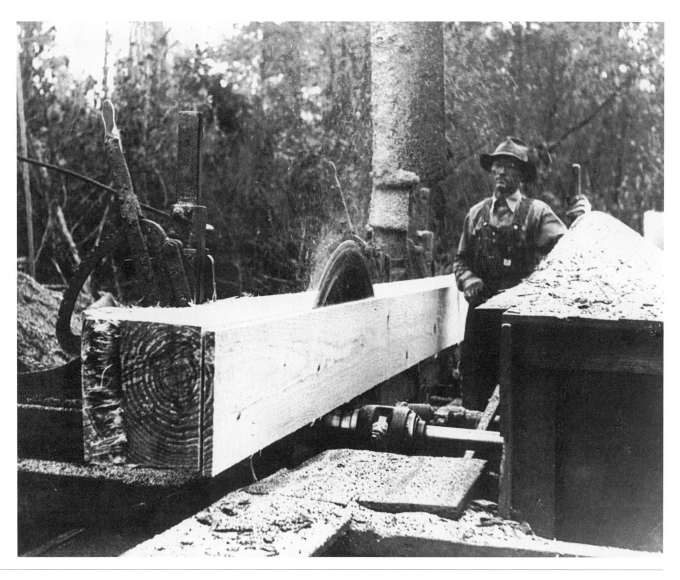

The saw mill operations relied on the sawyer's skill as well as the abundance of fine timber. This mill was located west of Clayton, but the operator's name is forgotten.

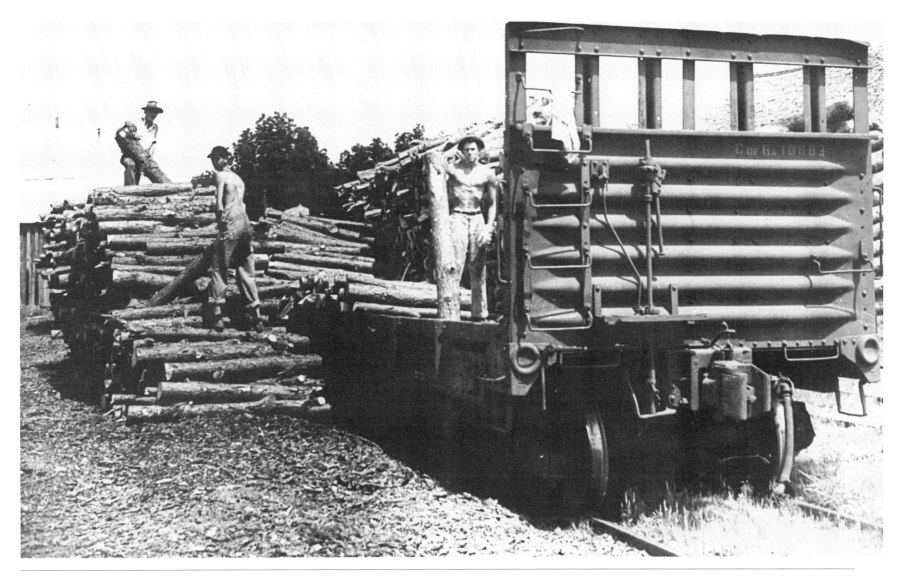

Barbour County's timber resources offered opportunity for enterprising young men unafraid of hard work to earn summer money. These fellows are loading pulpwood they have cut and transported onto a railway car, c. 1950. Don Bush, Edsel Barner, and Walter Warr (left to right) demonstrated considerable initiative in making this project financially successful. At least one, Walter Warr, would go into a career in forest management.

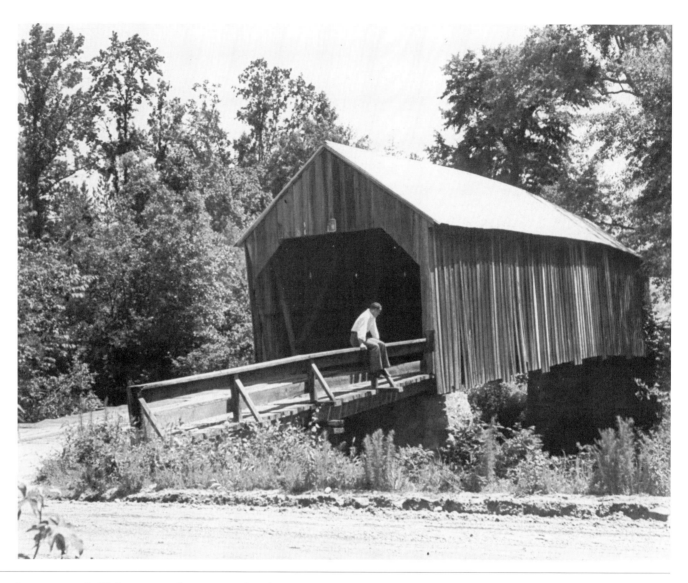

Selling cars and traveling across the county made Hightower acutely conscious that the automobile was changing the face of the land. A covered bridge would yield to a stronger plank construction (facing page) designed to carry an automobile. Covered bridges were not a common sight in Barbour County and this one on Baker Creek may have been the only one left when Hightower photographed it in the 1930s. On the other hand, the plank bridges, such as this one crossing Bickey pond, were none too reassuring either. Paved farm-to-market roads and modern bridges would not begin to appear until the late forties.

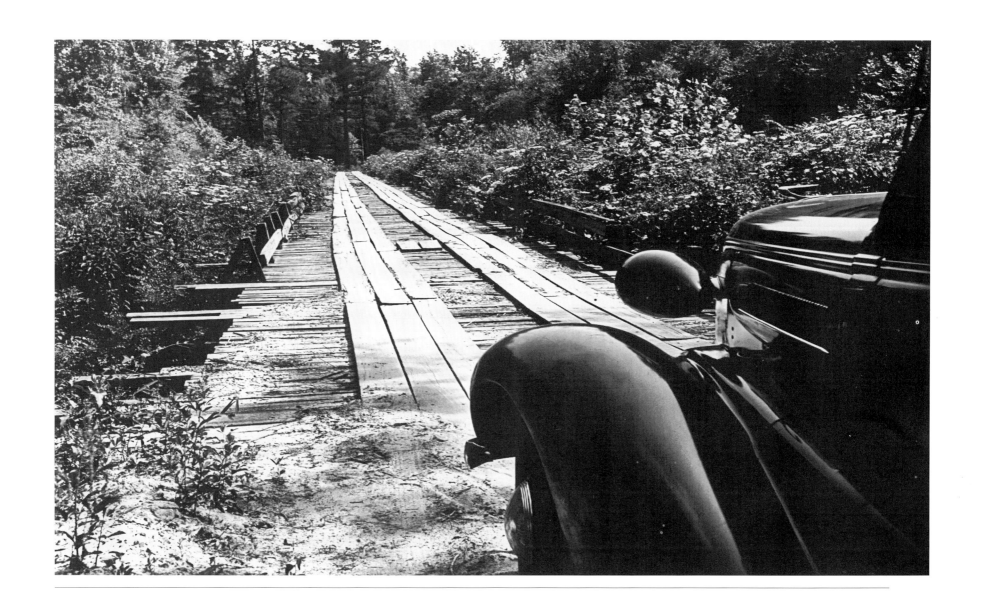

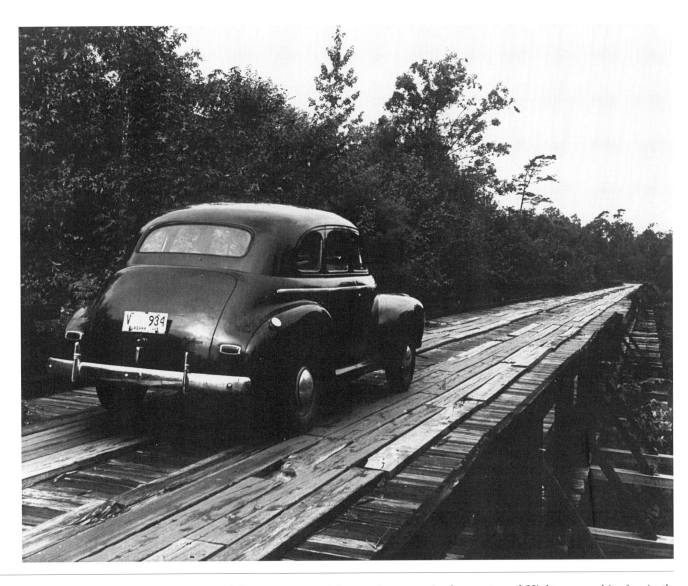

The bridge across the Pea River west of Clayton was one of the more important in the county and Hightower used it often in the thirties and forties. The planks which ran the length of such bridges were designed to give them extra stability and the crude guard rails made users feel a little safer as they made the crossing. The roads leading to such bridges were unpaved and could be treacherous when it rained, or produce clouds of dust when it was dry.

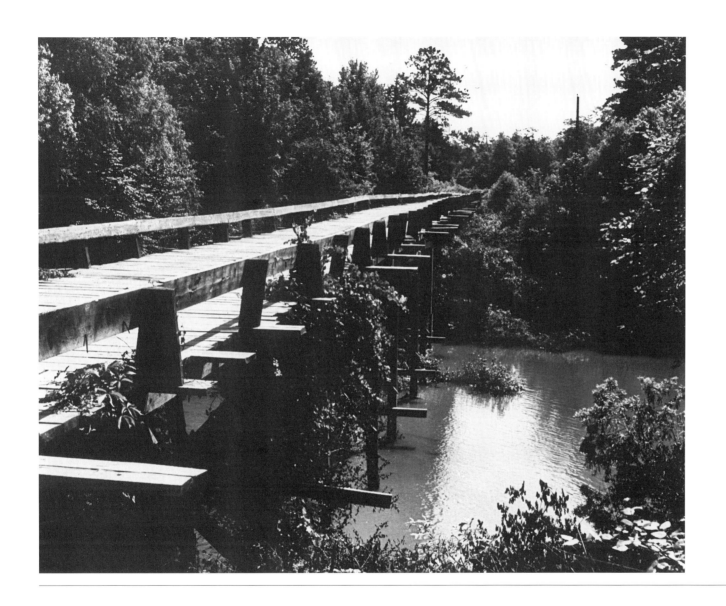

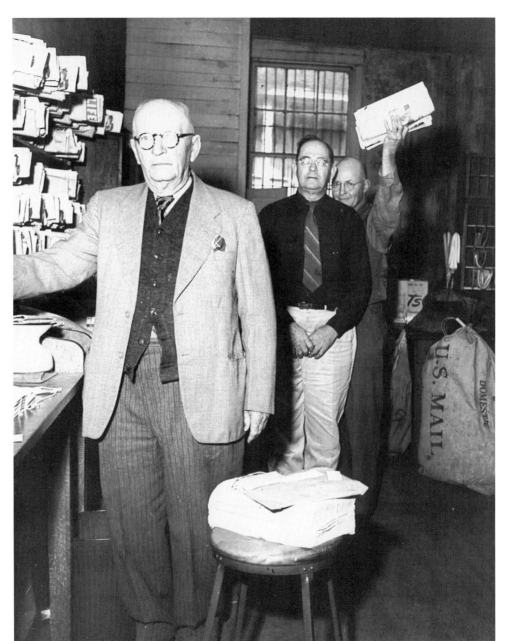

Dirt roads and wooden bridges, however wanting by more modern standards, enabled the regular delivery of mail to rural households via Rural Free Delivery. These were the RFD postmen photographed c. 1941. In the photo on this page they sort the mail in the post office on Clayton's courthouse square, while on the facing page they posed next to their cars. The postmen were (left to right) Jim Creel, Dean Hoffman, Dellon Vinson, and John Coles.

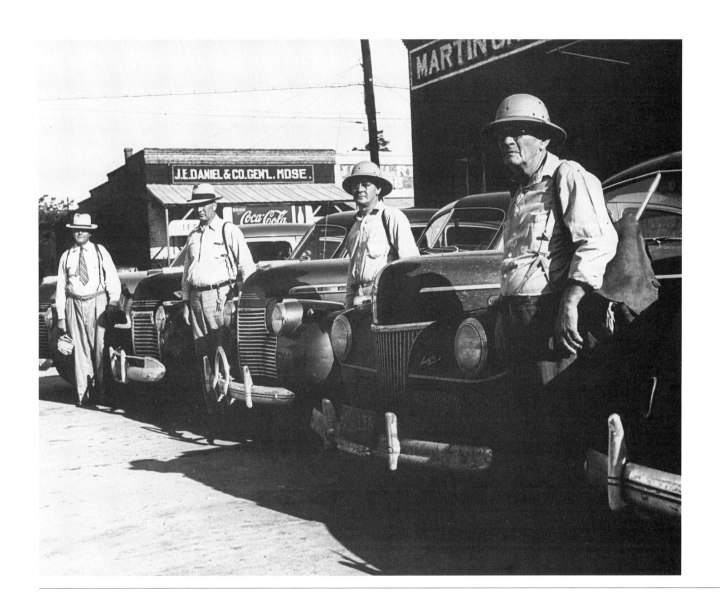

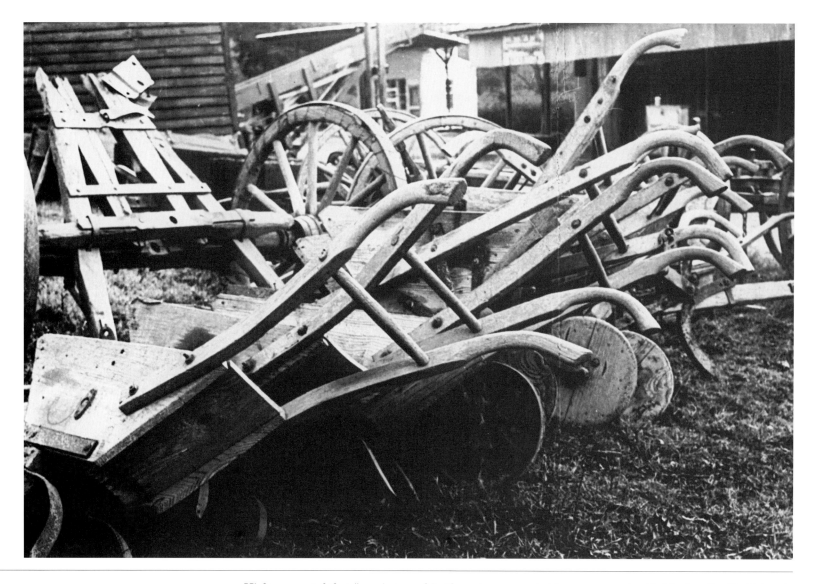

Hightower noted that "new improved implements came and old ones were cast aside" to describe this picture he made c. 1940. In it cotton-seed planters predominate, graphically illustrating the change which had occurred as peanuts, timber, and people simply leaving the land ended King Cotton's long reign.

The Spencer-Bickley mill, also known as Williams mill, was a water-powered corn mill which was still function-ing on the eve of the World War. However, it also housed a machine shop, perhaps in an effort to respond to the changes that mechanization was bringing, when Hightower made this photo.

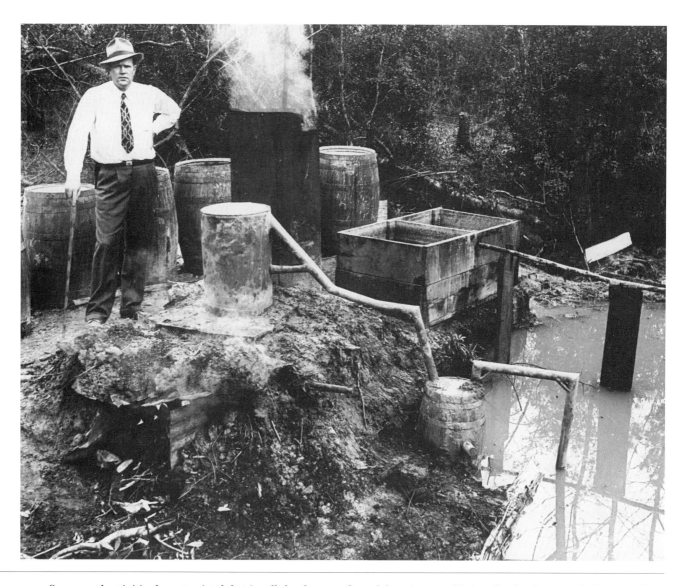

Some rural activities have persisted despite all the changes. One of them is moonshining. In the photograph above, made in 1949, Sheriff Marshall Williams, Sr. has raided a still near Comer. It was operated by a black man named Shin, though it probably had a white owner. As the photographs show, the still was rather large, and state ABC agents joined Williams and his deputies in the operation. Such stills were scattered across the county as they were in most of the rural South.

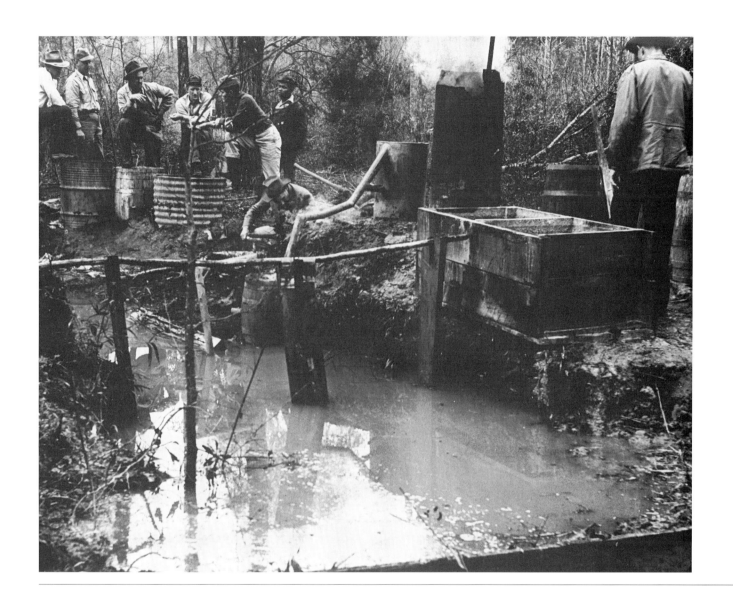

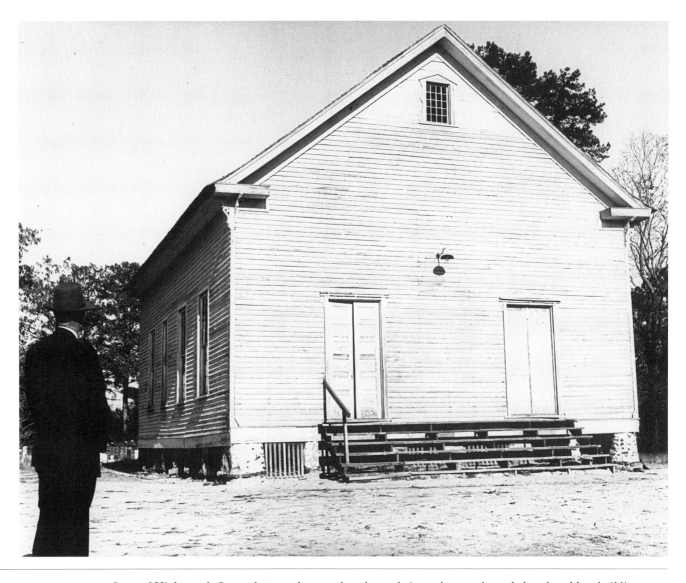

Some of Hightower's finest photographs were those he made in and around rural churches. Most buildings were humble affairs, but inspired by photographers such as Ansel Adams, he gave them the dignity and importance they deserved. The photograph above is the Rocky Mount Church between Clayton and Baker Hill, which his grandmother attended. It took her two hours in a wagon to get there, demonstrating the loyalty people felt to these churches. On the facing page is a newer structure, Mount Zion Church, near Louisville.

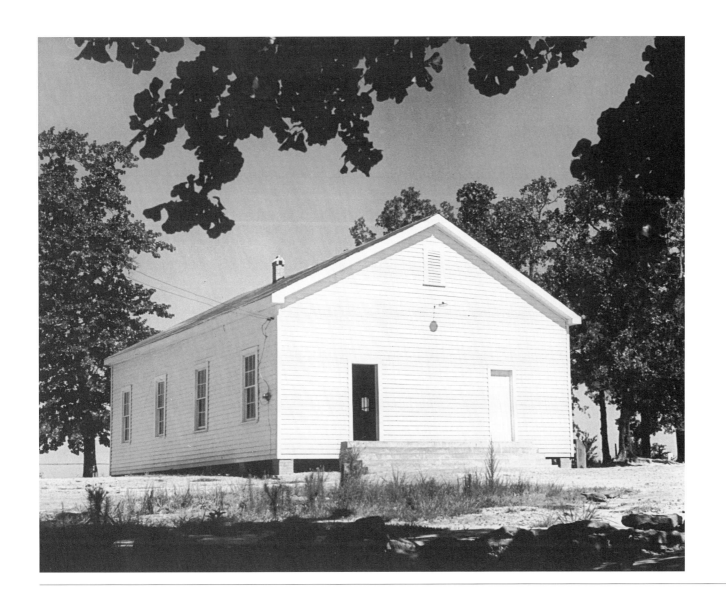

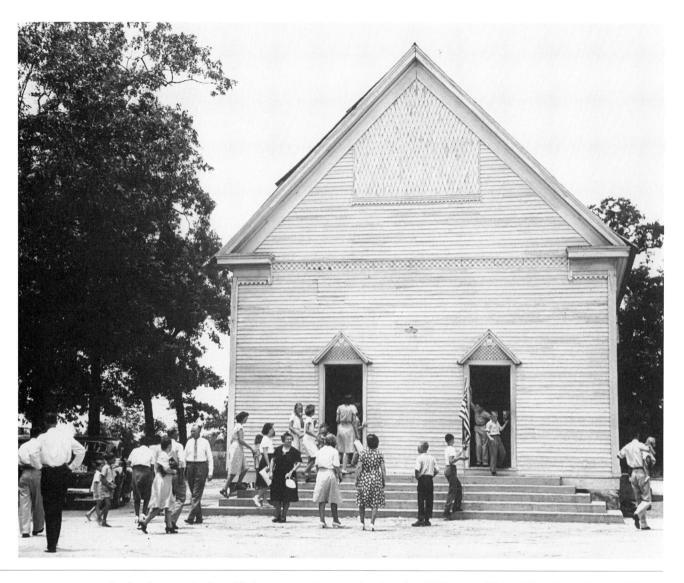

In the photograph above Hightower records people leaving the old Pleasant Plains Church southeast of Clayton after Sunday services. On the facing page people arrive at Pleasant View Presbyterian for the Second Sunday in May All Day Sing. Black or white, rural congregations often made a full day of it at church on Sunday with preaching, singing, and socializing the order of the day.

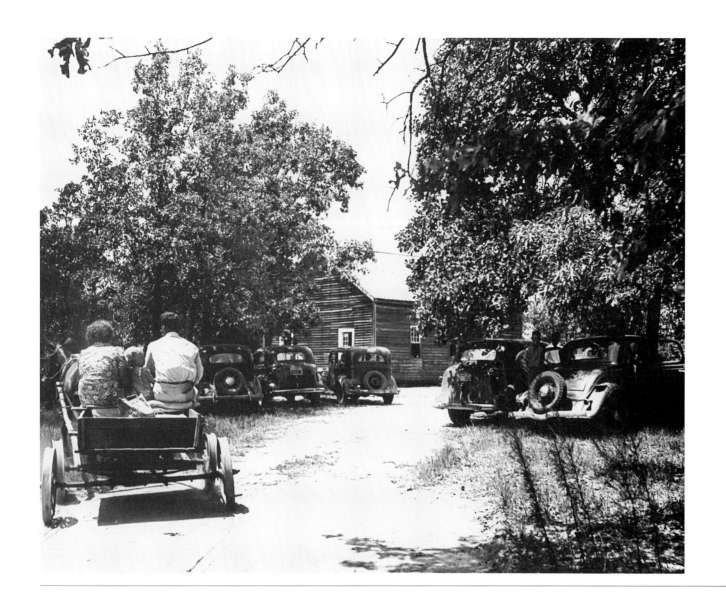

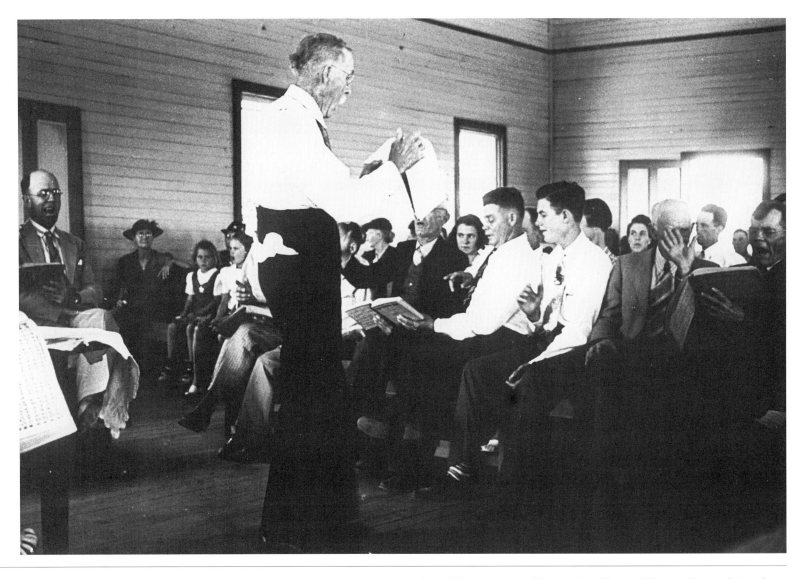

In these pictures made in the thirties Hightower records an All Day Sing at Mount Zion Church. The people were doing shape-note or sacred harp singing, a distinctive musical style practiced by the Scotch-Irish pioneers of the South. The leader in the photograph above is Cato Baker Junian, while the woman on the facing page is not identified. The rhythmic motion of the hand helped singers keep time. Considering the lighting these are remarkable candid photographs for this period.

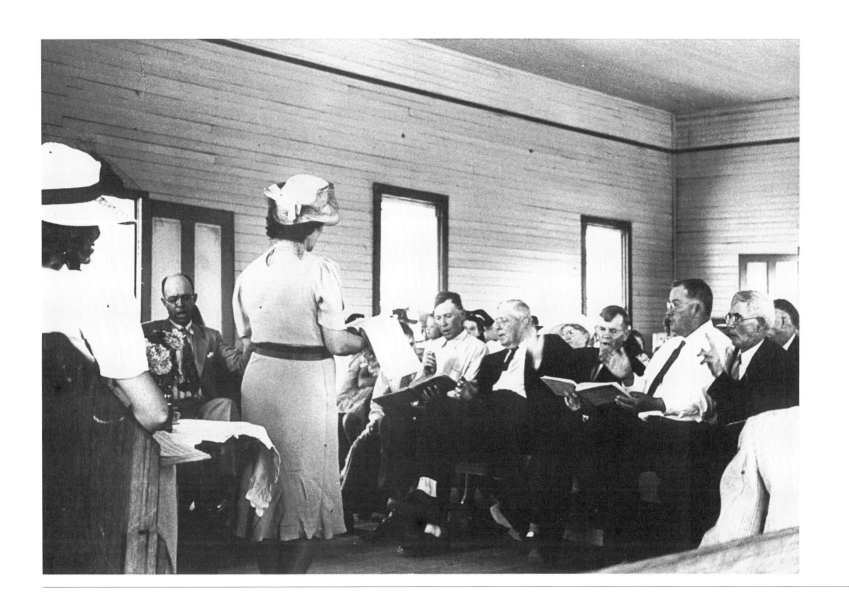

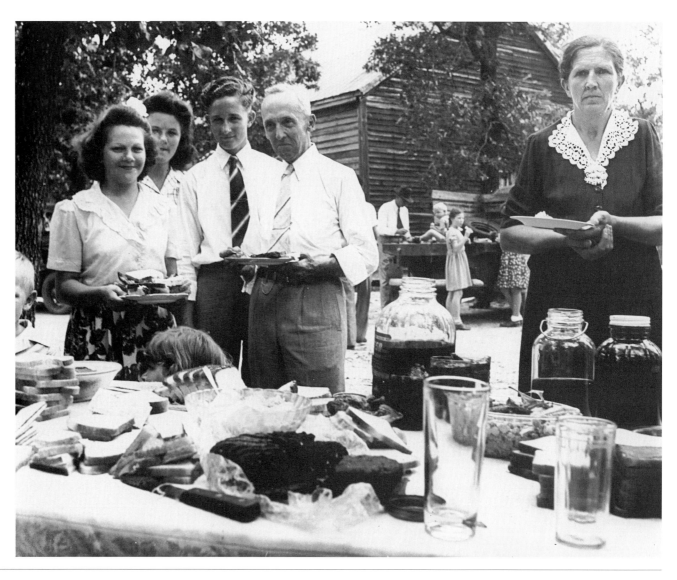

Part of the appeal of events like the All Day Sing was the dinner on the grounds which often accompanied it. Members of Pleasant View Presbyterian are gathered around tables laden with food which had been set up beside the church. In the photograph above their pastor, Dr. Stork, stands in the center.

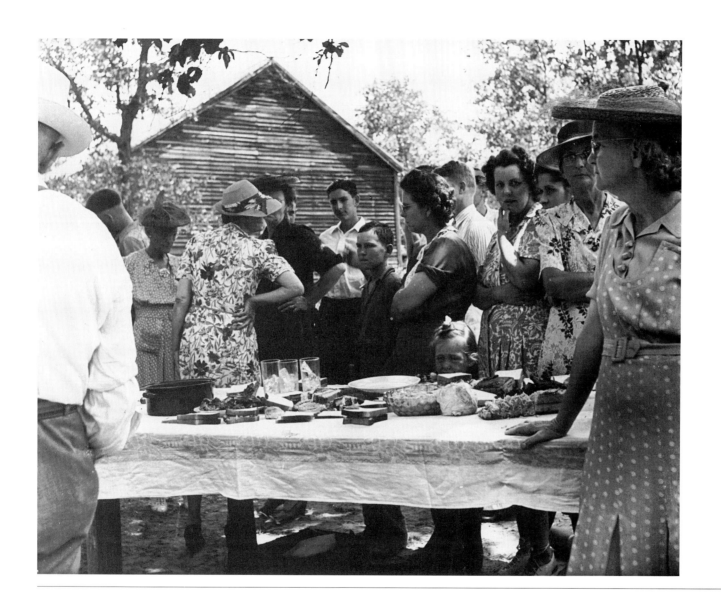

Hightower photographed this Depression-era gathering of the Pleasant Plains congregation around their baptizing pool after a week-long summer revival. Their minister was the Rev. J.D. Willingham, shown above being helped into the pool. The girl being baptized on the facing page is not identified. As Hightower noted these revivals "brought people to church or bush arbor where they would sing, pray and hear good preaching strait (sic) from the good Book."

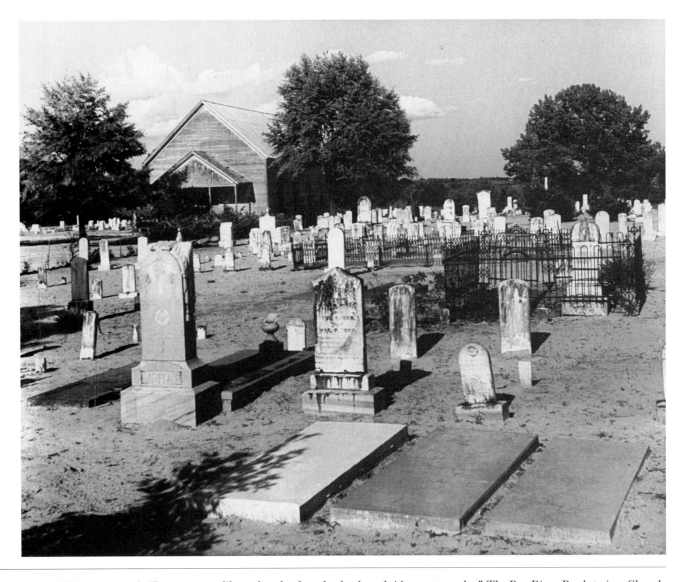

As Hightower noted, "It seems more like a church when the dead are laid to rest nearby." The Pea River Presbyterian Church, organized in 1823 near Clio, was typical of many rural congregations as its cemetery was adjacent to it. Strongly influenced by the realism of straight photography, Hightower made many of his most dramatic photographs of such churches. This one especially attracted him since it was built by the pioneers who first settled the county.

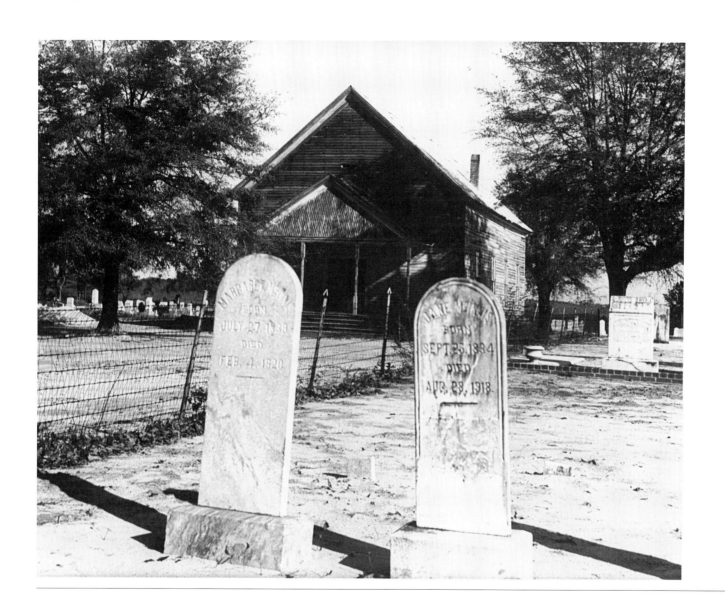

Hightower's careful attention to composition is especially evident in this picture of the old Bethel Church near Blue Springs, made in 1945. His control of depth of field and tonal values from the darkened sky to the white church itself demonstrates a mastery of the medium.

Scattered around Barbour County and most southern counties were hand-made signs calling on people to repent and pray. Hightower found this one on a roadside before the war and skillfully captured the power such proclamations had for many people.

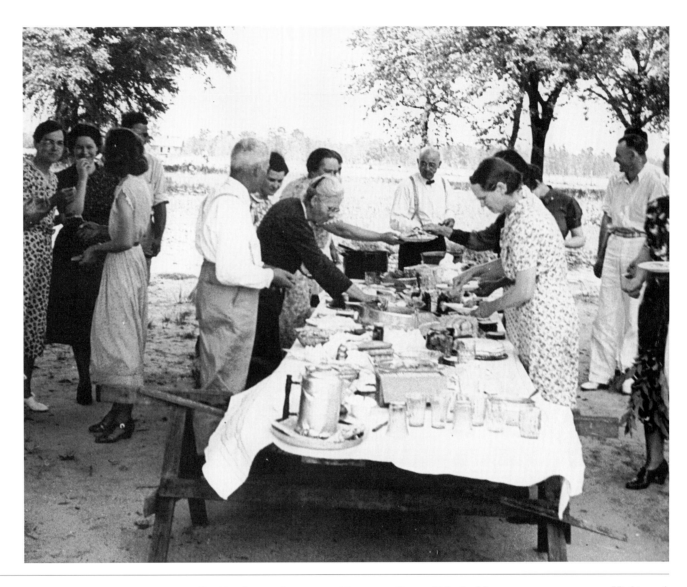

Despite changes he saw sweeping away the world he had known as a young man, Hightower's optimism persisted, whether it was family ties strengthened by annual reunions or the youthful optimism of a young wartime couple, Mr. and Mrs. Fred Shirley, the legacy of the world he knew sustained him and through his record of it, fascinates us.

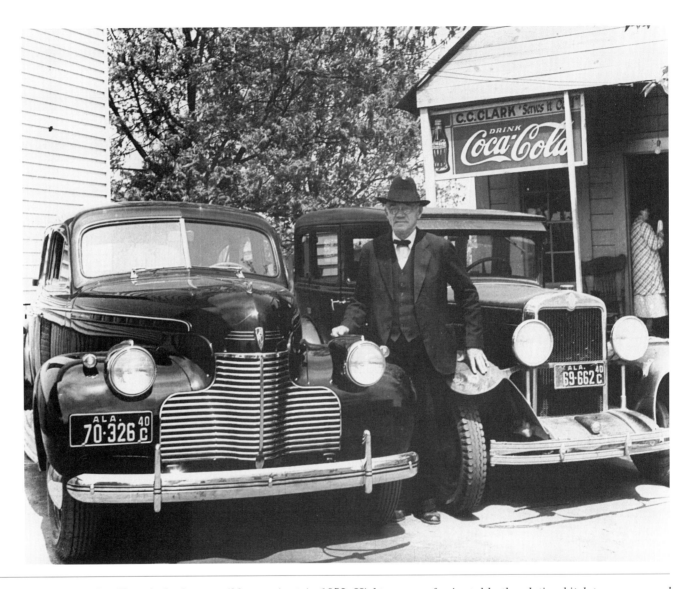

Never far from his Chevrolet business until he gave it up in 1953, Hightower was fascinated by the relationship between man and automobiles. Mr. C.C. Clark, above, had just traded in his well-used 1929 Chevy for a new 1940 model. He was one of Hightower's many faithful patrons. On the facing page the photographer takes his own picture getting out of his Chevrolet. Without automobiles he could not have recorded so much with his camera, but without them there might not have been so much to record.

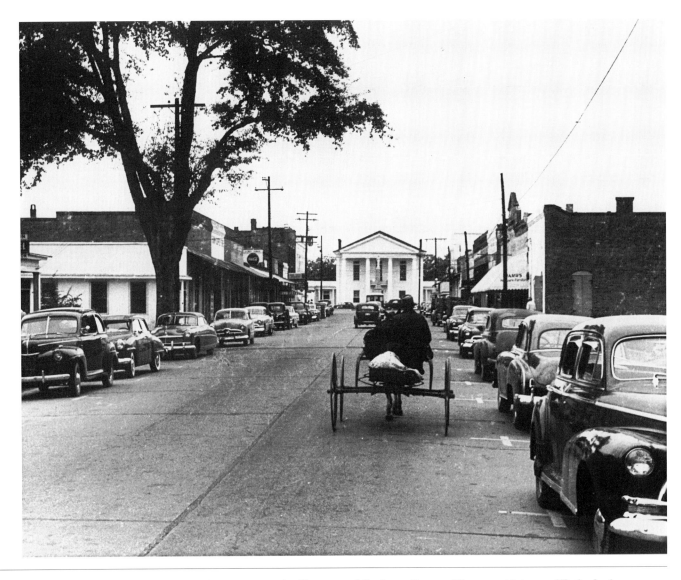

For over three decades Hightower recorded the changing scene in Clayton and Barbour County. These two pictures of Eufaula Avenue, one c. 1950, the other a decade later, offer an interesting contrast. Will Grice and his horse and buggy are gone along with the Clayton Hotel by the end of the fifties. Soon the old courthouse would be, too. In the later picture the street is less crowded but many of the buildings, including Warr's hardware, where Hightower first worked in the 1920s when it was Robertson's Ford, still found productive use.

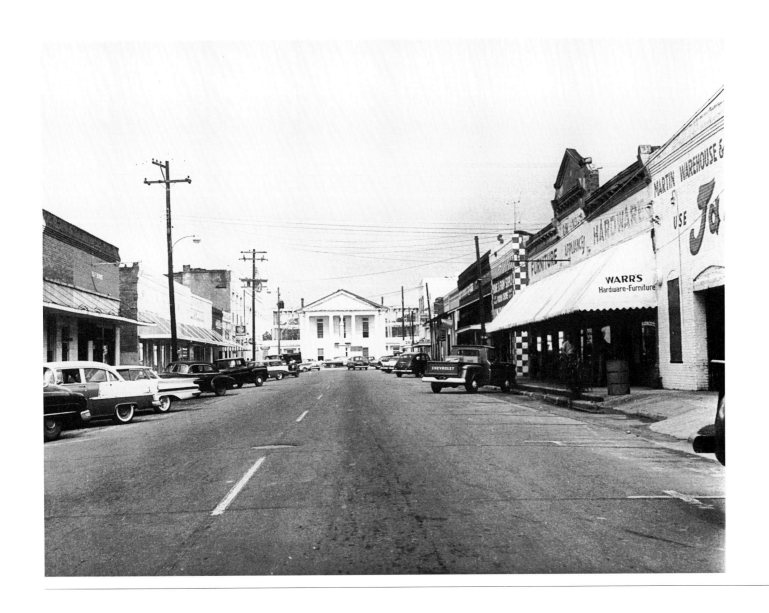

Whether serious or whimsical, Hightower sought to record the world he knew. Boys enjoying the ultimate cooling power of a country creek on a summer's day in the mid-60s was as important an event to record as their fathers going off to World War II had been.

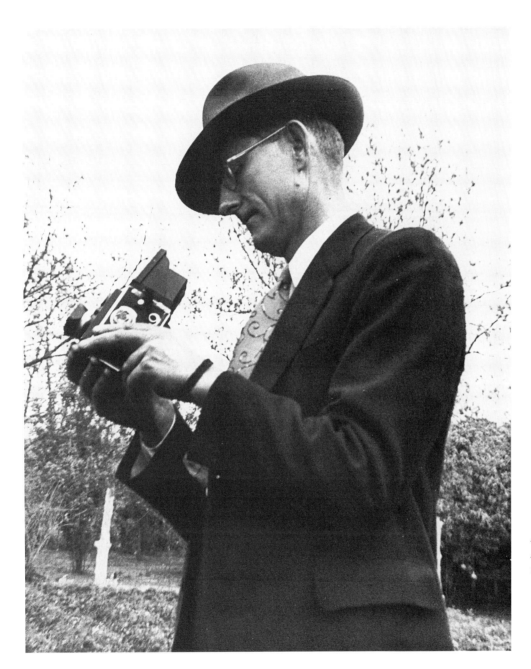

Hightower's favorite camera was the Rolleiflex.
He used it to make some of the best pictures of life in the South
that have ever been made.

Index